CANO
EOS 6(_

THE EXPANDED GUIDE

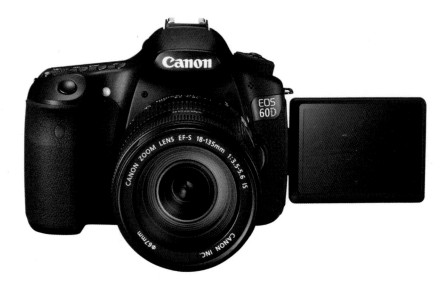

CANON
EOS 60D

THE EXPANDED GUIDE

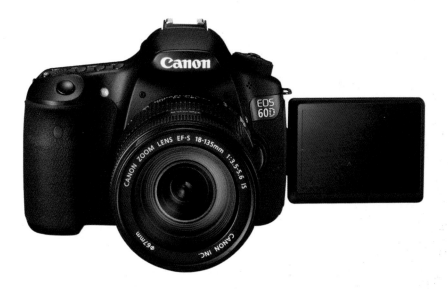

Tracy Hallett

AMMONITE
PRESS

First published 2011 by
Ammonite Press
an imprint of AE Publications Ltd
166 High Street, Lewes, East Sussex, BN7 1XU, UK

ISBN 978-1-907708-08-4

British Library Cataloging in Publication Data: A catalog
record of this book is available from the British Library.

Editor: Ian Penberthy
Series Editor: Richard Wiles
Design: Fineline Studios

Typefaces: Giacomo
Color reproduction by GMC Reprographics
Printed and bound by Maurice Payne Colourprint Ltd

《 PAGE 2
Looking toward the
island of Rum from
Eigg in Scotland.
The curve of the
river leads the eye
toward the peaks of
the Cuillin.

» CONTENTS

Chapter 1
OVERVIEW

1 OVERVIEW

The EOS range was born out of a desire to bring speed and precision to the SLR market with user-friendly equipment—something that remains part of the Canon ethos to this day.

The Canon story begins in 1933, when Goro Yoshida, Saburo Uchida, and Takeo Maeda established the Precision Optical Instruments Laboratory in Tokyo. The men claimed to have produced three prototypes of a 35mm rangefinder camera, although no working models were ever found. The prototype was called Kwanon (later known as Canon) after the Buddhist Goddess of Mercy. Despite the group's best efforts, lenses were tricky to procure and the men were forced to seek assistance from Japan Optical Industries, Inc., (the predecessor of the Nikon Corporation). In 1937, they launched the Hansa Canon with a Nikkor 50mm f/3.5 lens.

Canon's first 35mm SLR, the Canonflex, appeared in May 1959, and was swiftly followed by Nikon's "F" camera a month later. By the 1960s, through-the-lens metering was in demand, and Canon responded with the Pellix and the FT QL, both featuring partial-area TTL systems. Soon afterward, the company started

EOS 60D ≈
The EOS 60D borrows technology from its high-spec siblings.

producing calculators and copying machines after a message from the president, Mr Mitarai, to "hold cameras in our right hand, and business machines and special optical equipment in our left."

In 1971, after five years of development, Canon unveiled the F-1—an SLR camera designed for professionals. This groundbreaking model was compatible with more than 180 accessories. While working on the F-1, Canon also designed an autoexposure SLR called the EF, which was launched in 1973. Five years later, the A-1 was released, featuring five AE modes and a microcomputer—technology that later inspired the T and EOS camera ranges. Some 10 years after its launch, the F-1 was updated to include selectable AE modes, and a hybrid shutter that could be operated without battery power. Due to an unfavorable market in the early 1980s, Canon decided to concentrate on cheaper models for amateur/enthusiast photographers. This resulted in the T series, starting with the T50 in 1983. These low-cost SLRs were extremely user-friendly, and featured fully automated mechanisms.

Continuing in the same vein, Canon designed its first autofocus SLR, the EOS 650, with the end user firmly in mind. The EOS 650 was launched in 1987 and provided a lightweight, reasonably priced option for those looking to move beyond the basics. The camera was an instant success. Shortly afterward, the EOS 620 arrived, followed by the EOS 630 and the EOS-1. Crucially, the arrival of the EOS range prompted an overhaul of Canon's lens technology. Having designed a new (electronic) mount, the company released a series of EF lenses using Ultrasonic Motors (USM) for fast, silent operation. By 1994, the EOS-1 was ready to be replaced, and the newcomer, the EOS-1N, featured a five-point AF system and improved evaluative metering, making the most of the latest lens technology.

In September 1993, the EOS 500/ Rebel X hit the shelves, combining intuitive handling with features you would normally expect to find on a pro-spec SLR. Three years later, a replacement arrived, the

EOS 7D ⌄
In 2009, the EOS 7D joined as a big brother to the EOS 50D.

EOS 500N/Rebel G, borrowing more creative tools from its high-end brothers. In the mid-1990s, the EOS 5QD and EOS 55 continued to bring something new to the table with eye-controlled focusing systems. Around the same time, Canon joined Kodak, Fuji, Minolta, and Nikon to develop APS (Advanced Photo System) technology. The next milestone came in July 1996 with the arrival of the Powershot 600, an event that marked the start of Canon's digital era.

Digital innovation

While film cameras still dominated the market, Canon responded with innovative models such as the EOS-3 and the EOS 300/Rebel 2000. Six years after its launch, the EOS-1N was ready for a revamp, and returned to the market as the EOS-1V, with 20 Custom functions. Meanwhile, Canon was busy on the digital front, and in September 2000 it released the EOS D30, with a 3.25-megapixel CMOS sensor and RAW file capabilities. For the first time, consumers were being offered a high-spec digital SLR at an affordable price. The response was overwhelming.

In 2001, the EOS-1D arrived, based on Canon's professional film SLR, the EOS-1V, and was followed by the full-frame EOS-1Ds a year later. These high-spec models have been regularly updated ever since. Meanwhile, the semi-professional range

THE MEANING OF EOS

The name EOS is an abbreviation for Electro Optical System, but it's also the name of the goddess of the dawn in Greek mythology.

was receiving some attention, with the D60 replacing the D30, announced just one day after Nikon released the D100. In 2003, the D60 was replaced by the 10D, setting the tone for the 20D, 30D, 40D, 50D, and 60D. (There was a notable exception in 2005 with the release of the 20Da, designed specifically for astrophotography.) By now, the enthusiast market was growing, with many consumers looking to upgrade from a compact camera. As a result, the EOS 300D/Digital Rebel entered the scene. The camera was a huge hit, and the range has expanded rapidly over the past decade. In 2008, the EOS 1000D/Rebel XS took its place under the EOS 450D/Digital Rebel Xsi, redefining the entry-level sector, while in 2009 the EOS 7D joined as a big brother to the EOS 50D. The boundaries between professional, semi-professional, and entry-level cameras are blurring, and with the arrival of the EOS 60D the trend continues.

» THE CANON EOS 60D AND EOS 50D COMPARED

- 18-megapixel APS-C CMOS sensor (the EOS 50D has 15.1 megapixels)

- Body made of aluminum and polycarbonate resin (making it 8% lighter than the magnesium-alloy body of the EOS 50D). The EOS 60D is also slightly smaller than the EOS 50D

- Compatible with SD/SDHC/SDXC memory cards (the EOS 50D uses CompactFlash Type I and II memory cards, plus UDMA)

- The EOS 60D offers 20 custom functions (the EOS 50D offered 25)

- Articulated LCD monitor (the EOS 50D has a fixed monitor, and fewer dots)

- Improved layout of top plate and information panel

- The EOS 60D has a 63-zone dual-layer sensor that analyzes Focus, Color, and Luminance information to improve metering accuracy

- Full HD (1080p) movie capture with manual controls (the EOS 50D does not feature a movie mode)

- Standard ISO range extended to 6400 (compared to 3200 on the EOS 50D)

- Continuous shooting at 5.3fps (the EOS 50D offered 6.3fps)

- In-camera RAW conversion (files can be processed according to different conditions, creating multiple JPEGs without altering the original RAW file)

- The EOS 60D has an adjustable Auto ISO limit

- A lithium-ion LP-E6 rechargeable battery is used to power the EOS 60D (the EOS 50D uses a lithium-Ion BP-511/BP-511A or BP-512/BP-514 rechargeable battery)

- Electronic level to help straighten horizons (the 50D has no such facility)

- Ambience settings including Monochrome, Darker, Brighter, Cool, Intense, Warm, Soft, and Vivid (the EOS 50D has no ambience settings)

- Four in-camera Creative filters: Grainy B/W, Soft focus, Toy camera effect, and Miniature (the EOS 50D has no in-camera Creative filters)

- The EOS 60D has no flash synchronization socket. However, it does offer wireless control of Speedlites

- Redesigned and improved control layout (the EOS 60D has fewer buttons than the EOS 50D)

- The EOS 60D has no AF micro adjust feature (the EOS 50D has a micro adjust feature that adjusts up to 20 lenses individually)

1 » MAIN FEATURES OF THE EOS 60D

Design and build

With a body made of aluminum and polycarbonate resin, the EOS 60D weighs 8% less than the magnesium-alloy body of the EOS 50D. Aside from its lighter, slimmer build, the button layout of the EOS 60D is significantly different from other models in the X0D range. Notably, the camera features a large Multi-controller in place of the joystick found on previous versions. This button is surrounded by a Quick Control Dial, which enables the user to alter or set a variety of key functions. Within the Multi-controller lies the SET button, which allows you to confirm your settings. In addition, the Mode Dial features a lock to prevent the wheel from being knocked out of place mid-shoot. Aside from other key button groupings on the top plate, the back of the EOS 60D sports a Quick Control button that provides fast access to the most common shooting settings and playback controls.

Sensor and processor

The EOS 60D uses an 18-megapixel APS-C CMOS sensor, measuring 22.3 x 14.9mm. Information from the sensor is handled by a DIGIC 4 processor, producing smooth gradations and natural looking colors. The sensor has a built-in, fixed low-pass filter, which is cleaned automatically every time you turn the power on or off.

Focusing

When it comes to autofocus (AF), the EOS 60D can "lock on" to still or moving subjects using one of three selectable modes: One-Shot AF, AI Focus AF, or AI Servo AF. The first of these modes (One-Shot AF) is best suited to still subjects, whereas the second (AI Focus AF) has been designed for moving subjects. The third mode (AI Servo AF) switches from One-Shot AF to AI focus AF if it detects that a subject has started to move. The EOS 60D has nine AF points, arranged in a diamond shape with one in the center— this middle sensor is twice as sensitive as the other AF points. In the Basic Zone, the AF point is selected automatically, but in the Creative Zone you can choose between points. On some occasions the autofocus will struggle to "lock on"—e.g., when faced with a low-contrast subject—and so the lens can be switched to Manual Focus (MF).

Exposure

Using technology first seen on the EOS 7D, the EOS 60D combines a 63-zone dual-layer sensor with a DIGIC 4 processor to provide accurate and consistent exposures. In the Basic Zone modes, the camera uses evaluative metering, which is ideal for most average conditions. However, in the Creative Zones, you have a choice between Evaluative and Partial, Spot, or Center-weighted average metering. The first of these modes (Partial metering) is best suited to situations when the background is much brighter than the subject. The second mode (Spot metering) has been designed for taking a reading from a specific area of the subject or scene, making it ideal for portraiture. The third mode (Center-

weighted average metering) places emphasis on the center of the frame and is unaffected by brightness at the edges, making it useful for landscape photography. On some occasions, the metering system might be fooled—e.g., when faced with a snow scene—and in these instances Exposure compensation or Auto Exposure Bracketing can be used.

File types and sizes
The EOS 60D offers a choice of JPEG, RAW, RAW+JPEG, plus MOV (movie) files in various sizes. The largest RAW file measures 5184 x 3456 pixels, whereas the smallest JPEG file measures 720 x 480 pixels. The size you select will depend on what you intend to do with the final photograph. If you plan to produce prints at around A4 size, then a Small 1 (S1) JPEG is ideal. However, if you simply want to upload your images to social networking and photo sharing sites, then S3 (Small 3) JPEG will suffice. Larger files take up more room on the memory card: shooting in Standard Picture Style at ISO 100, you will be able to fit either 130 RAW files on a 4GB card or 1500 S1 JPEGS.

Full HD movie making
The first of the X0D range to feature a movie mode, the EOS 60D offers SD (Standard Definition) and full HD (High Definition) capture, with manual controls and selectable frame rates (including 24, 25, and 30fps). By purchasing HDMI cable HTC-100, you can connect the camera to an HD TV set and watch your movies in Full HD (1920 x 1080 pixels). In addition, clips can be altered in-camera using the movie editing feature, which allows you to shorten footage or remove unwanted portions without the need for external software.

Flash
The EOS 60D has a built-in pop-up flash with a guide number of 13 (meters) at ISO 100. Flash exposure compensation can be set to +/-3 stops in ⅓- or ½-stop increments. While there is no flash synchronization socket, the camera does offer wireless control of Speedlites.

Vari-Angle LCD monitor
The articulated LCD monitor has seven brightness levels, 1.04 million dots, and an anti-reflective coating enabling you to review your images and movies comfortably, even in strong sunlight. In addition, the monitor can be used for Live View shooting and making movies. Thanks to a viewing angle of 160°, it is ideal for low-level setups and occasions when the camera is attached to a raised tripod. The screen measures 3in and provides 100% coverage.

Custom functions
The EOS 60D offers 20 custom functions with 59 settings.

Memory card
The EOS 60D accepts SD, SDHC, and SDXC memory cards, but is not compatible with CompactFlash.

1 » FULL FEATURES & CAMERA LAYOUT

FRONT OF CAMERA

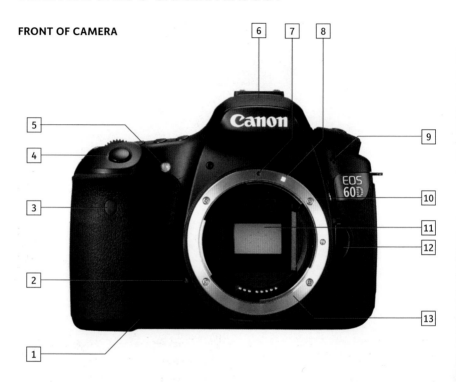

1	DC coupler cord hole	8	EF-S lens mount index
2	Depth-of-field preview button	9	Microphone
3	Remote-control sensor	10	Flash pop-up button
4	Shutter-release button	11	Mirror
5	Self-timer/Red-eye reduction lamp	12	Lens-release button
6	Built-in flash/AF-assist beam	13	Lens mount
7	EF lens mount index		

BACK OF CAMERA

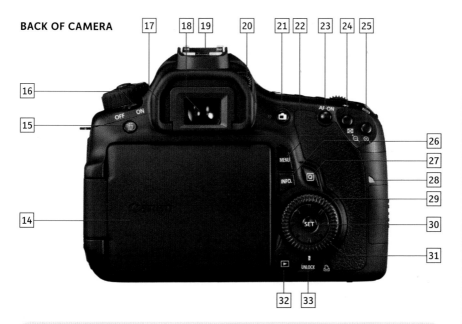

14 LCD monitor	**24** AE lock/FE lock/Index/Reduce button
15 Erase button	**25** AF-point selection/Magnify button
16 Power switch	**26** INFO button
17 Eyecup	**27** Quick Control button
18 Viewfinder eyepiece	**28** Access lamp
19 Accessory hotshoe	**29** Multi-controller
20 Diopter adjustment dial	**30** Setting button
21 Live View shooting/Movie shooting button	**31** Quick Control dial
	32 Playback button
22 MENU button	**33** Quick Control Dial lock release button/Direct print button
23 AF-ON button	

1 » FULL FEATURES & CAMERA LAYOUT

TOP OF CAMERA

LEFT SIDE

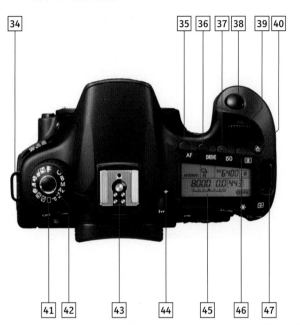

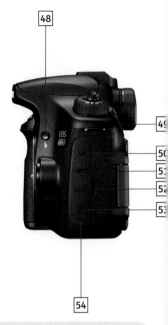

34 Camera strap mount	41 Mode dial	48 Flash pop-up button
35 AF mode selection button	42 Mode Dial lock release button	49 Speaker
36 Drive mode selection button	43 Accessory hotshoe	50 External microphone IN terminal
37 ISO speed setting button	44 Focal plane mark	51 HDMI mini OUT terminal
38 Shutter-release button	45 LCD panel	52 Audio/video OUT/Digital terminal
39 Main dial	46 Metering mode selection button	53 Remote control terminal
40 LCD panel illumination button	47 Camera strap mount	54 Terminal cover

BOTTOM OF CAMERA

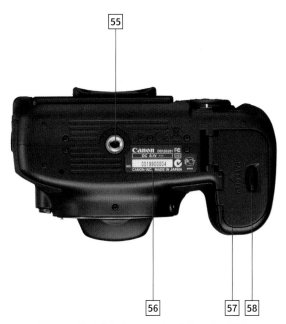

RIGHT SIDE

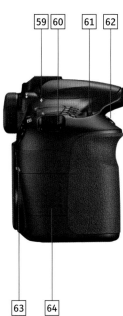

55	Tripod socket (¼in)
56	Camera serial number
57	Battery compartment
58	Battery compartment release lever

59	Focal plane mark
60	Camera strap mount
61	Main dial
62	Shutter-release button
63	Flash pop-up button
64	Memory card slot cover

1 » VIEWFINDER DISPLAY

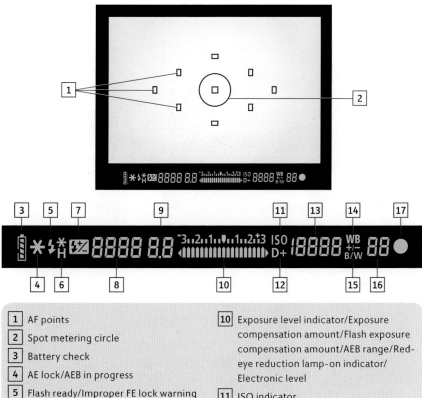

1 AF points	**10** Exposure level indicator/Exposure compensation amount/Flash exposure compensation amount/AEB range/Red-eye reduction lamp-on indicator/Electronic level
2 Spot metering circle	
3 Battery check	
4 AE lock/AEB in progress	
5 Flash ready/Improper FE lock warning	**11** ISO indicator
6 High-speed sync (FP flash)/ FE lock/FEB in progress	**12** Highlight Tone Priority
7 Flash exposure compensation	**13** ISO speed
8 Shutter speed/FE lock/Busy/built-in flash recycling/Card full warning/Card error warning/No card warning	**14** White balance correction
	15 Monochrome (B/W) setting
	16 Maximum burst
9 Aperture value	**17** Focus confirmation light

18 CANON EOS 60D

» SHOOTING SETTINGS DISPLAY

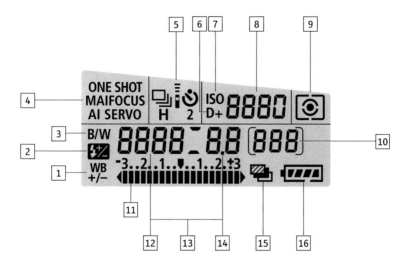

1	White balance correction	
2	Flash exposure compensation	
3	Monochrome (B/W) setting	
4	AF mode	
5	Drive mode	
6	Highlight Tone Priority	
7	ISO indicator	
8	ISO speed	
9	Metering mode	
10	Shots remaining on card/Shots remaining during WB bracketing/Self-timer countdown/Bulb exposure time	
11	Exposure level indicator/Exposure compensation amount/AEB range/Flash exposure compensation amount/Card writing status/Electronic level	
12	Shutter speed/Busy/Built-in flash recycling	
13	AF point selection/Card full warning/Card error warning/No card warning/Error code/Cleaning sensor	
14	Aperture	
15	AEB indicator	
16	Battery check	

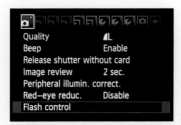

Shooting menu 1 📷
> Image quality
> Beep
> Release shutter without card
> Image review
> Peripheral illumination correction
> Red-eye reduction
> Flash control

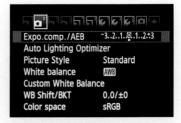

Shooting menu 2 📷
> Exposure compensation/Automatic
> Exposure Bracketing (AEB)
> Auto Lighting Optimizer
> Picture style
> White balance
> Custom White Balance
> White balance Shift/ Bracketing
> Color space

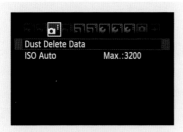

Shooting menu 3 📷
> Dust Delete Data
> ISO Automatic

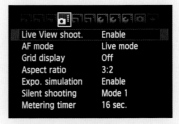

Shooting menu 4 📷
> Live View shooting
> Autofocus (AF) mode
> Grid display
> Aspect ratio
> Exposure simulation
> Silent shooting
> Metering timer

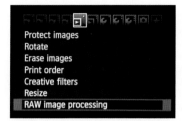

Playback menu 1 ▶

> Protect images
> Rotate
> Erase images
> Print order
> Creative filters
> Resize
> RAW image processing

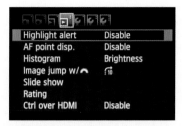

Playback menu 2 ▶

> Highlight alert
> Autofocus (AF) point display
> Histogram
> Image jump with ⌒
> Slide show
> Rating
> Control over HDMI

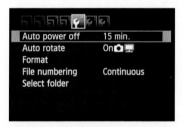

Set-up menu 1 ⚟

> Automatic power off
> Automatic rotate
> Format
> File numbering
> Select folder

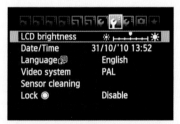

Set-up menu 2 ⚟

> LCD brightness
> Date/Time
> Language
> Video system
> Sensor cleaning
> Lock Quick Control Dial

1 **» MENU DISPLAYS**

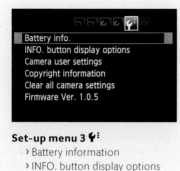

Set-up menu 3 🔧
> Battery information
> INFO. button display options
> Camera user settings
> Copyright information
> Clear all camera settings
> Firmware Version 1.0.5

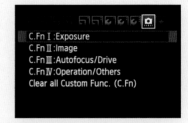

Custom Function menu 📷
> Custom Function I: Exposure
> Custom Function II: Image
> Custom Function III: Autofocus/ Drive
> Custom Function IV: Operation/ Others
> Clear all Custom Functions (C.Fn)

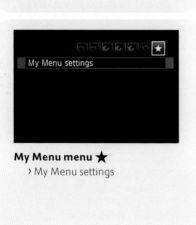

My Menu menu ★
> My Menu settings

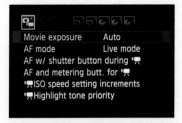

Movie Shooting Mode menu 1 ◘'🎬

> Movie exposure
> Autofocus (AF) mode
> Autofocus (AF) with shutter button during Movie mode
> Autofocus (AF) and metering button for Movie mode
> Movie ISO speed setting increments
> Movie Highlight tone priority

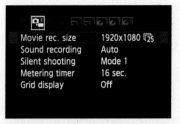

Movie Shooting Mode menu 2 ◘'🎬

> Movie recording size
> Sound recording
> Silent shooting
> Metering timer
> Grid display

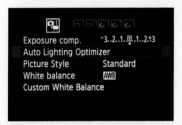

Movie Shooting Mode menu 3 ◘'🎬

> Exposure compensation
> Automatic Lighting Optimizer
> Picture Style
> White balance
> Custom White Balance

Chapter 2
FUNCTIONS

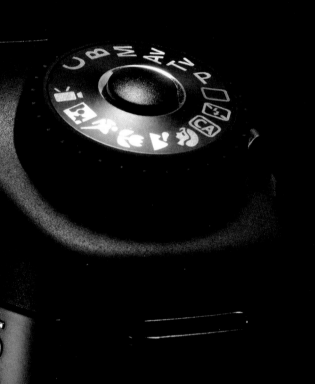

2 FUNCTIONS

At first, the sheer number of dials and menu choices available on the EOS 60D might seem intimidating. Thankfully, Canon has designed this high-spec DSLR to be as intuitive as possible. All of the dials are within easy reach, and the menu options are straightforward to access and navigate.

Creativity is key with this camera, and, once you have mastered the basics, a whole host of semiautomatic and fully manual controls can be used to give your pictures punch and vibrancy, even before you download them to a computer or install the EOS Utility software provided. In addition, the EOS 60D has the capacity to shoot, and edit, full HD (High Definition) movies—a feature that will certainly appeal to budding filmmakers.

☆
The EOS 60D offers auto, semiautomatic, and full manual controls, supporting you at every stage of your photographic development.

» CAMERA PREPARATION

This chapter begins with advice on preparing your EOS 60D for action. While inserting memory cards and checking battery power are simple enough tasks, practicing them means they will become completely intuitive.

› Attaching the strap

If you decide not to attach a strap to your EOS 60D, you will regret it when it hits the ground with an expensive thud. Thankfully, the camera is provided with a comfortable neck strap, which is easy to secure. Simply release one end of the strap and feed it through the bottom of one of the mounts on the sides of the camera. Now pass the end through the small clip and on through the buckle. Pull it firmly to take up any slack. Ensure that the strap is tight at the buckle. Repeat the process on the other side. Handily, the strap features an eyepiece cover, which blocks out light when you're using the self-timer function or operating the camera with a remote control.

› Fitting and removing a lens

To reduce the chances of dust entering the camera body, switch off the EOS 60D and hold it face down before attaching or detaching a lens. Carefully remove both the rear lens cap and the camera body cap. If you are fitting an EF lens, align the barrel with the red lens-mount index on the camera, and turn the lens until it clicks into position. Alternatively, if you are attaching an EF-S lens, align the barrel with the white lens-mount index before securing it with a click. Finally, slide the focus switch on the lens to AF (to enable autofocus) and remove the front lens cap. To detach a lens, hold down the lens release button and grip the barrel with the other hand. Turn the lens until it stops, then remove it from the camera body. Replace the rear cap immediately to protect the electrical contacts.

Tip

Always try to fit or remove your lenses in an environment with minimal dust. If dirt or dust appears on the body caps, clean them with a blower before replacing them. Finally, if you store your camera without a lens attached, make sure you protect it with the camera body cap.

› Using Image Stabilization (IS)

Many of Canon's EF-series lenses feature Image Stabilization (IS) technology, which counteracts camera shake and helps to reduce blur in your images. This function will correct movement caused by handholding, but will not reduce the effects of excessive shaking, such as that caused by the rocking of a boat. To use this feature, slide the IS switch on the lens barrel **ON** and turn the Power switch on the camera **ON**. Take the photograph as normal.

Warning!

Never leave a lens or camera with lens attached in the sun without the lens cap attached. Doing so could result in a fire. In addition, never look directly at the sun through the lens, since this can cause blindness.

› Using a lens hood

Despite their rather unassuming appearance, lens hoods (available separately) can dramatically improve your pictures by reducing ghosting and flare *(see page 161)*. These hoods work by blocking stray light, but they can also be used to protect the front element of the lens from raindrops, snow, and dust.

› Adjusting the diopter

The focus of the viewfinder can be adjusted to compensate for minor eyesight defects (about -3 to +1 diopter). To use this facility, look through the viewfinder (without a lens attached) and turn the Dioptric adjustment knob (at the top of the eyecup) toward the - symbol if you are shortsighted or the + symbol if longsighted. When the AF (autofocus) points appear sharp in the viewfinder, you have reached the ideal setting. If the AF points remain blurred, you might like to consider purchasing Dioptric Adjustment Lens E (available in 10 strengths).

› Charging the battery

The EOS 60D uses a lithium-ion LP-E6 rechargeable battery, which, when fully exhausted, takes approximately 2.5 hours to regain full power. To charge the battery using Battery Charger LC-E6E, first remove the protective cover and lay the unit in the battery pack slot. Gently slide the battery toward the contacts until it clicks into place. Finally, plug one end of the power cord into the power cord socket on the charger and the other end into a household power supply. As soon as the connection is made, the battery will begin

Battery status

0-49%	Orange lamp	Blinks once per second
50-74%	Orange lamp	Blinks twice per second
75%+	Orange lamp	Blinks three times per second
100%	Green lamp	Light stays on

> **Note:**
> The time it takes to recharge the battery will depend on the ambient temperature of the room. In cold conditions (5–10°C), it can take as long as four hours for a fully exhausted battery to reach full capacity.

charging and the Charge lamp will start to flash in orange. As the battery regains power, the lamp will flash once, twice, or three times per second depending on its capacity *(see table, left)*. When the lamp turns green and stops blinking, the battery is full. To remove it from the charger, simply slide it away from the contacts and lift it out of the battery pack slot. Finally, unplug the charger from the household power supply. Alternatively, the battery can be charged using Battery Charger LC-E6. Simply insert the battery (as above), flip out the prongs on the charger, and fit it directly into a household power outlet.

› Inserting and removing the battery

To install the LP-E6 battery, simply turn the EOS 60D upside down and open the battery compartment door by sliding the lever in the direction indicated by the arrow. Insert the battery with the contacts facing downward. Push gently until you

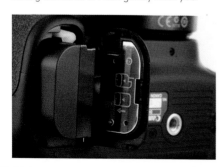

hear it click into place. Now close the door, making sure that it snaps shut. To remove the battery, open the battery compartment door (as above) and move the battery release lever to one side. The unit will pop up, allowing it to be removed easily. Finally, close the door.

› Connecting to a household power supply

Using the AC Adapter Kit ACK-E6 (available separately), the EOS 60D can be connected to a household power supply. Before attaching the camera, it's important to make sure that the power is set to **OFF**. Insert the plug of the DC Coupler into the AC Adapter socket. Now push one end of the power cord into the AC Adapter and the other end into a household power supply. Position the cord of the DC Coupler in the groove of the unit, allowing the cord to flow behind. Open the battery compartment door (as above) and flick out the DC Coupler cord notch cover. Insert the unit, pushing gently until you hear it click into place. Place the cord through the notch and close the door. When you have finished, unplug the adapter from the household power supply.

› Inserting and removing a memory card

› Using the LCD monitor

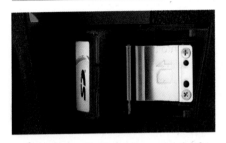

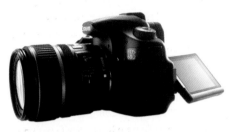

The EOS 60D is compatible with SD, SDHC, and SDXC memory cards (available separately). To install a card, switch the camera **OFF** and open the card slot cover by pushing it in the direction of the arrow. Next, with the back of the camera and the front of the card facing you, insert the card in the slot. Push gently until you feel it click into place. Close the cover and slide it in the direction of the arrow, making sure that it clicks shut. To check the number of shots remaining on the card, switch the camera **ON** and refer to the LCD panel—this figure will differ depending on the file size set. Before removing a memory card, switch the camera **OFF**. Next, check that the access lamp is off and that the LCD monitor is not displaying **Recording**. You can now open the card slot cover (as above). To eject the card, push it down and let it go. The card will pop up, allowing it to be removed easily. Be careful not to touch the contacts with your fingers. Finally, close the cover.

With seven brightness levels and a viewing angle of 160°, the LCD monitor on the EOS 60D is ideal for shooting and reviewing images and movies. To use the monitor, hold the camera with the front facing away from you and flip the screen out fully using the right-hand edge. Now rotate the monitor up or down, depending on the angle you require. Do not force the hinge. For standard shooting, the monitor can be opened out, turned 180°, and folded back into the camera body. When the camera is not in use, return the monitor to its original position with the screen facing inward.

› Illuminating the LCD panel

For ease of viewing, the LCD panel can be illuminated by pressing the ☀ LCD panel illumination button. The light will automatically switch off after six seconds, or when the button is pressed a second time.

» BASIC CAMERA FUNCTIONS

Before plunging into the menu system, there are a few dials and buttons to familiarize yourself with, namely the Power switch, Shutter button, Mode Dial, Main Dial, and Quick Control Dial.

› Switching the camera ON

The Power switch on the EOS 60D has two settings: **ON** and **OFF**. Each time the camera is turned on or off, the low-pass filter over the sensor is cleaned *(see pages 245–248)*. You can save battery power by instructing the camera to switch off automatically *(see page 118)*. From now on, unless otherwise specified, all of the instructions in this guide assume that the power switch has been turned to **ON**.

› Pressing the shutter-release button

The shutter-release button has two stages on the EOS 60D: pressing it halfway down activates the autofocus and exposure systems—as a result, the shutter speed and aperture appear on the LCD panel and in the Viewfinder. Pressing the button all the way down releases the shutter and takes a picture. (If you are in the process of viewing images or navigating menus, you can still prepare the camera for shooting by pressing the button halfway down.)

› Using the Mode Dial

The Mode Dial offers 15 shooting modes, divided into two areas: Basic Zone and Creative Zone. In the first zone, there are nine fully automatic modes, optimized for certain scenes and situations. In the second, there are five semiautomatic and manual modes, plus one user-defined setting. To select a mode, hold down the Mode Dial lock-release button and turn the dial until the required icon falls in line with the white mark on the camera body. Release the Mode Dial lock-release button.

Basic Zone

⬭	Full Auto
⚡	Flash Off
CA	Creative Auto
⚘	Portrait
⛰	Landscape
❀	Close-up
⚐	Sports
⚞	Night Portrait
▶︎	Movie

Creative Zone

P	Program AE
Tv	(Tv) Shutter Priority AE
Av	(Av) Aperture Priority AE
M	Manual
B	Bulb
C	Camera User setting

› Using the Main Dial

› Quick Control Dial

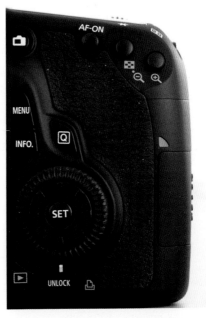

The 🔆 Main Dial is used to alter shooting settings such as drive mode, ISO speed, metering mode, AF mode, and AF point. The dial can be used on its own—to set the shutter speed and aperture, for example— or after pressing a button such as **MENU**, **ISO**, **AF**, or **DRIVE**. After pressing one of these buttons, the function will remain active for six seconds. During this time, the dial can be turned to adjust the settings.

› Operating the Multi-controller

The 🔆 Multi-controller can be pushed in eight directions and is used for precise adjustments, including selecting an AF point, correcting white balance, moving the AF or magnifying frame during Live View, or scrolling over the image in magnified view. When using menus and the Quick Control screen *(see page 60)*, only the ◄►▲▼ directions are active.

On many occasions, the ⭕ Quick Control Dial can be used in place of the ◄►▲▼ directions on the Multi-controller. This dial can be used on its own—to set exposure compensation or alter the aperture, for example—or after pressing a button such as **MENU**, **ISO**, **AF**, or **DRIVE**. After pressing one of these buttons, the function will remain active for six seconds. During this time, you can turn the dial to adjust the settings.

› Using the UNLOCK button

To prevent the ⊙ Quick Control Dial from being knocked out of place in the Creative Zone—potentially altering exposure compensation or aperture settings—it can be locked in ♥ᶤ Set-up Menu 2 *(see page 121)*. This can be canceled temporarily by pressing the **UNLOCK** button underneath the ⊙ Quick Control Dial.

› Setting the date/time

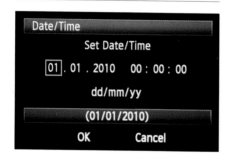

The first time you turn the power switch **ON**, the Date/Time screen will appear on the LCD monitor. In this instance, follow steps 3–5.

1) Press **MENU** and use the 🗘 Main Dial or ◄► on the Multi-controller to select ♥ᶤSet-up Menu 2.

2) Rotate the ⊙ Quick Control Dial or use ▲ ▼ on the Multi-controller to

highlight Date/Time. Press **SET**. The Date/Time screen will appear on the LCD monitor.

3) Rotate the ⊙ Quick Control Dial or use ◄► on the Multi-controller to highlight the desired digit. Press **SET**. An arrow will appear at the top and bottom of the box.

4) Rotate the ⊙ Quick Control Dial or use ▲ ▼ on the Multi-controller to set the desired number. Press **SET**. The arrows at the top and bottom of the box will disappear, and the date/time will be set. Repeat steps 3–4 to change any of the other digits.

5) To exit the Date/Time screen, rotate the ⊙ Quick Control Dial or use ◄► on the Multi-controller to highlight **OK**. Press **SET**.

> **Note:**
> It's important that the date/time is set correctly, since the information is appended to images captured with the EOS 60D.

› Setting the language

› Formatting a memory card

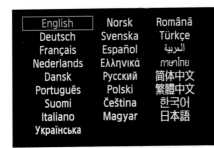

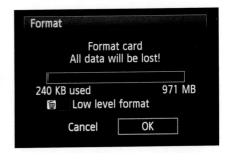

There are 25 interface languages on the EOS 60D.

1) Press **MENU** and use the 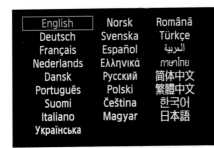 Main Dial or ◄► on the Multi-controller to select ♥ Set-up Menu 2.

2) Rotate the ⓞ Quick Control Dial or use the ▲ ▼ on the Multi-controller to highlight Language (third down the list). Press **SET**.

3) Rotate the ⓞ Quick Control Dial or use ▲ ▼ on the Multi-controller to highlight the desired language. Press **SET**. The interface language will now be set.

> **Note:**
> If the battery of the EOS 60D becomes exhausted, or is removed for a long time, the date/time may need to be reset.

If your memory card is new, or has been used in a camera other than the EOS 60D, it's a good idea to format it. Formatting the card will remove all of the data, making it a fast, effective way of deleting a full card.

If there are any images that you want to keep, you will need to transfer them to a computer or other storage device before formatting the card.

1) Press **MENU** and use the 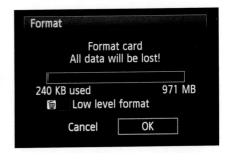 Main Dial or ◄► on the Multi-controller to select ♥ Set-up Menu 1.

2) Rotate the ⓞ Quick Control Dial or use ▲ ▼ on the Multi-controller to highlight **Format**. Press **SET**.

3) The screen will display a bar showing the amount of memory used on the card and a final warning that **All data will be lost!** Rotate the ⓞ Quick Control Dial or use ◄► on the Multi-controller to highlight **OK**. Press **SET**. The card will be

formatted and all of the images it held will be erased.

Normal formatting of the card will only change the file management information; the actual data will not be erased completely. To erase all of the information, use Low-level formatting (see below).

1) Follow steps 1–2 (see above).

2) Press the 🗑 Erase button to place a white check mark in the Low-level format box.

3) Rotate the ⊙ Quick Control Dial or use ◄► on the Multi-controller to highlight **OK** and press **SET**. Low-level formatting will take slightly longer than normal formatting and can be stopped by selecting **Cancel**.

› Focusing

The EOS 60D uses nine AF (autofocus) points, which function as a group or can be selected individually *(see page 70)*. When using EF, EF-S, and L lenses with an AF/MF switch, you can choose between auto and manual focusing (MF). Although autofocus is suitable for most purposes, there will be occasions when manual focus is preferable. If the lighting level is low, the scene has very low contrast, or the subject

is heavily backlit or particularly reflective, the lens may "hunt" for a point of focus, refusing to settle. In these instances, set the lens switch to MF (M FOCUS will appear in the LCD panel) and turn the focusing ring on the lens until the subject looks sharp in the viewfinder. Next, press the shutter button halfway. Any AF point that has achieved focus will flash briefly in red and the ● Focus confirmation light will flash in the viewfinder. In addition, you will hear a beep sound. Alternatively, you can focus manually in Live View *(see page 104)*.

There are three AF modes available on the EOS 60D: One Shot AF, AI Servo AF, and AI Focus AF. In the Basic Zone, the camera automatically selects the most suitable AF mode. In the Creative Zone, you can select whichever AF mode seems most appropriate for the subject or conditions. To do so, ensure that the focus mode switch on the lens is set to AF. Press the AF button (next to the LCD panel). Rotate the ⌂ Main Dial or ⊙ Quick Control Dial to scroll through the AF modes on the LCD panel. Choose between:

One Shot AF
One Shot AF is suited to relatively still subjects. When you press the shutter-release button halfway, the camera will focus just once on the subject. For as long as the shutter-release button is pressed,

focus will be locked and you can recompose the photograph. To refocus, you need to release the shutter-release button before depressing it again. Any AF point that achieves focus will flash briefly in red and the ● Focus confirmation light will flash in the viewfinder. In addition, you will hear a beep sound. The exposure settings for the picture will be determined at the moment of focus.

AI Servo AF

AI Servo AF is suited to continually moving subjects. When you press the shutter-release button halfway, the camera will continue to readjust focus automatically as the subject moves. When the AF point

Tips

If focus cannot be achieved with the lens set to AF, the ● Focus confirmation light will blink in the viewfinder, and the picture cannot be taken. You will need to recompose the picture and try again.

The beep (confirming focus) can be disabled in 📷 *Shooting menu 1 (see page 90).*

Pressing the AF-On button while in the Creative Zone has the same effect as pressing the shutter button halfway.

selection is automatic, the camera will use the center AF point first to achieve focus. As a result, you must make sure that the subject is central in the frame to begin with. When the subject moves away from the center, focus tracking will take place, as long as the subject is covered by another AF point. In AI Servo AF, the ● Focus confirmation light will not flash in the viewfinder and the beep will not sound. The exposure settings will be fixed at the moment the picture is taken.

AI Focus AF

AI Focus automatically switches between One Shot AF and AI Servo AF if a still subject starts to move, or vice versa. When AI Servo is active, the beeper will sound softly, but the ● Focus confirmation light will not flash in the viewfinder.

› ISO setting

The ISO speed determines how sensitive the sensor is to light. This directly affects the combined exposure settings of shutter speed and aperture. A higher ISO speed enables a faster shutter speed, which can help reduce camera shake in low-light conditions. Unfortunately, high ISO speeds often result in high levels of noise *(see page 162)*. To minimize the effects, you can enable the High ISO speed noise reduction feature in the Custom Functions menu *(see page 131)*.

Using a low ISO speed will generally produce a crisper image with more detail than one taken with a high ISO speed. As a rough guide, ISO 100–400 is ideal for sunny, outdoor scenes. By contrast, ISO 400–1600 is useful for overcast skies or photographs taken in the evening. For dark conditions, ISO 1600–6400 is most apt.

When shooting in Basic Zone modes, the camera will automatically set the ISO speed within a range of ISO 100–3200. In Creative Zone modes, Auto ISO is also possible, or the ISO can be set manually within a range of ISO 100–6400 in ⅓-stop increments.

To set the ISO speed manually, press the ISO button (near the LCD panel). Rotate the Main Dial ✌ or ◎ Quick Control Dial until you reach the desired ISO speed—the figure is shown in the viewfinder and on the LCD panel.

Tips

Increasing the ISO speed will increase the effective range of a built-in or external flash.

The ISO speed can be increased to ISO 12,800 ("H") in the Custom Functions menu (see page 129). To use this feature, Highlight tone priority must be disabled.

› Built-in flash

In Basic Zone modes, except for 🔲 Flash Off, 🏔 Landscape, and 🏃 Sports modes, the built-in flash operates automatically. In Creative Zone modes, the built-in flash can be raised by pressing the 🔆 Flash button (on the front of the camera).

To return the flash to its original position, push it down with your fingers. The **CA** Creative Auto mode allows you to select between automatic flash and flash on/off. In 🎥 Movie mode, the flash cannot be used.

2 › Metering modes

The EOS 60D offers four metering modes
to measure the brightness of a scene:

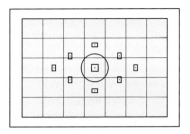

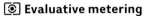 Evaluative metering

Evaluative metering uses readings from 63
zones. This works well for most situations,
including backlit subjects and portraits.

☐ Center-weighted average metering

Center-weighted metering places emphasis
on the center of the frame, and then
averages the readings for the entire scene.

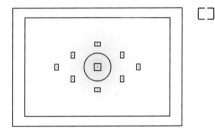

⟨○⟩ Partial metering

Partial metering takes readings from 6.5% of
the frame (in the center) and is useful when
the background is brighter than the subject.

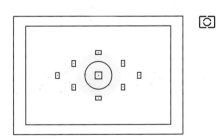

⟨·⟩ Spot metering

Spot metering concentrates on just 2.8%
of the viewfinder area, which is ideal for
taking accurate readings of very precise
areas, such as skin tones for a portrait.

In Basic Zone modes, Evaluative metering is
preset and cannot be altered. To set it
manually in the Creative Zones, press the
◉ Metering mode selection button and
rotate the 🕸 Main Dial or ◯ Quick
Control Dial until you reach the desired
setting. The metering mode appears as a
symbol on the LCD panel.

› Image playback

Pressing the ▶ Playback button will allow you to manually review the images on the memory card, beginning with the last image captured. Rotate the ◌ Quick Control Dial or use ◀ ▶ on the Multi-controller to scroll through the images. Press the **INFO** button to cycle through the four display formats: Single image with no information, Single image with exposure settings, Thumbnail with detailed information display, and Thumbnail with histogram display.

You can quickly search for images by using the Index display. During image Playback, press the ▦ Index button to display four images at once, with the selected image highlighted in blue.

Pressing the button a second time will display nine images. You can rotate the ⌂ Main Dial to display the next screen of index images. To select an individual frame, rotate the ◌ Quick Control Dial or use ▲ ▼ and ◀ ▶ on the Multi-controller; before pressing **SET**. The image will appear as a single picture.

To zoom in to an image, press the ⊕ Magnify button. By holding the button down, the image will continue to enlarge, up to the maximum magnification. You

Tips

Pressing the ⊕ Magnify button will switch the index display from nine back to four and then to one image.

Rotate the ⌂ Main Dial to jump by one image, 10 images, 100 images, shooting date, folder, format, or rating depending on the setting made in ▶ Playback Menu 2 (see page 115).

Note:
After an image has been taken, it will appear on the LCD monitor for either 2, 4, or 8 seconds, depending on the review time set. Alternatively, the camera can be instructed to show an image indefinitely, or not to show one at all. The review time is set in ◻ Shooting Menu 1 *(see page 90).*

can use the ☼ Multi-controller to scroll around the image (to check sharpness, detail, etc). To zoom out again, press the ⊖ Reduce button or the ▶ Playback button to return the display to a single full-frame image.

When you press the ◯ button, the Quick Control screen will be superimposed over the image. Use ▲ ▼ on the Multi-controller to select the desired function by highlighting it blue. The setting options will be displayed on the bottom of the screen. Protect Images, Rating, Highlight alert, AF point display, and **Image jump w/** ⚙ can be set in movies and stills. Rotate, Creative filters, and Resize (JPEGs only) can be set in stills only. Rotate the ◯ Quick Control Dial or use ◀ ▶ on the Multi-controller to set the function. For Creative filters and Resize, you will need to press SET to set the function. Press the ◯ Quick Control button to exit the Quick Control screen. To exit Playback, press the ▶ Playback button.

› Erasing images

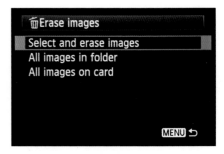

Images can be erased from the memory card either one at a time or in batches. In both instances, protected images *(see page 108)* will not be deleted. Once an image is erased, it cannot be recovered, so make sure that you no longer require it before proceeding.

Method 1: To delete a single image

1) During image Playback or review, press the 🗑 Erase button.

2) Rotate the ◯ Quick Control Dial or use ◀▶ on the Multi-controller to highlight **Erase**. Press **SET**. If you no longer want to erase the image, use ◀▶ on the Multi-controller to highlight **Cancel**. Press **SET**.

CHECKING THE IMAGE **«**
When an image has been magnified, you can scroll around it to check sharpness, etc—you can see where you are by referring to the white square.

Method 2: To delete single and multiple images

1) Press **MENU** and use the 🗑 Main Dial or ◄► on the Multi-controller to select ▶ Playback Menu 1.

2) Rotate the ○ Quick Control Dial or use ▲ ▼ on the Multi-controller to highlight **Erase images**. Press **SET**.

3) Rotate the ○ Quick Control Dial or use ▲ ▼ on the Multi-controller to highlight **Select and erase images**. Press **SET**.

4) Press the ⊞ Index button to display three images at once. Press the ⊕ Magnify button to return to a single image.

5) Rotate the ○ Quick Control Dial or use ◄► on the Multi-controller to scroll through the images and locate an image to be erased. Press ▲ ▼ on the Multi-controller to make a check mark appear, thus selecting the image for deletion.

6) To select other images to be erased, repeat step 5.

When you are ready to erase all of the selected images, press the 🗑 Erase button. Rotate the ○ Quick Control Dial or use ◄ ► on the Multi-controller to highlight **OK** in the dialog box. Finally, press **SET**.

Method 3: To erase all images

To erase all of the images in a folder, or on a memory card, repeat steps 1-2 in Method 2 and either select **All images in folder** or **All images on card**. All of the images in the folder or memory card will be deleted, except for protected images.

To protect images from deletion, *see page 108*.

Tip

To quickly erase protected images, format the card.

PROCEED WITH CONFIDENCE ≫
Having prepared the camera and
familiarized yourself with the main
dials, it's time to unleash your
creativity and select a scene mode.

Settings
Lens: 10–20mm
Aperture: f/25
Shutter speed: 1/50sec.
ISO 100

» SHOOTING MODES

The EOS 60D employs a whole host of sophisticated features inherited from its high-spec older brothers. From the DIGIC 4 processor to the HD movie mode, this DSLR takes what it needs from the professionals and serves it up in a neat, user-friendly package. In addition, anyone upgrading from a compact camera will feel right at home thanks to an extensive range of automated controls and simple tools for optimizing images. Whether you're picking up a DSLR for the first time, or looking to refresh some old skills, the EOS 60D is the perfect learning tool.

The catch-all qualities of this camera can be seen on the Mode Dial. This sizeable switch features 15 shooting modes divided into two areas: the Basic Zone and the Creative Zone. The options range from Full Auto (where the camera makes all of the technical decisions) to Manual (where the photographer takes control of the camera). The Basic Zone modes (with the exception of Full Auto) are denoted by illustrations, whereas the Creative Zone modes use letters.

First-time DSLR users often switch a camera to Full Auto mode and leave it there, but keeping the Mode Dial on the green rectangle eventually will limit your creativity. As your confidence grows, explore all of the modes in the Basic Zone, from Landscape and Portrait right through

to Movie and Creative Auto. Despite their names, many of the modes have multiple functions: the Night Portrait mode, for example, can also be used to shoot illuminated buildings. When you become familiar with a setting, use the INFO button to check the shutter speed and aperture the camera has selected each time—you can then use this information to increase your own knowledge.

When you're ready to move on, you can take what you've learned in the Basic Zone and apply it in the Creative Zone. Here, six advanced settings, including Shutter Priority AE, and Manual, enable you to take varying degrees of control over the camera. The results are limited only by your own imagination.

Tip

To achieve optimum brightness and contrast in your images, the Auto Lighting Optimizer (see page 94) is set automatically in the Basic Zone modes.

Note:
You can shoot files of any size—from RAW RAW to ◢S Small JPEG—in any of the Basic Zone modes.

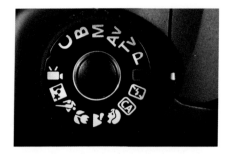

Tip

When you're feeling more confident, try switching from Full Auto mode to Creative Auto mode, where you can take partial control of the camera (see pages 46–47).

While you're getting to grips with the dials and menus of the EOS 60D, the Full Auto mode can be a blessing. Turning the Mode Dial to the green rectangle instructs the camera to set an aperture, shutter speed, and ISO to suit the prevailing conditions, while allowing you to handhold the camera. This amount of automation is perfect for situations where light conditions are changing, or the action is unfolding and you need to react fast. When light levels are low, the built-in flash will pop up, but it can still be pushed down with one finger if not required *(see page 37)*.

In Full Auto mode, the camera makes the technical decisions for you, but it can't tell you what to photograph or how to compose your shot—for that, you need to use your own creativity.

WOODLAND FUNGI ⌃
Full Auto mode makes all of the technical decisions for you, allowing you to concentrate on composing your shot.

Using Full Auto mode

1) Turn the Mode Dial to ⬭.

2) Aim any of the AF points over the subject. Focus will usually be achieved at the AF point covering the subject closest to the camera. Aiming the center AF point over the subject will make focusing easier.

3) Press the shutter button halfway to focus. The ● Focus confirmation light and automatically selected AF points will flash briefly in the viewfinder when focus is achieved. In addition, you will hear a beep sound. The exposure settings (aperture and shutter speed), along with the selected ISO, will also appear.

4) The flash may pop up depending on light conditions, with the ⚡ Flash symbol appearing in the viewfinder. It can be pushed back down by hand after the photograph has been taken.

5) Continue to press the shutter button halfway to keep the focus locked. Recompose the picture, if necessary, before fully depressing the shutter button to take the photograph.

6) After a brief delay, the captured image will appear on the LCD monitor for two seconds, unless the default review time has been altered (see page 90).

FULL AUTO MODE SETTINGS

Exposure settings
Evaluative metering using 63 zones; shutter speed, aperture, and ISO are automatically chosen to suit the subject and light conditions.

Focus settings
Automatic AF point selection in AI Focus mode (focuses on a moving subject, as long as an AF point covers it and the shutter button is held halfway).

Frame advance
Single-frame shooting; 10-second self-timer.

Flash and AF-assist settings
Automatic flash; Red-eye reduction; AF-assist beam (effective up to 13.1ft/ 4 meters).

Basic+
N/A.

Notes
To make focusing easier, aim the center AF point over the main subject and try to find an area of high contrast.

› Creative Auto mode

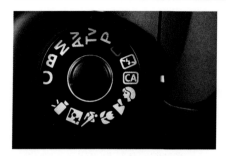

Using Creative Auto mode is like learning to swim while wearing water wings—you experience a certain amount of freedom, but you are still fundamentally supported. As with Full Auto mode, when using Creative Auto the camera sets aperture, shutter speed, and ISO. However, depth of field, drive mode, and the flash can all be adjusted, allowing you to take partial control of your camera.

You can also set a mood for your picture by choosing from vivid, soft, warm, intense, cool, brighter, darker, or monochrome settings. By watching how these settings change the feel of your pictures, you'll learn about contrast, color intensity, depth of field, and emotional impact.

SELECTIVE FOCUS ⌃
Creative Auto mode allows you to take some control over how your images look, even helping you to add blur to backgrounds.

Using Creative Auto mode

1) Turn the Mode Dial to **CA**.

2) Press the **Q** Quick Control button.

3) Use ▲ ▼ on the Multi-controller to cycle through the three functions until **Shoot by ambience selection** is highlighted. Press ◄► on the Multi-controller, or rotate the ⌂ Main Dial or

> ### Tip
>
> *In Creative Auto mode, the Drive settings can be set to either Single shooting, Low speed continuous, or Self-timer/Remote control.*

Quick Control Dial to select the desired ambience (see page 62).

4) Use ▲ ▼ on the Multi-controller to highlight **Effect**. Press ◀▶ on the ☼ Multi-controller, or rotate the Main Dial or Quick Control Dial to select the desired effect.

5) Use ▲ ▼ on the Multi-controller to highlight **Background: Blurred—Sharp**. Press ◀ ▶ on the Multi-controller, or rotate the Main Dial or Quick Control Dial to change background focus. Move the index mark to the left for a more blurred background, or to the right for a sharper background.

6) Use ▲ ▼ on the Multi-controller to highlight **Drive mode/Flash firing**. Press SET. Rotate the Main Dial to select the desired drive mode.

7) Press ◀ ▶ on the Multi-controller or rotate the Quick Control Dial to select the desired flash mode. Press **SET** to return to the Quick Control menu. Press the **Q** Quick Control button to return to the shooting screen, or depress the shutter-release button fully to take the picture.

8) Take the photograph following steps 2–6 of Using Full Auto mode (see page 45).

CREATIVE AUTO MODE SETTINGS

Exposure settings

Evaluative metering using 63 zones; shutter speed and ISO are automatically chosen to suit the subject and light conditions; aperture can be set through the background blur function.

Focus settings

Automatic AF point selection in AI Focus mode (focuses on a moving subject, as long as an AF point covers it and the shutter button is held halfway).

Frame advance

Single frame shooting; Low-speed (maximum 3fps) continuous shooting; 10-second self-timer.

Flash and AF-assist settings

Automatic flash; Flash on or off; Red-eye reduction; AF-assist beam (effective up to 13.1ft/4 meters).

Basic+

Ambience selection settings.

Notes

When the camera is turned off or changed to a different shooting mode, the Creative Auto settings will revert to default.

Tip

By pressing the shutter-release button down fully and holding it in place, the camera will take a series of shots (maximum 3fps), allowing you to capture different poses and facial expressions.

Natural looking portraits are hard to master, since people often feel uncomfortable in front of a camera. However, by leaving most of the technical decisions to the EOS 60D, you can concentrate on putting your subject at ease. Using Portrait mode instructs the camera to set a wide aperture, resulting in a relatively shallow depth of field. Consequently, your subject will appear sharp against a blurred background. In addition, Portrait mode is more flattering to hair and skin tones than Full Auto mode. When light levels are low, the built-in flash will pop up, but it can still be pushed down with one finger if not required *(see page 37).*

Although most portraits are head-and-shoulder shots, you can tell a great deal about a person from simple details. Photographing a hand, or the fold of a dress, can often say more about life and character than a traditional posed portrait.

BEACH PORTRAIT ⌃
The Portrait mode is flattering to hair and skin tones, producing a natural result.

Using Portrait mode

1) Turn the Mode Dial to 🔆.

2) Aim the camera at your subject. Let the subject fill the frame and try to avoid distracting features in the background.

3) Press the shutter-release button halfway to focus. The ● Focus confirmation light and automatically selected AF points will flash briefly in the viewfinder when focus is achieved. In addition, you will hear a beep sound. Ensure an AF point is illuminated on the face.

4) The flash may pop up depending on light conditions, with the ⚡ Flash symbol appearing in the viewfinder. It can be pushed back down by hand after the photograph has been taken.

5) Continue to press the shutter-release button halfway to keep the focus locked. Recompose the picture, if necessary, before fully depressing the shutter-release button to take the photograph.

6) After a brief delay, the captured image will appear on the LCD monitor for two seconds, unless the default review time has been altered *(see page 90)*.

PORTRAIT MODE SETTINGS

Exposure settings
Evaluative metering using 63 zones; auto ISO; a wide aperture is selected to blur the background and make the subject more prominent.

Focus settings
Automatic AF point selection in One Shot focus mode.

Frame advance
Low-speed (maximum 3fps) continuous shooting; 10-second self-timer.

Flash and AF-assist settings
Automatic flash; Red-eye reduction; AF-assist beam (effective up to 13.1ft/4 meters).

Basic+
Ambience selection settings and Lighting or scene type settings.

Notes
The farther your subject is from the background, the more out of focus the background will appear, and the more your subject will stand out against it.

2 > Landscape mode

Tip

To ensure that the horizon is level in your landscape photographs, use the Electronic level function (see page 124).

Being able to capture the breadth and scale of a landscape in a two-dimensional form such as a photograph is no mean feat. Using Landscape mode is a good place to start, since the camera automatically sets a small aperture, resulting in extensive depth of field. In addition, by using a wide-angle lens (or the wide end of a zoom) and accentuating the foreground, you can add a real sense of depth to your pictures. In this mode, blues and greens appear more vivid, bringing the color of the great outdoors into focus. The opportunities are

DEPTH OF FIELD ❯❯
In Landscape mode, the camera uses a relatively small aperture, ensuring that the scene is sharp from front to back.

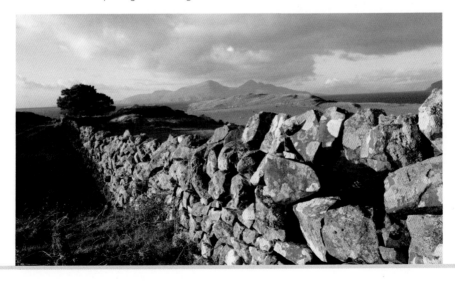

endless, so get out there and explore.

Since the flash will not fire in Landscape mode, it can also be used for night scenes. On these occasions (and when the shutter speed blinks in the Viewfinder generally), you should use a tripod or other support to prevent camera shake *(see pages 226-7)*.

Using Landscape mode

1) Turn the Mode Dial to 🏔 .

2) Aim the camera at your subject. Pay attention to every part of the frame to avoid distracting elements.

3) Press the shutter-release button halfway to focus. The ● Focus confirmation light and automatically selected AF points will flash briefly in the viewfinder when focus is achieved. In addition, you will hear a beep sound. The exposure settings (aperture and shutter speed), along with the selected ISO, will also appear.

4) Continue to press the shutter-release button halfway to keep the focus locked. Recompose the picture, if necessary, before fully depressing the shutter-release button to take the photograph.

5) After a brief delay, the captured image will appear on the LCD monitor for two seconds, unless the default review time has been altered *(see page 90)*.

LANDSCAPE MODE SETTINGS

Exposure settings
Evaluative metering using 63 zones; auto ISO; a narrow aperture is selected to maximize depth of field and ensure the entire scene is in focus.

Focus settings
Automatic AF point selection in One Shot focus mode.

Frame advance
Single-frame shooting; 10-second self-timer.

Flash and AF-assist settings
Flash and AF-assist beam are switched off; Red-eye reduction.

Basic+
Ambience selection settings and Lighting or scene type settings.

Notes
If light levels are too low, the shutter speed will blink in the Viewfinder; the camera should be mounted on a tripod to avoid camera shake.

The terms "close-up" and "macro photography" are often used interchangeably, but in reality only a reproduction ratio of 1:1, or a magnification of 1x (life size), can be classed as macro; anything less than that is simply close-up. For macro work, you need extension tubes, bellows, or a dedicated lens *(see pages 195–8)*. However, for general close-up

SHORE THINGS ⌄
When shooting close-ups, any movement of the camera or subject is magnified, so it's a good idea to use a tripod and practice on relatively static objects, such as these seashells.

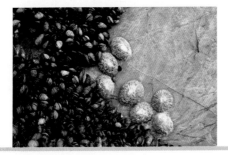

photography, all you require is a camera and, preferably, the telephoto end of a zoom.

Before approaching your subject, check the minimum focusing distance of the lens (usually indicated on the barrel). If you decide to move in closer than the recommended distance, autofocus will struggle and your subject may appear blurred. Using Close-up mode instructs the camera to set a wide aperture, resulting in a relatively shallow depth of field. As with Portrait mode, your subject will appear sharp against a blurred background. When light levels are low, the built-in flash will pop up, but it can be pushed down if not required.

Using Close-up mode

1) Turn the Mode Dial to 🌷.

2) Aim the camera at your subject. Try to get as close as possible, using a support such as a tripod or beanbag to reduce camera shake.

3) Press the shutter-release button halfway to focus. If achieving focus is difficult, try to change the camera position or adjust the AF/MF switch on the lens to MF and focus manually.

4) The ● Focus confirmation light and automatically selected AF points will flash briefly in the viewfinder when focus is achieved. In addition, you will hear a beep sound. The exposure settings (aperture and shutter speed), along with the selected ISO, will also appear.

5) The flash may pop up depending on light conditions, with the ϟ Flash symbol appearing in the viewfinder. It can be pushed back down by hand after the photograph has been taken.

6) Continue to press the shutter-release button halfway to keep the focus locked. Recompose the picture, if necessary, before fully depressing the shutter-release button to take the photograph.

7) After a brief delay, the captured image will appear on the LCD monitor for two seconds unless the default review time has been altered *(see page 90)*.

8) Press the ▶ Playback button to review the image and zoom in with the ⊕ Magnify button to check for sharpness.

CLOSE-UP MODE SETTINGS

Exposure settings

Evaluative metering using 63 zones; shutter speed, aperture, and ISO are automatically chosen to suit the subject and light conditions.

Focus settings

Automatic AF point selection in One Shot focus mode.

Frame advance

Single-frame shooting; 10-second self-timer.

Flash and AF-assist settings

Automatic flash; Red-eye reduction; AF-assist beam (effective up to 13.1ft/4 meters).

Basic+

Ambience selection settings and Lighting or scene type settings.

Notes

In Close-up mode, the camera focuses on what it considers to be the closest subject, so be sure that there is no unwanted clutter in the foreground.

› Sports mode

> **Tip**
>
> *Using a telephoto lens with Sports mode will enable you to keep your distance from the subject (which could be useful if you are on safari!).*

Photographing a moving subject requires quick reactions, technical know-how, and an ability to anticipate what might happen next. Thankfully, the technical side is catered for by Sports mode. To freeze any movement, the camera uses a fast shutter speed and correspondingly wide aperture. As a result, the action is often frozen against a blurred background. By holding down the shutter-release button, you can also shoot up to 5.3fps (frames per second), allowing you to capture all the action as it unfolds. For more on capturing motion *(see pages 152–3)*.

Even when light levels are low, the built-in flash will not pop up, but the shutter speed may blink in the viewfinder to indicate that camera shake is likely. In this instance, use a tripod or other support *(see pages 226–7)*.

Using Sports mode

1) Turn the Mode Dial to ♐.

2) Aim the camera with the center AF point on the subject. Be ready to pan the camera to follow the subject.

3) Press the shutter-release button halfway to focus. In ♐ Sports mode, the ● Focus confirmation light and AF points will not light in the viewfinder. Instead, a soft continual beeping will confirm focus.

4) In the bottom right corner of the viewfinder, a number will indicate how many continuous shots can be taken.

5) Depress the shutter-release button fully to take the photograph. Continue pressing the shutter-release button to take multiple pictures while panning the camera to keep the subject in the frame.

6) As each file needs to be written from the camera buffer to the memory card, there may be a short delay before the images appear on the LCD monitor. This figure will depend on the number of shots recorded.

TRACKING THE ACTION **«**
In Sports mode, the EOS 60D uses AI Servo focus: while the shutter-release button is partially depressed, the camera will track and continually focus on the subject.

SPORTS MODE SETTINGS

Exposure settings
Evaluative metering using 63 zones; shutter speed, aperture, and ISO are automatically chosen to suit the subject and light conditions.

Focus settings
Automatic AF point selection in AI Servo focus mode.

Frame advance
High-speed (maximum 5.3fps) continuous shooting; 10-second self-timer.

Flash and AF-assist settings
Flash and AF-assist beam are switched off; Red-eye reduction.

Basic+
Ambience selection settings and Lighting or scene type settings.

Notes
The file size will influence the amount of shots that can be taken in a single burst. It is possible to take more JPEG than RAW images continuously, before the camera buffer becomes full.

2 ### › Night Portrait mode

Tip

In dark conditions, the subject's pupils are likely to dilate, making them prone to red-eye. To minimize the effect, use the Red-eye reduction function (see page 91).

When darkness falls, it's tempting to pack the camera away, but with Night Portrait mode you can keep on shooting until the small hours. Despite its name, this mode can be used to capture any subject against an illuminated backdrop.

Using Night Portrait instructs the camera to set a relatively narrow aperture, resulting in extensive depth of field. As a result, much of the background will remain

in focus. Small apertures require correspondingly slow shutter speeds, so to freeze any movement of the foreground subject, the built-in flash will fire. To illuminate the scene successfully, the flash and the main subject must be no more than 16.4ft (5 meters) apart.

When photographing people in front of floodlit buildings, ask them to remain still even after the flash has fired—this will provide a sharper result. If the shutter speed is so slow that camera shake seems likely, mount the camera on a tripod or other support (see pages 226–7). Alternatively, try experimenting with Full Auto mode (see pages 44–45).

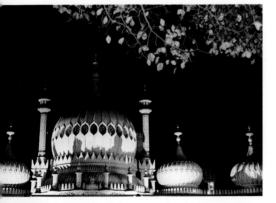

SEASIDE PAVILION 〈〈
Despite its name, the Night Portrait mode is not just for portraits. Here the branch of a tree frames the Royal Pavilion in Brighton, UK—a burst of flash brings out the elaborate detail.

Using Night Portrait mode

1) Turn the Mode Dial to ▣.

2) If possible, use a tripod with a cable release or the self-timer function to avoid camera shake. Aim the camera at your subject. If focusing proves difficult due to low light, adjust the AF/MF switch on the lens to MF and focus manually.

3) Press the shutter-release button halfway to focus. The ● Focus confirmation light and automatically selected AF points will flash briefly in the viewfinder when focus is achieved. In addition, you will hear a beep sound. The exposure settings (aperture and shutter speed), along with the selected ISO, will also appear.

4) The flash may pop up depending on light conditions, with the ⚡ Flash symbol appearing in the viewfinder. Push it back down after the photograph has been taken.

5) Continue to press the shutter-release button halfway to keep the focus locked. Recompose the picture, if necessary, before fully depressing the shutter-release button to take the photograph.

6) After a brief delay, the captured image will appear on the LCD monitor for two seconds, unless the default review time has been altered *(see page 90)*.

NIGHT PORTRAIT MODE SETTINGS

Exposure settings
Evaluative metering using 63 zones; a narrow aperture is selected to maximize depth of field; shutter speed and ISO are chosen to suit the background.

Focus settings
Automatic AF point selection in One Shot focus mode.

Frame advance
Single-frame shooting; 10-second self-timer.

Flash and AF-assist settings
Automatic flash; Red-eye reduction; AF-assist beam (effective up to 13.1ft/4 meters).

Basic+
Ambience selection settings.

Notes
Using the wide-angle end of a zoom lens will allow you to include a generous amount of the illuminated background.

› Flash Off mode

Despite its many benefits, there will be occasions when the built-in flash is either inappropriate (e.g., shooting in a church) or creatively destructive (e.g., capturing a candlelit scene). Using Flash Off mode will disable the flash so that you can retain the ambience of the scene or remain sympathetic to the subject. Like Full Auto mode, the camera will set an aperture, shutter speed, and ISO to suit the prevailing conditions. However, with the flash disabled there is a real danger of camera shake when light levels fall too low. (The shutter speed will blink in the viewfinder as a warning.) If this seems likely, mount the camera on a tripod or other support.

Using Flash Off mode

1) Turn the Mode Dial to 🚫.

2) Aim the camera at the subject.

3) Press the shutter-release button halfway to focus. If focusing is difficult, place the center AF point on the main subject. The ● Focus confirmation light and automatically selected AF points will flash briefly in the viewfinder when focus is achieved. In addition, you will hear a beep sound. The exposure settings (aperture and shutter speed), along with the selected ISO, will also appear.

4) In low-light conditions, it may be necessary to adjust the AF/MF switch on the lens to MF and focus manually.

5) Continue to press the shutter-release button halfway to keep the focus locked. Recompose the picture, if necessary, before fully depressing the shutter-release button to take the photograph.

6) After a brief delay, the captured image will appear on the LCD monitor for two seconds, unless the default review time has been altered *(see page 90).*

SEEING THE LIGHT «
On occasions, the built-in flash will be inappropriate, so it can be disabled. (This church interior was treated to the zoom burst tool in some post-production software.)

CLOSE-UP MODE SETTINGS

Exposure settings
Evaluative metering using 63 zones; shutter speed, aperture, and ISO are automatically chosen to suit the subject and light conditions.

Focus settings
Automatic AF point selection in AI Focus mode (focuses on a moving subject, as long as an AF point covers it and the shutter button is held halfway).

Frame advance
Single-frame shooting; 10-second self-timer.

Flash and AF-assist settings
Flash and AF-assist beam are switched off; Red-eye reduction.

Basic+
N/A.

Notes
If you are using Flash Off mode with a zoom lens, you can reduce blur (caused by camera shake) by using the wide-angle end.

Adjusting and selecting shooting functions can be confusing and time consuming. The EOS 60D solves the problem with the **Q** Quick Control button. One press brings up the Quick Control screen on the LCD. Available functions are displayed (depending on the Shooting mode) and each can be adjusted via one screen. The Quick Control screen works in Basic and Creative Zone modes, although in Basic Zone it is simpler, since there are fewer adjustable functions.

Using the Quick Control screen in Basic Zone modes

1) Turn the Mode Dial to any of the Basic Zone modes.

2) Press the **Q** Quick Control button to display the Quick Control screen on the LCD. The functions that appear will depend on which Basic Zone mode is selected.

3) Use ▲ ▼ and ◄ ► on the Multi-controller to highlight the desired function. The name of the highlighted function appears on the bottom of the screen.

4) Rotate the 🔄 Main Dial or the ◯ Quick Control Dial to change the function setting.

5) Press the **Q** Quick Control button to return to the shooting screen, or depress the shutter-release button fully to take the picture.

6) After a brief delay, the captured image will appear on the LCD monitor for two seconds, unless the default review time has been altered (see page 90).

Function			○	🔲	CA	🏃	🏔	🌷	🏃	🌆
Drive	Single shooting		o	o	o	–	o	o	–	o
	Continuous shooting	Low-speed	–	–	o	o	–	–	–	–
		High-speed	–	–	–	–	–	–	o	–
	Self timer: 10 sec./Remote control		o	o	o	o	o	o	o	o
Flash firing	Automatic firing		•	–	o	•	–	•	–	•
	Flash on		–	–	o	–	–	–	–	–
	Flash off		–	•	o	–	•	–	•	–
Shoot by ambience selection			–	–	o	o	o	o	o	o
Shoot by lighting or scene type			–	–	–	o	o	o	o	–
Blurring/sharpening the background			–	–	o	–	–	–	–	–

• Set automatically o User selectable - Not selectable

Using the Quick Control screen in Creative Zone modes

1) Turn the Mode Dial to any of the Creative Zone modes.

2) Follow steps 2–4 for using the screen in Basic Zone modes.

3) To see options for each function (except shutter speed and aperture) in a separate screen, press **SET**. Rotate the ⚙ Main Dial or ⚙ Quick Control Dial to change the function setting. Some settings allow the use of ◄ ► on the Multi-controller, too.

4) Press **SET** to confirm the setting and return to the Quick Control screen. While on the Electronic level, Custom controls, or AF point selection screen, press **MENU** to return to the Quick Control screen.

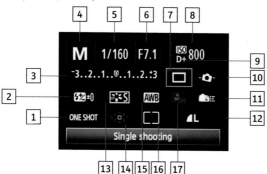

1 AF mode	**9** Highlight tone priority (this cannot be set with the Quick Control screen)
2 Flash exposure compensation	
3 Exposure compensation/AEB setting	**10** Electronic level
4 Shooting mode (this cannot be set with the Quick Control screen)	**11** Custom controls
	12 Image recording quality
5 Shutter speed	**13** Picture style
6 Aperture	**14** AF point
7 Drive mode	**15** White balance
8 ISO speed	**16** Metering mode
	17 Auto Lighting Optimizer

> Shoot by ambience selection

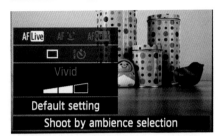

Default setting
Shoot by ambience selection

The EOS 60D features ambience options that will enhance the mood of an image.

1) Turn the Mode Dial to a Basic Zone mode (except ⬭ Full Auto and ⚡ Flash Off).

2) Press the 📷 Live View button to switch to Live View shooting.

3) Press the **Q** Quick Control button to display the Quick Control screen.

4) Use ▲ ▼ on the Multi-controller to highlight **Standard setting**. **Shoot by ambience selection** will appear at the bottom of the screen.

5) Use ◄ ► on the Multi-controller, or rotate the 🎛 Main Dial or ◌ Quick Control Dial to select an ambience setting appropriate to the scene. The effect can be viewed instantly on the LCD monitor.

6) Use ▲ ▼ on the Multi-controller to highlight the effect bar so that **Effect** appears at the bottom of the screen.

7) Use ◄ ► on the Multi-controller or rotate the 🎛 Main Dial or ◌ Quick Control Dial to select an effect setting.

8) Press the shutter-release button halfway to focus before fully depressing it to take the picture, or press the 📷 Live View button to exit Live View shooting.

9) Selecting a different shooting mode, or turning the power switch to **OFF**, will return the settings to default.

AMBIENCE SETTINGS

Standard setting Uses the default image characteristics for each shooting mode.

Vivid Intensifies colors and sharpens the image.

Soft Smoothes out the subject—great for portraits and pets.

Warm Adds a warmer color tone.

Intense Lowers the overall brightness, but emphasizes the subject.

Cool Adds a cooler color tone.

Brighter Brightens the image.

Darker Darkens the image.

Monochrome Select from black & white, sepia, or blue.

› Shooting by lighting or scene type

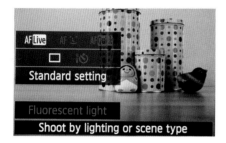

In Portrait, Landscape, Close-up, and Sports modes, you can brighten skin tones, reduce the orange cast caused by tungsten lighting, or boost the colors of a sunset by matching the lighting conditions to the scene.

Using the Lighting or Scene Type function

1) Turn the Mode Dial to 🐾, 🏔 , 🌷, or 🏃.

2) Press the 📷 Live View button to switch to Live View shooting.

3) Press the **Q** Quick Control button to display the Quick Control screen.

4) Use ▲ ▼ on the Multi-controller to highlight **Default setting. Shoot by lighting or scene type** will appear at the bottom of the screen.

5) Use ◄ ► on the Multi-controller, or rotate the 🎛 Main Dial or ⊙ Quick Control Dial to scroll through and select

the lighting or scene type. As you make the adjustment, the effect can be viewed instantly on the LCD monitor.

6) Press the shutter-release button halfway to find focus before fully depressing it to take the picture, or press the 📷 Live View button to exit Live View shooting.

7) Selecting a different shooting mode, or turning the power switch to **OFF**, will return the settings to default.

LIGHTING OR SCENE TYPE SETTINGS

Default setting The image is unaltered.

Daylight Designed for subjects shot in sunlight, this setting makes greens and blues appear more natural looking.

Shade Suitable for subjects shot in shade, this setting reduces blue tones.

Cloudy Designed for subjects shot under cloud cover, this setting adds a warm tone.

Tungsten light Suitable for subjects shot under tungsten lighting, this setting reduces the orange color cast.

Fluorescent light Designed for subjects shot under fluorescent lighting.

Sunset Designed to record the vibrant colors of sunsets.

Obtaining a "correct" photographic exposure requires a basic understanding of the relationship between ISO, aperture, and shutter speed. The ISO determines how sensitive the sensor is to light; the aperture (measured in f/stops) describes the size of the hole in the lens through which light passes; and the shutter speed (measured in fractions of a second) refers to the amount of time the light is permitted to hit the sensor. Each of these variables is completely dependent on the other.

All of these factors can be adjusted, providing very different results. Selecting a wide aperture produces shallow depth of field; while a fast shutter speed freezes movement, for example. The role of the

Tip

The aperture is measured in f/stops, but, somewhat confusingly, the smaller the number, the larger the opening: f/2.8, for example, is wider than f/22.

TEATIME INDULGENCE ⌃
I used a relatively wide aperture (f/5.6) to throw the background of this sweet treat out of focus. The shutter speed was 1/125sec., but I could have used any of the combinations in the table to achieve a correct exposure.

Shutter speed/aperture

Shutter speed

1/500sec.	1/250sec.	1/125sec.	1/60sec.	1/30sec.

Aperture (f/stops)

f/2.8	f/4	f/5.6	f/8	f/11

ISO is to facilitate these changes. It is important to note that if you alter the aperture, the shutter speed must be adjusted to compensate. Similarly, if you alter the shutter speed, the aperture must be adjusted.

When it comes to light, aperture and shutter speed share one huge similarity: each figure allows half/double the amount of light to reach the sensor as its immediate neighbor—a shutter speed of 1/250sec., for example, allows twice as much light in as one of 1/500sec.; whereas an aperture of f/8 lets in half the amount of light as f/5.6. Similarly, if you halve the ISO speed, the amount of light the sensor requires will double, and vice versa.

› Exposure and metering

The amount of light required to obtain a correct exposure is calculated by the TTL (through-the-lens) metering system built into the camera. This system reads the light reflected by a subject, relates it to the chosen ISO, and calculates the exposure based on an assumption that the scene has a tone and reflectance equivalent to 18% (mid-tone) gray. Of course, this is not always the case, and you may find yourself shooting excessively light or dark subjects, or scenes with high contrast or mixed lighting.

To calculate exposure, the EOS 60D uses one of four selectable metering modes:

Evaluative, Partial, Spot, and Center-weighted average. While these modes still measure the light reflected by a subject rather than the light falling on it (which is more accurate), they will cater for most eventualities. For the ultimate in exposure calculations, however, you will need to invest in a handheld light meter. These devices frequently offer both reflected and incident light readings.

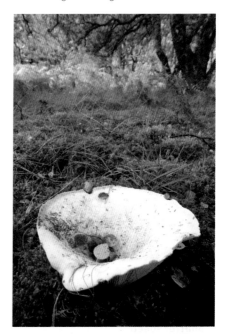

ORGANIC FORM ⌃
Using the spot metering system on the EOS 60D, you can take a reading from the brightest and darkest parts of the scene, and work out the average to determine an accurate exposure.

Lightmeter readings explained

Evaluative metering uses light/brightness readings from zones across the frame (the EOS 60D has 63) to help you select the most appropriate aperture/shutter speed combination. **Best for:** Most "average" situations.

Center-weighted average metering measures the light/brightness across the frame, giving emphasis to the center of the viewfinder. **Best for:** Situations where the subject is occupying the center of the frame.

Partial metering takes a reading from a small area in the center of the frame (the EOS 60D uses 6.5%) to help you select the most appropriate aperture/shutter speed combination.

Best for: Preventing excessively light or dark areas from influencing your exposure.

Spot metering measures the light/brightness in a very small area of the frame (the EOS 60D uses 2.8%) to help you select the most appropriate aperture/shutter speed combination. **Best for:** Taking readings from highlight and shadow areas, and averaging the two.

Incident light readings using a handheld meter. These devices measure the amount of light falling on a subject. The readings are not based on the reflectance of the subject, making them suitable for subjects that fall outside of 18% (mid-tone) gray—a white wedding dress or a black car, for example.

› Exposure and metering

There will be occasions when the metering system in the EOS 60D is fooled into under- or overexposing a scene—when faced with an excessively bright or dark subject, for instance. In these cases, you can use the Exposure compensation feature or Auto Exposure Bracketing (AEB) to produce a more accurate result.

METER MATE »
Handheld lightmeters, such as the Sekonic L-758DR, offer precise exposure calculations based on incident-light readings.

To set Exposure compensation

1) Turn the Mode Dial to either **P**, **Tv**, or **Av**.

2) Press the shutter-release button halfway to obtain an initial exposure reading. Rotate the ◯ Quick Control Dial to apply the desired amount of Exposure compensation, using the Exposure level indicator on the LCD panel or in the Viewfinder as a reference. Turning the dial to the right will make the final image lighter; turning it to the left will make it darker. (If the ◯ Quick Control Dial is locked, press the **UNLOCK** button to release it.)

3) Press the shutter-release button down fully to take the picture.

4) To cancel Exposure compensation, rotate the ◯ Quick Control Dial to reposition the marker in the center of the Exposure level indicator. (Note that the Exposure compensation will remain set, even after the power switch has been turned to **OFF**.)

> **Note:**
> If the Auto Lighting Optimizer is enabled, note that the final image may still look bright, even if a darker exposure has been set using Exposure compensation.

1

2

The brightness of the sand and sky fooled the camera into underexposing (picture 1). As a result, I used Exposure compensation to provide a more accurate record of the scene (picture 2).

> **Note:**
> Exposure compensation can be set up to +/- 5 stops in ⅓-stop increments, but the indicator on the LCD panel and in the Viewfinder will only display settings up to +/- 3 stops. If the amount exceeds this figure, an arrow will appear at the end of the Exposure level indicator. To apply a figure beyond these parameters, use the Quick Control screen *(see pages 60–61)*.

To set Auto Exposure Bracketing (AEB)

When Auto Exposure Bracketing is set, the camera changes the shutter speed or aperture to take three successive shots at different exposures.

1) Press **MENU**. Rotate the ⚙ Main Dial or ◄► on the Multi-controller to select ◉ Shooting Menu 2.

2) Rotate the ◯ Quick Control Dial or use ▲ ▼ on the Multi-controller to highlight **Expo.comp/AEB**. Press **SET**.

3) Rotate the ⚙ Main Dial to set the AEB amount. Press **SET**. (If you wish to use AEB alongside Exposure compensation, rotate the ◯ Quick Control Dial or use ◄ ► on the Multi-controller to shift the position of the marker, then press **SET**.) When you exit the menu, the AEB amount will appear in the LCD panel.

4) Press the shutter-release button halfway to focus before fully depressing it to take a picture. If the drive mode is set to One Shot, press the button three times to take the sequence. If the drive mode is set to Continuous, hold down the button.

5) To cancel Exposure compensation, follow steps 1–3 and rotate the ⚙ Main Dial to reposition the markers in the center of the Exposure level indicator. Press **SET**. (AEB is canceled when the Power switch is **OFF**, or when the flash is ready to fire.)

The AEB feature will take a series of three shots: the first will be taken at the standard exposure, the second at a decreased exposure, and the third with increased exposure—ideal for subjects such as this one, which can fool the meter. The exposure amount can be set up to +/- 3 stops in ⅓-stop increments.

› Highlight tone priority

While Exposure compensation lightens or darkens all of the tones in an image, Highlight tone priority allows you to expand the dynamic range, retaining detail in the highlights without sacrificing information in the shadows.

1) Press **MENU**. Rotate the 🎛 Main Dial or use ◄► on the Multi-controller to select 📷 Custom functions menu.

2) Rotate the ⚪ Quick Control Dial or use ▲ ▼ on the Multi-controller to highlight **Image**. Press **SET**.

3) Rotate the ⚪ Quick Control Dial or use ◄► on the Multi-controller to select **Highlight tone priority**. Press **SET**.

4) Rotate the ⚪ Quick Control Dial or use ▲ ▼ on the Multi-controller to highlight **Enable**. Press **SET**.

5) Press **MENU** to return to the Custom functions menu screen. When Highlight tone priority is enabled, a **D+** icon will appear on the LCD panel and in the Viewfinder.

6) To cancel Highlight tone priority, follow steps 1–4, highlighting **Disable**. Press **SET**.

› AE Lock

AE (Autoexposure) Lock is mostly used when one area of the scene is being focused on, while a different area is being metered from. Alternatively, the feature can be used to take multiple frames at the same exposure setting.

1) Press the shutter button halfway to focus the subject. The exposure settings will be displayed in the viewfinder and on the LCD panel.

2) Press the ✱ AE lock button. The ✱ icon will appear in the viewfinder, confirming AE lock. With every press of the ✱ button, the current auto exposure setting will be locked.

3) Recompose the picture and press the shutter-release button down fully. To take multiple frames at the locked exposure, continue to hold down the ✱ AE lock button and press the shutter-release button again. (If the drive mode is set to Continuous shooting, you can take multiple images by holding down the shutter-release button.)

› Selecting the AF point

In the Basic Zone, the camera automatically selects an AF point. In the Creative Zone, you can select any one of the nine AF points, or use all of them for automatic AF point selection. Custom Function III-2 offers two approaches for selecting the AF point while shooting: Default and Multi-controller direct. (To access the Custom Functions menu, press **MENU** and use the 🎛 Main Dial or ◄ ► on the Multi-controller to select 🖂 Custom Functions.)

Default (C.Fn III-2-0)

Press the ⊡ AF point selection button. The selected AF point (or points) will be displayed in the viewfinder or on the LCD panel. If all nine AF points are illuminated, automatic AF point selection is in operation. Press **SET** to toggle between the center AF point and automatic AF point selection. To select an AF point, rotate the 🎛 Main Dial or 🔘 Quick Control Dial, or use the ✳ Multi-controller to scroll through the options.

Multi-controller direct (C.Fn III-2-1)

Using this method, there is no need to press the ⊡ AF point selection button first. Instead, simply press the ✳ Multi-controller in the desired direction to select any AF point. Pressing the ⊡ AF point selection button at any time will activate automatic AF point selection.

› AF-assist beam

The AF-assist beam can be activated when the built-in flash is deployed. If light levels are low, this "beam" briefly illuminates a subject prior to a picture being taken, thus "assisting" the focusing system. The maximum effective distance of the AF-assist beam is 13.1ft (4 meters). If an external Speedlite is attached to the camera, it will perform the AF-assist beam function instead of the built-in flash. To use this feature, activate the built-in flash and press the shutter button halfway. The AF-assist beam can be disabled in the Custom Functions menu *(see page 133)*.

> **Note:**
> In 🏔 Landscape, ✤ Sports, and 🚫 Flash Off modes, the AF-assist beam will not fire.

› Drive modes

The EOS 60D features five drive modes: Single shooting, High-speed continuous, Low-speed continuous, Self-timer: 10-second delay, and Self-timer: 2-second delay. The drive mode determines how many shots will be taken, and at what rate (depending on file size, space on the memory card, etc).

☐ Single shooting

Pressing the shutter-release button fully will take one frame.

⊒н High-speed continuous

Holding down the shutter button will take up to 5.3 frames/second.

⊒ Low speed continuous

Holding down the shutter-release button will take up to 3 frames/second.

↺ Self-timer: 10-second delay/ Remote control

Instructs the camera to take a single frame 10 seconds after the shutter-release button has been fully depressed.

↺₂ Self-timer: 2-second delay/ Remote control

Instructs the camera to take a single frame 2 seconds after the shutter-release button has been fully depressed.

In the Creative Zone, the drive mode can be selected by pressing the **DRIVE** button (next to the LCD panel). To scroll through the options, rotate the ⛢ Main Dial or ⌾ Quick Control Dial. The modes will appear on the LCD panel.

› Using the Self-timer

The Self-timer can be used to take a picture of yourself, or to prevent camera shake. The ↺ 10sec. timer can be used in all shooting modes.

1) Press the **DRIVE** button.

2) Rotate the ⛢ Main Dial or ⌾ Quick Control Dial to select a self-timer mode on the LCD.

3) Looking through the viewfinder, compose the picture and focus the subject. Depress the shutter-release button fully to begin the self-timer countdown. The self-timer lamp will repeatedly flash and a beep will sound as the seconds count down on the LCD. In the final two seconds before exposure, the lamp will stay on and the beep will speed up.

2 » THE CREATIVE ZONE

The key difference between the Basic Zone and the Creative Zone is flexibility. Selecting from six shooting modes, the photographer can control every camera function, from setting the shutter speed and aperture right through to customizing buttons. In the Creative Zone, the EOS 60D becomes a tool in your hands. Despite the seemingly limitless permutations, this zone also features a series of semiautomatic modes, enabling you to set what you need, and then relax and concentrate on taking the picture.

› (P) Program AE mode

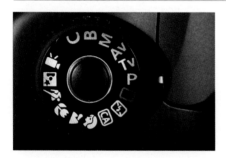

QUAINT CHARACTER ⌃
Using Exposure compensation in the Program AE mode, I was able to record the brightness of the sky and whitewashed walls of this cottage.

Offering a mixture of automated and manual controls, (P) Program AE mode (where AE stands for Auto Exposure) is the perfect introduction to the Creative Zone. As with Full Auto mode in the Basic Zone, the camera sets the shutter speed and aperture to suit the prevailing conditions. However, unlike Full Auto mode, you can alter the AF mode, drive mode, built-in flash, and a whole host of other functions and features. It might seem like a gentle step up from the Basic Zone modes, but in terms of flexibility, it's a sizeable leap.

Tip

Program shift enables you to change the shutter speed and aperture combination while keeping the same exposure—1/250sec. at f/8 becomes 1/1000sec. at f/4, for example. This function is automatically canceled after the picture has been taken. It cannot be used with flash.

› Using (P) Program AE mode

1) Turn the Mode Dial to **P**.

2) Aim the camera, placing the selected AF point on the main subject.

3) Press the shutter-release button halfway to focus. The ● Focus confirmation light and AF points will light in the viewfinder when focus is achieved. In addition, you will hear a beep sound.

4) The aperture and shutter speed settings will appear in the viewfinder and LCD panel. To change the settings (while retaining the same exposure), rotate the 🎛 Main Dial until the desired exposure settings are displayed. This technique is called Program Shift.

5) The built-in flash will not pop up automatically in **P** Program mode, but it can be raised manually by pressing the ⚡ Flash button.

6) Continue to press the shutter-release button halfway to keep the focus locked. Recompose the picture, if necessary, before fully depressing the button to take the photograph.

7) After a brief delay, the captured image will appear on the LCD monitor for two seconds, unless the default review time has been altered *(see page 90)*.

(P) PROGRAM AE MODE

Exposure settings
Evaluative, Partial, Spot, and Center-weighted metering; Exposure compensation; Autoexposure bracketing; AE lock.

Focus settings
One-Shot; AI Servo; AI Focus; auto or manual AF point selection.

Frame advance
Single frame; High-speed continuous, Low-speed continuous; Self-timer.

Flash and AF-assist settings
Flash on or off; Red-eye reduction; AF-assist beam; FE lock; Flash exposure compensation.

Notes
In Program AE mode, the "30" shutter speed and maximum aperture will blink in the Viewfinder if the picture is likely to be underexposed. To solve the problem, increase the ISO speed or activate the built-in flash. Similarly, if the picture is likely to be overexposed, the "8000" shutter speed and minimum aperture will blink. To solve the problem, decrease the ISO speed or attach an ND filter.

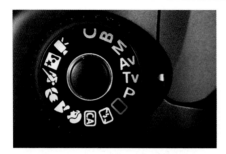

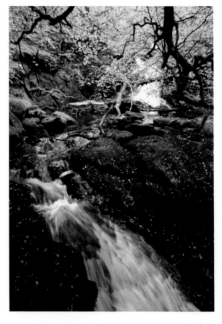

Photographing a moving subject—whether it's the swaying branches of a tree or a cyclist in a race—requires a basic understanding of shutter speed. Generally speaking, a slow shutter speed will record movement as a blur, whereas a fast shutter speed will keep the action sharp by "freezing" any motion. In (Tv) Shutter Priority AE mode (where Tv stands for Time value), the photographer sets the shutter speed, and the camera automatically chooses a suitable aperture.

The shutter speed you select will depend on how you wish to depict the movement of your subject (blur/freeze, etc), but this will be governed by the speed at which the movement takes place, the size of the subject in the frame, and the pace at which the action crosses the sensor plane. For more information, *see pages 152–3.*

CASCADING FALLS ⌃
To add a sense of movement to the waterfall, without reducing it to a milky blur, I used a relatively slow shutter speed in (Tv) Shutter Priority AE mode.

Tip

In Shutter Priority AE mode (and Aperture Priority AE mode), any fluctuations in the light conditions can be accommodated using the Safety shift Custom function (see page 130).

› Using (Tv) Shutter Priority AE mode

1) Turn the Mode Dial to **Tv**.

2) Rotate the ⚙ Main Dial until the desired shutter speed is displayed on the LCD panel; the aperture will be set automatically.

3) Aim the camera, placing the selected AF point on the main subject.

4) Press the shutter-release button halfway to focus. The ● Focus confirmation light and AF points will flash briefly in the viewfinder when focus is achieved. In addition, you will hear a beep sound.

5) The flash will not pop up automatically, but it can be raised manually by pressing the 🔦 Flash button.

6) Continue to press the shutter-release button halfway to keep the focus locked. Recompose the picture, if necessary, before fully depressing the button to take the photograph.

7) After a brief delay, the captured image will appear on the LCD monitor for two seconds, unless the default review time has been altered *(see page 90)*.

(Tv) SHUTTER PRIORITY AE MODE

Exposure settings
Evaluative, Partial, Spot, and Center-weighted metering; Exposure compensation; Autoexposure bracketing; AE lock.

Focus settings
One-Shot; AI Servo; AI Focus; auto or manual AF point selection.

Frame advance
Single frame; High-speed continuous, Low-speed continuous; Self-timer.

Flash and AF-assist settings
Flash on or off; Red-eye reduction; AF-assist beam; FE lock; Flash exposure compensation.

Notes
In Shutter Priority AE mode, the maximum aperture will blink in the Viewfinder if the picture is likely to be underexposed. To solve the problem, set a higher ISO speed or turn the ⚙ Main Dial to set a slower shutter speed. Similarly, if the picture is likely to be overexposed, the minimum aperture will blink. In this instance, decrease the ISO speed or turn the ⚙ Main Dial to set a faster shutter speed.

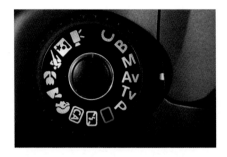

Tip

In Aperture Priority AE mode, using a small aperture will result in a slow shutter speed, increasing the risk of camera shake. To solve the problem, use a tripod or other support (see pages 226–7).

Altering the depth of field (area of acceptable sharpness) requires a basic understanding of apertures. A narrow aperture (large f/number) results in extensive depth of field—perfect for obtaining front-to-back sharpness in landscapes—whereas a wide aperture (small f/number) creates a narrow depth of field—ideal for flower portraits. In (Av) Aperture Priority AE mode (where Av stands for Aperture value), the photographer sets the aperture, and the camera chooses a suitable shutter speed.

The aperture you select will depend on how much of the scene you wish to remain sharp, but this will be governed by the chosen focal point, the subject-to-camera distance, and the focal length of the lens. For more details *see page 151.*

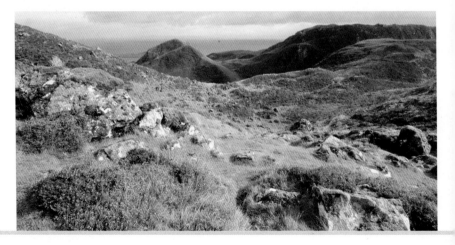

› Using (Av) Aperture Priority AE mode

1) Turn the Mode Dial to **Av**.

2) Rotate the ⚙ Main Dial until the desired aperture is displayed on the LCD panel; the shutter speed is set automatically. (The available apertures will vary depending on the lens attached to the camera body.)

3) Aim the camera, placing the selected AF point on the main subject.

4) Press the shutter-release button halfway to focus. The ● Focus confirmation light and AF points will flash briefly in the viewfinder when focus is achieved. In addition, you will hear a beep sound.

5) The flash will not pop up automatically, but it can be raised manually by pressing the ↯ Flash button.

6) Continue to press the shutter-release button halfway to keep the focus locked. Recompose the picture, if necessary, before fully depressing the button to take the photograph.

7) After a brief delay, the captured image will appear on the LCD monitor for two seconds, unless the default review time has been altered *(see page 90)*.

FEELING OF SPACE 〈〈
By selecting a relatively narrow aperture in (Av) Aperture Priority AE mode, I was able to obtain front-to-back sharpness.

(Av) APERTURE PRIORITY AE MODE

Exposure settings
Evaluative, Partial, Spot, and Center-weighted metering; Exposure compensation; Autoexposure bracketing; AE lock.

Focus settings
One-Shot; AI Servo; AI Focus; auto or manual AF point selection.

Frame advance
Single frame; High-speed continuous, Low-speed continuous; Self-timer.

Flash and AF-assist settings
Flash on or off; Red-eye reduction; AF-assist beam; FE lock; Flash exposure compensation.

Notes
In (Av) Aperture Priority AE mode, the "30" shutter speed will blink in the Viewfinder if the picture is likely to be underexposed. To solve the problem, set a higher ISO speed or turn the ⚙ Main Dial to set a wider aperture. Similarly, if the picture is likely to be overexposed, the "8000" shutter speed will blink. To solve the problem, decrease the ISO or turn the ⚙ Main Dial to set a smaller aperture.

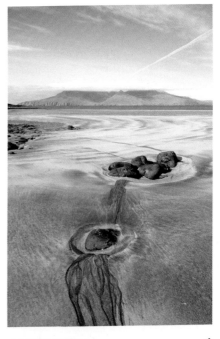

In (M) Manual mode, the photographer sets both the aperture and the shutter speed, using the Exposure level indicator as a guide. For the ultimate in creative control, this mode can't be beaten. However, for the sake of convenience, many photographers prefer to use semiautomatic shooting settings such as (Tv) Shutter Priority AE mode and (Av) Aperture Priority AE mode.

In this mode, the camera takes a light meter reading, but leaves the interpretation of this reading entirely up to the photographer. As a result, he/she can

SHIFTING SANDS ⟪
Being able to set both the shutter speed and aperture in (M) Manual mode allowed me to account for the brightness of this scene, and to make adjustments accordingly.

Tip

In (M) Manual mode, you can enable the Highlight tone priority feature in the Custom Functions menu (see page 131) to help retain detail in bright highlights.

make a judgment based entirely on the scene. If, for example, the subject is a snowy landscape, the meter in the camera may be fooled into underexposing, but the photographer can make adjustments to counteract this error *(see page 64–68).*

› Using (M) Manual mode

1) Turn the Mode Dial to **M**.

2) To set the shutter speed, rotate the 🔧 Main Dial until the desired figure is displayed on the LCD panel. To set the aperture, rotate the ⚙ Quick Control Dial until the desired aperture is displayed on the LCD. (If the ⚙ Quick Control Dial is locked, press the **UNLOCK** button.)

3) Aim the camera, placing the selected AF point on the main subject. Press the shutter-release button half-way to focus. The ● Focus confirmation light and AF points will flash briefly in the viewfinder. You will hear a beep sound. The aperture and shutter speed settings appear next to the exposure level indicator in the Viewfinder and on the LCD.

4) Adjust the shutter speed and aperture until the exposure level mark is centered on the exposure level indicator.

5) Raise the built-in flash manually, if needed, by pressing the ⚡ Flash button.

6) Continue to press the shutter-release button halfway to keep the focus locked. Recompose the picture, if necessary, before fully depressing the button to take the photograph.

7) The captured image will appear on the LCD for two seconds, unless the review time has been altered *(see page 90)*.

(M) MANUAL MODE

Exposure settings
Evaluative, Partial, Spot, and Center-weighted metering; Autoexposure bracketing.

Focus settings
One-Shot; AI Servo; AI Focus; auto or manual AF point selection.

Frame advance
Single frame; High-speed continuous, Low-speed continuous; Self-timer.

Flash and AF-assist settings
Flash on or off; Red-eye reduction; AF-assist beam; FE lock; Flash exposure compensation.

Notes
Handheld lightmeters (available separately) are an accurate alternative to the Exposure level indicator.

> (B) Bulb mode

Photographing star trails, fireworks, or dimly lit cityscapes requires an extremely long exposure. Using (B) Bulb mode, instructs the camera to open the shutter when the shutter-release button is fully depressed, and to keep it open all the time this button is held down.

As these types of exposure can last for several minutes, or even hours, it's worth investing in a cable release or remote control *(see page 229)* to operate the shutter, and save you from an aching finger! Unfortunately, long exposures often result in high levels of noise *(see page 162)*. To minimize the effects, you can enable the Long exposure noise reduction feature in the Custom Functions menu *(see page 131)*.

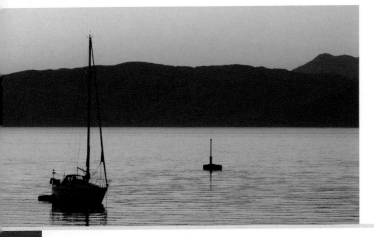

FADING LIGHT **«**
When light levels are extremely low, the (B) Bulb mode can be used with a tripod and remote control to reduce camera shake.

› Using (B) Bulb mode

1) Turn the Mode Dial to **B**.

2) Rotate the ⚙ Main Dial or ◯ Quick Control Dial until the desired aperture is displayed on the LCD panel.

3) Aim the camera, placing the selected AF point on the main subject.

4) Press the shutter-release button halfway to focus. The ● Focus confirmation light and AF points will light in the viewfinder along with the aperture and bulb settings.

5) Fully depress the shutter-release button to take the photograph, holding it down for the duration of the exposure. The elapsed exposure time appears on the LCD panel.

6) After a brief delay, the captured image will appear on the LCD monitor for two seconds, unless the default review time has been altered *(see page 90).*

(B) BULB MODE

Exposure settings
Evaluative, Partial, Spot, and Center-weighted metering.

Focus settings
One-Shot; AI Servo; AI Focus; auto or manual AF point selection.

Frame advance
Single frame; High-speed continuous, Low-speed continuous; Self-timer.

Flash and AF-assist settings
Flash on or off; Red-eye reduction; AF-assist beam; FE lock; Flash exposure compensation.

Notes
In (B) Bulb mode, the camera will be using slow shutter speeds, increasing the risk of camera shake. To solve the problem, use a tripod or other support *(see pages 226–7).*

› (C) Camera User Setting

Frequently used menu settings, shooting modes, and AF modes can be registered to the sixth "mode" in the Creative Zone, (C) Camera User Setting *(see page 126).*

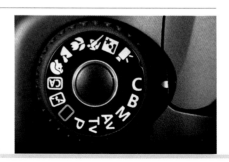

Pressing the **MENU** button instructs the camera to display a menu on the LCD monitor—each is identified by a tab and symbol. There are four Shooting menus, two Playback menus, three Set-up menus, a Custom Functions menu, and a customizable My Menu, offering fast access to frequently used settings. When the Movie mode is selected, three Movie menus replace three of the Shooting menus.

SLOW DOWN ☒

Take your time when navigating the menu options—remember, you can always press **MENU** to go back a level.

› Selecting menu options

1) Press the **MENU** button to display the menu screen. Rotate the ⚙ Main Dial or use ◀▶ on the Multi-controller to scroll through the menu tabs.

2) Rotate the ⬭ Quick Control Dial or use the ▲ ▼ on the Multi-controller to highlight the desired menu item. Press **SET**.

3) Rotate the ⬭ Quick Control Dial or use the ▲ ▼ ◀▶ buttons on the Multi-controller to highlight the desired setting. Press **SET** to select.

4) You can press the **MENU** button at any stage to go back one level.

» MENU SUMMARY

Menu options in italics are not displayed in the Basic Zone modes. In Movie mode, the following menu items will not be displayed: Red-eye reduction, Flash control, **INFO** display options, Camera user settings, Copyright information, Clear all camera settings, and Firmware version.

○ Shooting Menu 1 (Red)	Options
Quality	◢L / ◢L / ◢M / ◢M / ◢S / ◢S / S2 / S3 / RAW / MRAW / SRAW
Beep	Enable / Disable
Release shutter w/o card	Enable / Disable
Image review	Off / 2 / 4 / 8 secs / Hold
Peripheral illumination correction	Enable / Disable
Red-eye reduction	On / Off
Flash control	*Flash firing*
	Built-in flash functions
	External flash functions
	External flash Custom Functions
	Clear external flash Custom Functions

○ Shooting Menu 2 (Red)	Options
Exp. compensation/AEB	*⅓-stop increments, +/- 5 stops / AEB +/- 3 stops*
Auto Lighting Optimizer	*Disable / Low / Standard / Strong*
Picture Style	*S / P / L / N / F / M / 1 3 User Def. 1, 2, 3*
White balance	AWB / ☀ / ▲ / ☁ / ☀ / ▥ / ⚡ / ◨ / K *(Approximately 2500–10,000°K)*
Custom White Balance	*Manual setting of white balance*
WB Shift/Bracketing	*WB correction: White balance correction, WB-BKT: White balance bracketing*
Color space	*sRGB / Adobe RGB*

2

📷 Shooting Menu 3 (Red)	Options
Dust Delete Data	Obtains data for DPP to erase dust spots
ISO Auto	Max.: 400 / Max.: 800 / Max.: 1600 / Max.: 3200 / Max.: 6400

📷 Shooting Menu 4 (Red)	Options
Live View shooting	Enable / Disable
AF mode	Live mode / 👤 Live mode / Quick mode
Grid display	Off / Grid 1 / Grid 2
Aspect ratio	3:2 / 4:3 / 16:9 / 1:1
Exposure simulation	Enable / Disable
Silent shooting	Mode 1 / Mode 2 / Disable
Metering timer	4sec. / 16sec. / 30sec. / 1min. / 10min. / 30min.

▶ Playback Menu 1 (Blue)	Options
Protect images	Prevent shots from being erased accidentally
Rotate images	Rotate vertical images
Erase images	Erase images
Print images	Specify images to be printed (DPOF)
Creative filters	Grainy B/W / Soft focus / Toy camera effect / Miniature effect
Resize	Downsize the pixel count of the image
RAW image processing	Process RAW images

▶ Playback Menu 2 (Blue)

	Options
Highlight alert	Disable / Enable
AF point display	Disable / Enable
Histogram	Brightness / RGB
Image jump with 🏵 Main Dial	1 image / 10 images / 100 images / Date / Folder / Movies / Stills / Rating
Slide show	Select the images, Play time, Repeat, Transition effect for auto playback
Rating	OFF / [*] / [**] / [⁎] / [⁑] / [⁂]
Control over HDMI	Disable / Enable

♈ Set-up Menu 1 (Yellow)

	Options
Auto power off	1 min. / 2 min. / 4 min. / 8 min. / 15 min. / 30 min. / Off
Auto rotate	On 📷💻 / On 💻 / Off
Format	Initialize and erase data on the memory card
File numbering	Continuous / Auto reset / Manual reset
Select folder	Create and select a folder
Eye-Fi settings	Eye-Fi transmission: Disable / Enable, Connection information

(The Eye-Fi settings are only displayed when an Eye-Fi card is being used in the camera.)

♈ Set-up Menu 2 (Yellow)

	Options
LCD brightness	Adjustable to one of seven brightness levels
Date/Time	Set the date (year, month, day) and time (hour, min., sec.)
Language	Select the interface language
Video system	NTSC / PAL
Sensor cleaning	Auto cleaning: Enable / Disable; / Clean now / *Clean manually*
Lock ⊙ Quick Control Dial	Disable / Enable

2

✤ Set-up Menu 3 (Yellow)	Options
Battery info.	Type, Remaining capacity, Shutter count, Recharge performance, Battery registration, Battery history
INFO. Button display options	Displays camera settings / Electronic level / Displays shooting functions
Camera user settings	Register current camera settings to **C** on the Mode Dial
Copyright information	Display copyright information / Enter author's name / Enter copyright details / Delete copyright information
Clear all camera settings	Resets the camera to the default settings
Firmware Ver.	For updating the firmware

📷 Custom Functions Menu (Orange)	Options
C.Fn I: Exposure	Customize the camera settings as desired
C.Fn II: Image	Customize the camera settings as desired
C.Fn III: Autofocus/Drive	Customize the camera settings as desired
C.Fn IV: Operation/Others	Customize the camera settings as desired
Clear all custom functions (C.Fn)	Resets camera to default C.Fn settings

★ My Menu (Green)	Options
My Menu settings	Register frequently used menu items and Custom functions

▯▣̇ Movie Shooting Menu 1 (Red) Options

Movie exposure	Auto / Manual
AF mode	Live mode / ⌞∵⌟ Live mode / Quick mode
AF w/ shutter button during ▶▇	Disable / Enable
AF and metering buttons for ▶▇	Customize the shutter button, AF-ON button, and ✱ button
▶▇ ISO speed setting increments	⅓-stop / 1-stop
▶▇ Highlight tone priority	Disable / Enable

▯▣̇ Movie Shooting Menu 2 (Red) Options

Movie recording size	1920 x 1080 (▯30 / ▯25 / ▯24) / 1280 x 720 (▯60 / ▯50) / 640 x 480 (▯60 / ▯50) / Crop 640 x 480 (▯60 / ▯50)
Sound recording	Auto / Manual / Disable; Recording level
Wind Filter	Disable / Enable
Silent shooting	Mode 1 / Mode 2 / Disable
Metering timer	4sec. / 16sec. / 30sec. / 1min. / 10min. / 30min.
Grid display	Off / Grid 1 / Grid 2

▯▣̇ Movie Shooting Menu 3 (Red) Options

Exposure compensation	⅓-stop increments, +/- 5 stops
Auto Lighting Optimizer	Disable / Low / Standard / Strong
Picture Style	✧✦S Standard / ✧✦P Portrait / ✧✦L Landscape / ✧✦N Neutral / ✧✦F Faithful / ✧✦M Monochrome / ✧✦1 User Def. 1, 2, 3
White balance	AWB / ☀ / ⌂ / ☁ / ☀̇ / 🗚 / ⚡ / ◣ / 🄺 (Approximately 2500–10,000°K)
Custom White balance	Manual setting of white balance

1) Turn the Mode Dial to the Creative Zone. Press the **MENU** button and rotate the 🖾 Main Dial or use ◀ ▶ on the Multi-controller to highlight the ★ My Menu tab.

2) Rotate the ⬡ Quick Control Dial or use ▲ ▼ on the Multi-controller to highlight My Menu settings. Press **SET**.

3) Rotate the ⬡ Quick Control Dial or use ▲ ▼ on the Multi-controller to highlight **Register to My Menu**. Press **SET**.

4) Rotate the ⬡ Quick Control Dial or use ▲ ▼ on the Multi-controller to highlight an item to include in My Menu. Press **SET**. When the dialog box is displayed, rotate the ⬡ Quick Control Dial or use ◀ ▶ on the Multi-controller to highlight **OK**. Press **SET**.

5) Repeat step 4 for up to six items. You can press **MENU** at any stage to go back one level.

6) If you have more than one item registered, follow steps 2–3 and highlight **Sort**. Next, use the ⬡ Quick Control Dial or ▲ ▼ on the Multi-controller to highlight the item whose order you want to change. Press **SET**. Use the ▲ ▼ on the Multi-controller to move the item up or down. Press **SET** to confirm the new order.

7) To delete a single registered item, follow steps 2–3 and highlight **Delete item/items**. Rotate the ⬡ Quick Control Dial or use ▲ ▼ on the Multi-controller to highlight the item for deletion. Press **SET**. Rotate the ⬡ Quick Control Dial or use ◀ ▶ on the Multi-controller to highlight **OK** in the dialog box. Press **SET** to delete the item.

8) To clear all registered items at once, follow steps 2–3 and highlight Delete all items. Rotate the ⬡ Quick Control Dial or use ◀ ▶ on the Multi-controller to highlight **OK** in the dialog box. Press **SET**.

Tip

*To display ★ My Menu first every time you press **MENU**, select **Enable** in the Display from **My Menu option** in **My Menu settings**.*

» SHOOTING MENU 1

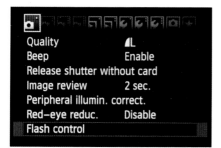

The EOS 60D has up to four shooting menus, depending on whether you are in the Basic Zone or Creative Zone. These menus contain all of the basic shooting related functions. For quick recognition, the shooting menus are colored red.

› Setting image quality

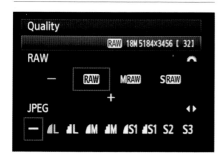

There are three RAW and eight JPEG file quality settings on the EOS 60D. RAW is the largest file size (about 24.5 MB) and will capture the greatest amount of information.

The smallest JPEG **S3** is about 0.3 MB and is best used for emails or publishing on the web. It is possible to record both RAW and JPEG files simultaneously, in any size combinations—the images will be saved in the same folder with the same file numbers, but with different file extensions (.JPG for JPEG and .CR2 for RAW).

Even when you're using the largest JPEG setting, less space will be taken up on the memory card than shooting with RAW. JPEGs also write to the memory card faster than RAW files, allowing a greater number of pictures to be taken continuously (this figure depends on the space remaining on the card). On the downside, JPEGs are compressed files and contain less information than RAW. As a result, they limit post-production options and shed information when they are resaved.

Using RAW files will give you the highest quality images with the most information, which can be adjusted on a computer with suitable processing software to "develop" the image to your exact requirements.

> ### Tip
>
> *The Quality menu in* 📷 *Shooting Menu 1 displays the size of the image in the upper right corner with the number of shots remaining in brackets.*

› Enable/disable beep

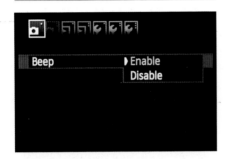

The beeper can be useful for confirming focus, but there will be times when it becomes intrusive and disruptive—when photographing the interior of a church, for example. As a result, this function can be disabled *(see page 82).*

› Release shutter without card

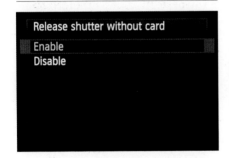

This option allows you to shoot without a memory card in the camera, mainly while shooting with the EOS 60D tethered to a computer. To select this feature, *see page 82.*

› Image review

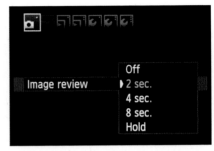

After each shot, the LCD will display the image for 2, 4, or 8 seconds. With **Hold** selected, it will remain on screen until Auto power off has elapsed. Turn the feature Off to conserve battery power or review images later. To select this feature, *see page 82.*

› Peripheral illumination correction

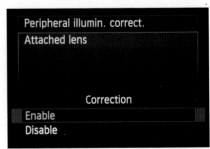

This feature corrects vignetting. The EOS 60D contains data for many lenses, but it is recommended that you stick to Canon brand optics. To select this feature, *see page 82.*

› Red-eye reduction

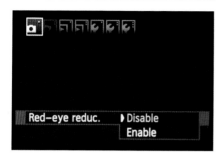

Portraits taken with flash often display red-eye, where light reflects off the retina of the subject. This setting reduces this effect, but it is not available in [🔲] Flash Off, [🏔] Landscape, [🏃] Sports, and [🎥] Movie modes. To select this feature, *see page 82.*

› Flash control

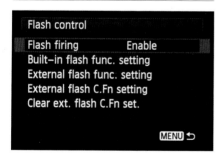

The Flash control menu allows you to access the following flash options:

Flash firing

The built-in flash, or an external flashgun, can be enabled or disabled with this menu setting. If disabled, the AF-assist beam will continue to work as long as it is not disabled too. To select this feature, *see page 82.*

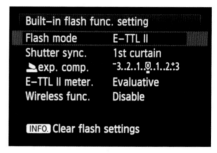

Built-in flash and External flash function settings

Both the Built-in flash menu and the External flash functions settings menu offer various options for improving your flash photography. Settings that are unavailable will be grayed out on the menu screens. The functions displayed under External flash func. settings will vary depending on the Speedlite model. To select this feature, *see page 82.*

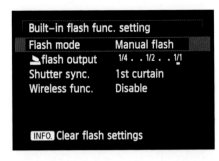

Built-in flash func. setting

Flash mode	Manual flash
▲flash output	1/4 . . 1/2 . . 1/1
Shutter sync.	1st curtain
Wireless func.	Disable

[INFO] Clear flash settings

Flash mode

Select the flash mode for your desired shooting method. **E-TTL II** is the standard mode of EX Speedlites for automatic flash shooting. **Manual flash** is for those who want to set their own flash output (1/1 to 1/128). For any other flash modes, you will need to refer to the manual of your particular Speedlite.

Shutter sync

Use this option for switching from first to second curtain settings. First curtain fires the flash immediately after the exposure begins, while second curtain fires the flash once when the shutter-release button is fully depressed, and again just before the exposure ends. When coupled with a slow sync speed, trails of light can be photographed at night.

Flash exposure compensation

You can set Flash exposure compensation up to +/-3 stops in $^1/_3$-stop increments. To select this feature, *see pages 180-1*.

E-TTL II flash metering

Select **Evaluative** for normal flash exposures. Advanced users can select **Average** to average the flash exposure for the entire metered scene.

Wireless flash

The E-TTL II flash exposure metering system on the EOS 60D is compatible with wireless flash units *(see pages 184-6)*.

Clear flash settings

Press **INFO** to display the **Clear all flash settings** dialog box. Select **OK** and press **SET** to confirm. For FEB (Flash Exposure Bracketing) and Zoom on the **External flash func. settings** menu, refer to the instruction manual of your particular Speedlite.

External flash custom function settings

When the camera is ready to shoot with an external Speedlite, select **External flash C.Fn setting** and press **SET**. Use ◄ ► on the Multi-controller to set the function.

Clear External flash custom function settings

Use this option to clear all of the External flash custom function settings.

» SHOOTING MENU 2

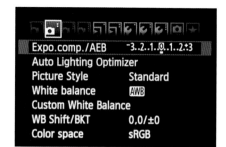

The second shooting menu concentrates on exposure settings in the Creative Zone modes.

› Exposure compensation and Autoexposure bracketing (AEB)

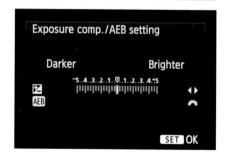

There may be occasions when the metering system of the EOS 60D is fooled into making an inaccurate exposure—when faced with an excessively bright or dark scene, for example. In these instances, you can make the exposure lighter or darker using the Exposure compensation setting. Available in **P**, **Tv**, and **Av** modes only, this feature allows you to over- or underexpose an image up to +/- 5 stops in ¹/₃-stop increments. To set this feature, *see page 82*.

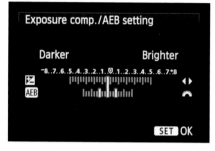

In a similar fashion, AEB or (Autoexposure bracketing) instructs the camera to take three successive shots: one standard, one underexposed, and one overexposed up to +/- 3 stops in ¹/₃-stop increments. The degree of over- or underexposure is shown by two marks on either side of the central marker on the Exposure level indicator. With single-frame shooting, the shutter-release button will need to be pressed three times, but with the drive mode set to continuous shooting you can press and hold it down for the duration of the sequence. AEB will reset when the camera is turned off or the flash is ready to fire. To set this feature, *see page 82*.

› Auto Lighting Optimizer

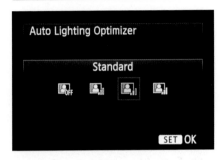

When pictures appear underexposed or lack punch, the Auto Lighting Optimizer will provide a boost by altering the brightness and contrast. Although the Auto Lighting Optimizer is automatically set to Standard in Basic Zone modes, it can be adjusted manually in the Creative Zones. There are three strengths available: **Low**, **Standard**, or **Strong**. Alternatively, you can set this feature to **OFF**, allowing you to process the file with more accuracy on a computer later on. To select this feature, *see page 82*.

Tip

If 📷 *C.Fn II-3: Highlight tone priority is set to Enable, the Auto Lighting Optimizer will be disabled.*

› Picture Style

Picture Styles allow you to enhance certain aspects of a scene, boosting colors or enhancing skin tones. In the Basic Zone, the camera automatically selects an appropriate Picture Style— 🏔 Landscape mode will adopt the Landscape Picture Style, for example.

In the Creative Zone, the Picture Styles can be tweaked to reflect your personal vision. Then they can be registered into 🎯 1 , 🎯 2 , and 🎯 3 User Def. 1 to 3 for later use or added as an option to ★ My Menu.

All of the Picture Style settings apply equally to JPEG and RAW files, but photographers shooting RAW files can change the parameters on a computer at a later date.

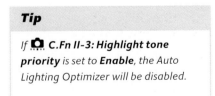

Picture Style effects

S Standard A general-purpose Picture Style suitable for most scenes, creating a vivid and sharp image.

P Portrait For pleasing skin tones and a softer focus that suits close-up images.

L Landscape For vivid blues and greens, creating very sharp images that are ideal for outdoor photography.

N Neutral For photographers who like natural colors and prefer to process images on a computer.

F Faithful Creates a subdued, accurately colored picture for photographers who prefer to process images on a computer.

M Monochrome Creates black and white images.

Picture Style default settings

Monochrome Filter Effect and Toning Effect are set to None. The three User Defined sets of parameters are all set to 0.

Color parameters

Each Picture Style, apart from Monochrome, has four sets of parameters: Sharpness, Contrast, Saturation, and Color Tone. The settings range from -4 to +4, apart from Sharpness, which ranges from 0 to +7.

Monochrome parameters

The Monochrome setting retains the Sharpness and Contrast parameters, but adds Filter effect and Toning effect menus. The Toning effect menu offers a choice of **None**, **Sepia**, **Blue**, **Purple**, or **Green** to add a colored tint to the entire image.

Monochrome Filter effects

None Black and white image with no filter effects.

Yellow Blue sky will look less washed out and white clouds will appear crisper.

Orange Blue sky will appear darker and white clouds more distinct, and sunsets intensified.

Red Blue sky will look very dark and white clouds very white; high contrast.

Green Enhances lips and skin tones; foliage will look brighter and crisper.

Setting a Picture Style

1) Press **MENU**. Rotate the Main Dial or use ◀ ▶ on the Multi-controller to highlight the Shooting Menu 2 tab.

2) Rotate the Quick Control Dial or

use ▲ ▼ on the Multi-controller to highlight **Picture Style**. Press **SET**.

3) Rotate the ⟲ Quick Control Dial or use ▲ ▼ on the Multi-controller to highlight the desired Picture Style. Press **INFO** to display the **Detail set.** menu.

4) Rotate the ⟲ Quick Control Dial or use ▲ ▼ on the Multi-controller to highlight the parameter you wish to change. Press **SET**.

5) Rotate the ⟲ Quick Control Dial or use ◄ ► on the Multi-controller to shift the setting. The white indicating mark will move along the scale, leaving a gray indicator showing the default setting. Press **SET** to confirm the parameter setting. (For the Filter Effect and Toning Effect parameters in the Monochrome Picture Style, rotate the ⟲ Quick Control Dial or use ▲ ▼ on the Multi-controller to select a setting. Press **SET** to confirm the selection.)

6) Press **MENU** to return to the Picture Style screen. Any settings changed from the default are now displayed in blue. Press **SET** to confirm your choice of Picture Style and return to the Shooting Menu.

Registering User Defined Picture Styles

1) Press **MENU**. Rotate the 🎛 Main Dial or use ◄ ► on the Multi-controller to highlight the 🎥 Shooting Menu 2 tab.

2) Rotate the ⟲ Quick Control Dial or

use ▲ ▼ on the Multi-controller to highlight Picture Style. Press **SET**.

3) Rotate the ⟲ Quick Control Dial or use ▲ ▼ on the Multi-controller to highlight ⚏ 1 User Def. 1. Press **INFO** to display the **Detail set.** menu.

4) Rotate the ⟲ Quick Control Dial or use ▲ ▼ on the Multi-controller to highlight **Picture Style**. Press **SET**.

5) Rotate the ⟲ Quick Control Dial or use ▲ ▼ on the Multi-controller to scroll through the base Picture Styles. Press **SET** to make your selection.

6) Rotate the ⟲ Quick Control Dial or use ▲ ▼ on the Multi-controller to highlight a parameter and press **SET**.

7) Rotate the ⟲ Quick Control Dial or use ◄ ► on the Multi-controller to shift the setting. The white indicating mark will move along the scale, leaving a gray indicator showing the default setting. Press **SET** to confirm the parameter setting. (For the Filter Effect and Toning Effect parameters, rotate the ⟲ Quick Control Dial or use ▲ ▼ on the Multi-controller to select a setting. Press **SET** to confirm the selection.)

8) Press **MENU** to return to the Picture Style screen. Settings changed from the default are displayed in blue. Press **SET** to confirm your choice and return to the Shooting Menu.

› White balance

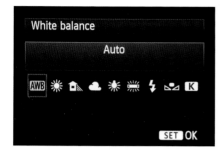

A human eye sees a white object as white, regardless of whether it is lit by an indoor bulb or the sun. Depending on the light conditions, a digital camera needs a little help to record whites as white.

Variations in light are measured in color temperature (degrees Kelvin). As well as the **AWB** Auto white balance function, the EOS 60D allows the user to specify an exact color temperature (within a range of 2500–10,000°K) by selecting **K**. Alternatively, use one of the following predetermined settings:

AWB Auto white balance: The camera selects a setting in the range of 3000–7000°K

☀ Daylight: 5200°K

🏠 Shade: 7000°K

☁ Cloudy, twilight, sunset: 6000°K

💡 Tungsten lighting: 3200°K

🔆 White fluorescent lighting: 4000°K

⚡ Flash: 6000°K

1) Press **MENU**. Rotate the 🎛 Main Dial or use ◄ ► on the Multi-controller to highlight the **📷ⁱ** Shooting Menu 2 tab.

2) Rotate the ◯ Quick Control Dial or use ▲ ▼ on the Multi-controller to highlight **White balance**. Press **SET**.

3) Rotate the ◯ Quick Control Dial or use ◄ ► on the Multi-controller to highlight the desired setting. Press **SET**.

Setting Custom White Balance

It can be difficult to gauge the precise color temperature of a scene, so use the ◾ Custom White balance setting, which offers a range of 2000–10,000°K.

1) With any White balance setting, manually focus on a white object that fills the spot-metering circle. Take a picture. In **📷ⁱ** Shooting Menu 2, highlight Custom White Balance. Press **SET**.

2) Rotate the ◯ Quick Control Dial or use ◄ ► on the Multi-controller to locate the image captured in step 1. Press **SET**.

3) On each dialog box, select **OK** to import the data. In **📷ⁱ** Shooting Menu 2, highlight White Balance. Press **SET**.

4) Highlight the ◾ Custom White balance setting. Press **SET**.

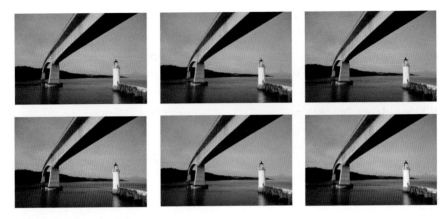

WHITE BALANCE SETTINGS

The EOS 60D offers a choice of predetermined White balance settings *(see page 97)*. Most of the time the **AWB** Auto setting will obtain the correct balance, but you can alter the mood of an image by selecting the "wrong" white balance setting. Here, I prefer the cooler tones provided by the Tungsten setting *(bottom right)*.

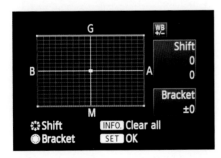

White balance shift

White balance can be corrected, resulting in similar effects to those obtained with a color compensating filter. Each color can be corrected to one of nine levels. This facility can be used with any White balance setting, but is only possible in the Creative Zone modes.

To set White Balance Shift:

1) In ◘¦ Shooting Menu 2, highlight **WB Shift/BKT**. Press **SET**.

2) Use the ✳ Multi-controller to move the white cursor to the desired position. B is for Blue, A is for Amber, M is for Magenta, and G is for Green. The Shift box on the right of the screen displays the new coordinates using the initial letter of the color plus a number from 0 to 9.

3) Press **INFO** at any time to re-center the white cursor and cancel any adjustments.

4) Press **SET** to confirm the setting.

White balance bracketing

By rotating the ⊙ Quick Control Dial in step 2, two extra cursors will appear on either side of the original white cursor. This feature is called white balance bracketing and is used to capture three versions of the same image, each with a different color tone. The image can be bracketed with a Blue/Amber or Magenta/Green bias, with a difference of up to three levels in single-level increments. The images will be bracketed as follows: Standard White balance, Blue bias, Amber bias; or Standard White balance, Magenta bias, Green bias.

To set white balance bracketing:

1) In ⬛ Shooting Menu 2, highlight **WB Shift/BKT**. Press **SET**.

2) Rotate the ⊙ Quick Control Dial clockwise to set a Blue/Amber bias with one to three levels of difference. Alternatively, rotate the ⊙ Quick Control Dial counterclockwise to set a Magenta/Green bias with one to three levels of difference. The Bracket box on the right of the screen displays the color correction bias and correction increments.

3) Press **INFO** at any time to re-center the white cursor and cancel any adjustments.

4) Press **SET** to confirm the setting.

› Color space

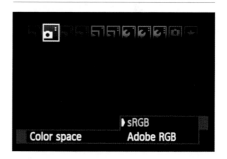

Color space describes the range of colors that can be reproduced within a given system. The Canon EOS 60D can capture images in two color spaces: sRGB and Adobe RGB. In the Basic Zone, the camera selects sRGB automatically, since this is ideal for most general photography. Adobe RGB is more likely to be used by photographers who need to convert images to CMYK color space for commercial printing. To select this feature, *see page 82*.

› Dust Delete Data

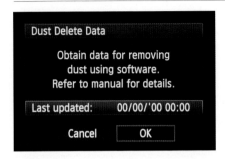

The EOS 60D can locate the position of blemishes, and record the details as Dust Delete Data. To use this feature, *see pages 246-7.*

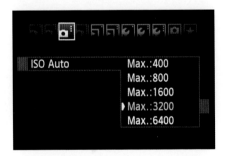

Setting the maximum ISO speed for ISO Auto

When the camera is using Auto ISO, the LCD panel will display the letter "A." The actual ISO speed will be displayed in the

Viewfinder when the shutter button is pressed halfway.

In all Basic Zone modes except 🏃 Portrait, the camera will set the ISO speed automatically between 100 and 3200. In 🏃 Portrait mode, the ISO will be fixed at 400.

In the Creative Zone modes, the ISO can be set between 100 and 6400, with the exception of **B** Bulb. In this mode (and when using flash), the ISO will be fixed at 400.

When you're using Auto ISO, the maximum ISO speed can be set between 400 and 6400. If image quality is crucial, you can set a lower ISO to reduce noise *(see page 162).* If you're handholding the camera in low-light conditions, a higher ISO will allow a faster shutter speed, making camera shake less likely. To select this feature, *see page 82.*

» SHOOTING MENU 4

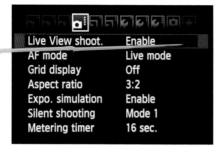

The fourth shooting menu concentrates on function settings that only apply during Live View shooting.

› Live View functions

Live View allows you to photograph a subject while viewing it on the LCD monitor, offering a 100% field of view. With the aid of the EOS Utility software provided, you can even use Live View with a computer screen. For full details on how to achieve this, read the instructions on the CD-ROM.

› Live View shooting

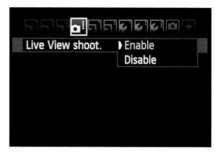

1) Press **MENU**. Rotate the Main Dial or use ◀ ▶ on the Multi-controller to highlight the Shooting Menu 4 tab.

2) Rotate the Quick Control Dial or use ▲ ▼ on the Multi-controller to highlight **Live View shoot**. Press **SET**.

3) Rotate the Quick Control Dial or use ▲ ▼ on the Multi-controller to highlight **Enable**. Press **SET**.

4) Press the Live View button to display the subject on the LCD monitor. (The sound heard is the mirror lifting, not the shutter firing.)

5) Aim the camera and press the shutter-release button halfway to focus. The AF point will turn green when focus is achieved. In addition, you will hear a beep sound.

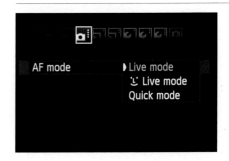

6) Press the shutter-release button fully to take the picture. The captured image will appear on the LCD monitor. After the image review ends, the camera automatically returns to Live View shooting.

7) Press the 📷 Live View button to exit.

Warning!

Using Live View for prolonged periods can cause the camera to become hot, leading to a reduction in image quality. If the 🔋 Internal temperature warning icon appears, discontinue Live View shooting. If you continue, and the temperature increases further, Live View may be stopped automatically and will not be available until the internal temperature drops.

Note:
Live View shooting will significantly drain the battery compared to using the viewfinder.

› Live View: AF modes

There are three AF modes to choose from when shooting with Live View: Live mode, Face Detection Live mode 😊, and Quick mode.

Live mode uses the image sensor to achieve focus. Focusing takes longer and is harder to achieve.

😊 **(Face detection) Live mode** also uses the image sensor to achieve focus, but automatically locks on to human faces.

Quick mode uses the same dedicated AF sensor as the Viewfinder to make focusing quicker, but Live View is briefly interrupted by the AF operation.

Setting the AF mode in Live View
1) Press **MENU**. Rotate the 🎛 Main Dial or use ◀ ▶ on the Multi-controller to

highlight the 📷 Shooting Menu 4 tab.

2) Rotate the ⬡ Quick Control Dial or use ▲ ▼ on the Multi-controller to highlight **AF mode**. Press **SET**.

3) Rotate the ⬡ Quick Control Dial or use ▲ ▼ on the Multi-controller to highlight the desired mode. Press **SET**.

4) Press the 📷 Live View button to display the subject on the LCD monitor. (The sound heard is the mirror lifting, not the shutter firing.)

Or skip steps 1–3 to begin with step 4.

5) Press the AF button to display the three AF modes. Rotate the ⛭ Main Dial or ⬡ Quick Control Dial, or use ◀ ▶ on the Multi-controller to highlight the desired option. Press **SET**.

Using Live mode
1) Repeat steps 1–4, selecting Live mode in step 3.

2) Aim the camera at the subject. Move the ☐ AF point with the ❄ Multi-controller to the desired point of focus. (To return the AF point to the center, press 🗑.)

3) Press the shutter-release button halfway to focus. The ☐ AF point will turn

green when focus is achieved and a beep will sound. If focusing fails, the AF point will turn orange.

4) If it is difficult to focus, press the ⊕ Magnify button to enlarge the image at the AF point. Check the focus and exposure before pressing the shutter-release button fully to take the picture.

Using ⚲ Live mode
1) Repeat steps 1–4 of Setting the AF mode above, selecting ⚲ Live mode in step 3.

2) Aim the camera at the subject. The ⸢⸥ frame will appear over the detected face. If more than one face is detected, the ⸢⸥ frame will appear. Use the ❄ Multi-controller to move the ⸢⸥ frame over the target face.

3) Press the shutter-release button halfway to focus. The AF point will turn green when focus is achieved and a beep will sound. If focusing fails, the AF point will turn orange. If a face cannot be detected, the ☐ AF point will be displayed.

4) Check the focus and exposure before pressing the shutter-release button fully.

Using Quick mode

1) Repeat steps 1–4 of Setting the AF mode on *pages 102–3*, selecting Quick mode in step 3.

2) Press 📷. The small boxes that appear on the LCD monitor are AF points, and the larger box is the magnifying frame.

3) Aim the camera at the subject. Press the **Q** button to display the Quick Control screen. Use ▲ ▼ on the Multi-controller to highlight the AF points. Rotate the 🖲 Main Dial or ⊙ Quick Control Dial to highlight the desired AF point in blue.

4) Press the shutter-release button halfway to focus. Live View will briefly turn off as the reflex mirror returns to its original position for autofocusing. The ☐ AF point will turn green when focus is achieved, a beep will sound, and Live View will return.

5) To check focus, use the ✳ Multi-controller to position the magnifying frame and press the ⊕ Magnify button to enlarge that particular section of the image.

6) Check the focus and exposure before pressing the shutter-release button fully to take the picture.

Focusing manually with Live View

1) Set the focusing switch on the lens to MF (Manual Focus) and aim the camera at the subject. Turn the lens focusing ring to achieve rough focus.

2) Use the ✳ Multi-controller to position the magnifying frame on the desired area of focus. (Press 🗑 the Erase button to re-center the magnifying frame.) Press the ⊕ Magnify button to enlarge that section of the image. Each press of the ⊕ Magnify button will cycle through views from normal to 5x magnification to 10x magnification and back to normal.

3) While looking at the magnified view, turn the lens focusing ring until the image is sharp. Press the ⊕ Magnify button to return to normal Live View shooting.

4) Check the focus and exposure before pressing the shutter-release button fully to take the picture.

Live View Shooting Function settings

Press the AF, DRIVE, or ISO button during Live View to superimpose the respective setting screen on the LCD monitor. Rotate the 🖲 Main Dial or ⊙ Quick Control Dial, or use ◄ ► on the Multi-controller to select the function.

› Live View: Quick Control screen

› Grid display

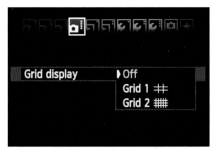

1) Press the **Q** Quick Control button to superimpose the settable functions over the Live View image.

2) Use ▲ ▼ on the Multi-controller to select the desired function by highlighting it blue. The setting of the function is displayed on the bottom of the screen.

3) Rotate the 🖉 Main Dial or ⊙ Quick Control Dial, or use ◄ ► on the Multi-controller to quickly change the setting. In Creative Zone modes, you can press **SET** to display the setting options (apart from AF point selection).

It is possible to overlay Live View with a grid to aid composition. There are two different types of Grid display to choose from: ⊞ or ▦. To select this feature, *see page 82.*

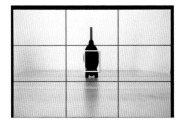

› Aspect ratio

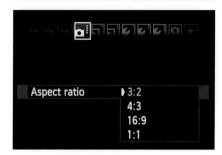

› Exposure simulation

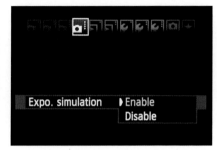

The aspect ratio of an image can be set to 3:2, 4:3, 16:9, or 1:1, with lines indicating the dimensions on Live View. The size of the image file changes as the ratio increases or decreases. JPEG images will be saved with the set aspect ratio, while RAW images will always be saved with the 3:2 aspect ratio. Only when the RAW image is processed on a computer will the set aspect ratio take effect. To select this feature, *see page 82.*

By enabling Exposure simulation, the brightness of the Live View image will alter as you change the exposure settings, offering an indication of how the final image will look. Disabling this function will set Live View to a standard brightness. This will make the image easy to see, but it will not reflect any changes in the exposure settings. To select this feature, *see page 82.*

Warning!

When printing a borderless print, make sure the aspect ratio of the paper can accommodate the aspect ratio of the image. Otherwise the image may be cropped significantly.

› Silent shooting

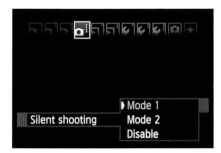

The noise created by the shutter release in the EOS 60D can be reduced. In Live View, there are two main options:

Mode 1 will reduce the sound of the shot being taken while also allowing Continuous shooting at both speed levels.

Mode 2 minimizes the sound of the shot being taken, but only allows single shooting.

To select this feature, *see page 82.*

> **Notes:**
> If you use a TS-E lens or extension tube, you should disable the silent shooting feature.
>
> When using flash, silent shooting will be disabled, even if Mode 1 or Mode 2 has been selected.

› Metering timer

The Metering timer allows you to select how long the camera continues to meter the scene after the shutter button is released, before turning off.

To select this feature, *see page 82.*

Playback menu 1 is color-coded blue.

› Protecting images

1) Press **MENU**. Rotate the ⌒ Main Dial or use ◀ ▶ on the Multi-controller to highlight the ▶ Playback Menu 1 tab.

2) Rotate the ⃝ Quick Control Dial or use ▲ ▼ on the Multi-controller to highlight **Protect images**. Press **SET**.

3) Rotate the ⃝ Quick Control Dial or use ▲ ▼ on the Multi-controller to highlight **Select images**. Press **SET**.

4) Rotate the ⃝ Quick Control Dial or use ◀ ▶ on the Multi-controller to scroll through the images and locate a picture to protect. Press **SET** to protect the image and make the 🔑 key icon appear.

5) To cancel the protection of an image, press **SET** again. The 🔑 key icon will disappear.

6) To protect more images, repeat step 4.

7) To exit image protection, press **MENU**.

Protect all images in a folder or card

You can protect all of the images in a folder or on a memory card at once. Repeat steps 1 and 2 above and select **All images in folder** or **All images on card** in step 3. To cancel the image protection, select **Unprotect all images in folder** or **Unprotect all images on card** in step 3.

› Rotate images

This function allows you to rotate images to the desired orientation.

1) Press **MENU**. Rotate the 🐾 Main Dial or use ◄ ► on the Multi-controller to highlight the ▶ Playback Menu 1 tab.

2) Rotate the ◌ Quick Control Dial or use ▲ ▼ on the Multi-controller to highlight **Rotate**. Press **SET**.

3) Rotate the ◌ Quick Control Dial or use ◄ ► on the Multi-controller to scroll through the images and locate a picture you would like to rotate.

4) Press **SET** to rotate the image. Each time you press **SET**, the image will rotate clockwise 90°, 270°, and back to 0°.

5) To rotate another image, repeat steps 3 and 4.

6) To exit, press **MENU**.

Note:
A movie cannot be rotated.

Tip

The image will not rotate unless ♈ Auto rotate is set to On 🗆🖳. See page 118.

› Erase images

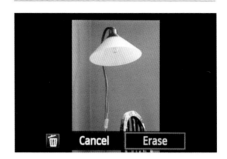

Images can be erased from the memory card one at a time or in batches. To use this feature, *see pages 40–41.*

› Creative filters

The EOS 60D features four Creative Filter settings: Grainy B/W, Soft focus, Toy camera effect (above left), and Miniature effect (above right). To use this feature, *see pages 224–5.*

› Print order

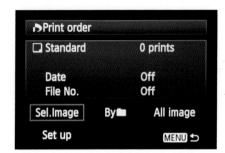

Digital Print Order Format (DPOF) records printing instructions to the memory card. To use this feature, *see pages 239–40*

› Resize images

With this feature, you can resize images in-camera. Images are made smaller by a reduction in pixels, only possible with ▲L / ▋L / ▲M / ▋M / ▲S / ▋S / S2 images.

1) Press **MENU**. Rotate the 🔆 Main Dial or use ◄ ► on the Multi-controller to highlight the ▶ Playback Menu 1 tab.

2) Rotate the ◯ Quick Control Dial or use ▲ ▼ on the Multi-controller to highlight **Resize**. Press **SET**.

3) Rotate the ◯ Quick Control Dial or use ◄ ► on the Multi-controller to scroll through the images and locate a picture to

resize. (Press the ▦ Index button to switch to the index display.)

4) Press **SET** to display the image resize options. Rotate the ◯ Quick Control Dial or use ◄ ► on the Multi-controller to select the image size. Press **SET**. Use ◄ ► on the Multi-controller to highlight **OK** in the dialog box. Press **SET** again to save the image in its new size. Note the destination folder and file number before selecting **OK**.

5) To resize other images, repeat steps 3 and 4.

6) To exit and return to ▶ Playback Menu 1, press **MENU**.

› Processing RAW images with the camera

With this feature, you can process **RAW** images, but not **MRAW** or **SRAW** images in-camera, and save them as JPEGs. The

original RAW image will remain unchanged, allowing you to process the image in different ways, with a number of different adjustments before saving it as a separate JPEG.

1) Press **MENU**. Rotate the 🖾 Main Dial or use the ◀ ▶ on the Multi-controller to highlight the ▶ Playback Menu 1 tab.

2) Rotate the ◌ Quick Control Dial or use ▲ ▼ on the Multi-controller to highlight **RAW image processing**. Press **SET**.

3) Rotate the ◌ Quick Control Dial or use the ◀ ▶ on the Multi-controller to scroll through the images and locate a RAW image you would like to process. (Press the 🞖 Index button to switch to the index display.)

4) Press **SET** to display the RAW processing options (*see table page 112*). Use ◀▶ and ▲ ▼ on the Multi-controller to highlight the desired option, and rotate the ◌ Quick Control Dial to change the setting. Alternatively, after highlighting the desired option, press **SET** to display the settings, and rotate the ◌ Quick Control Dial or use ◀ ▶ on the Multi-controller to scroll through them before pressing **SET** to confirm the selection. In either case, the displayed image will instantly reflect

any changes you make to the settings. Pressing **INFO** will return the image to its original settings.

5) Pressing the ⊕ Magnify button will enlarge the image unless the icon is grayed out. You can scroll around the image by using the ✳ Multi-controller. Press the 🞖 Index button to exit the magnified view.

6) Using ◀ ▶ and ▲ ▼ on the Multi-controller, highlight the 🖳 Save icon. Press **SET**.

7) Using the ◌ Quick Control Dial or ◀ ▶ on the Multi-controller, highlight **OK** in the dialog box. Press **SET** to save the processed image. Note the destination folder and file number before selecting **OK**.

8) To process other images, repeat steps 3–6.

9) To exit and return to ▶ Playback Menu 1, press **MENU**.

> **Note:**
> RAW images shot with a Live View aspect ratio will be displayed in the respective dimensions. JPEG images will be saved in the set aspect ratio.

RAW image processing options

☀±0 Brightness

For adjusting the image brightness up to +/- 1 stop in ¹/₃ increments.

◘AWB White balance

For selecting the white balance settings. By selecting **K**, you can adjust the color temperature by rotating the ⚙ Main Dial.

◘ Picture Style

For selecting the Picture Style settings. To alter the parameters, highlight **Picture Style** and press **SET**. Rotate the ⚙ Main Dial to highlight the desired Picture Style, and then rotate the ◯ Quick Control Dial to highlight one of the parameters. Rotate the ⚙ Main Dial once more to adjust the parameter setting. Press **SET** to confirm the setting and return to the processing screen.

◘ Auto Lighting Optimizer

For selecting the Auto Lighting Optimizer settings.

NR Lu High ISO speed noise reduction

For setting the noise reduction level on images using high ISO speeds. Use the ⊕ Magnify button to enlarge the image and check for noise.

▲L Quality

For setting the pixel count and image size of the saved JPEG image when converting

from **RAW**. (The image size displayed is for a 3:2 aspect ratio.)

sRGB Color space

For selecting either sRGB or Adobe RGB as the color space. The LCD monitor is not compatible with Adobe RGB, so any change to the color space will not be reflected on the displayed image.

□OFF Peripheral illumination correction

For enabling or disabling Peripheral illumination correction.

⊞OFF Distortion correction

For enabling or disabling distortion correction. If enable is set, the lens distortion will be corrected and the image trimmed, making the displayed shot appear larger than before. The Digital Photo Professional software provided will give better results than the in-camera processing.

╱OFF Chromatic aberration correction

For enabling or disabling chromatic aberration correction. If enable is set, chromatic aberration (see page 161) will be corrected and the image trimmed, making the displayed picture appear larger than before. The Digital Photo Professional software provided will give better results than the in-camera processing.

» PLAYBACK MENU 2

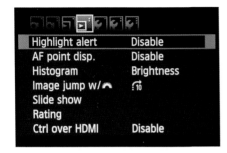

Playback menu 2 is color-coded blue.

› Highlight alert

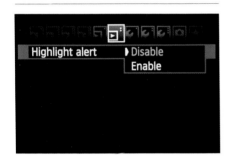

With Highlight alert enabled, overexposed highlights will flash on recorded images. To obtain more detail in the highlights, you can set Exposure compensation to a negative amount before shooting again.

1) Press **MENU**. Rotate the ⚙ Main Dial or use ◄► on the Multi-controller to highlight the ▶ Playback Menu 2 tab.

2) Rotate the ◯ Quick Control Dial or use ▲▼ on the Multi-controller to select **Highlight alert**. Press **SET**.

3) Rotate the ◯ Quick Control Dial or use ▲▼ on the Multi-controller to highlight **Enable** or **Disable**. Press **SET**.

› AF point display

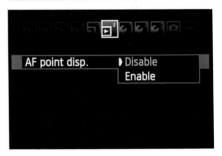

When AF point display is enabled, reviewed images will display the AF points that achieved focus at the time of shooting. To select this function, follow the same process as above for Highlight alert.

› Histogram

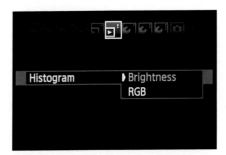

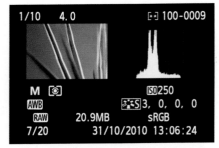

If you press the **INFO** button while an image is being viewed on the LCD monitor, a new screen will appear displaying a thumbnail version of the picture alongside useful shooting information. One part of this information is a histogram. By selecting the Histogram menu function, you can choose which type of histogram is displayed (either a Brightness histogram or an RGB histogram). Learning how to interpret these histograms will enable you to fine-tune your exposures. To select this feature, *see page 82.*

Using the Brightness histogram

The Brightness histogram is a graph showing the overall exposure level of an image. The horizontal axis shows the brightness level of the image, with its darkest level on the left and its brightest level on the right. Generally speaking, if the majority of peaks are to the left, then the image may be underexposed. Conversely, if the majority of the peaks are to the right, then the image may be overexposed. The vertical axis shows how many pixels exist for each level of brightness. If there are too many pixels on the far left, shadow detail may be lost. If too many pixels gather on the far right, the detail in the highlights may be lost.

› Setting the Image jump function

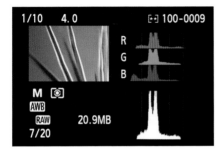

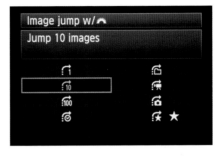

Using the RGB histogram

The RGB histogram is a graph showing the separate brightness levels of Red, Green, and Blue in an image. The horizontal axis shows the brightness level of each color in the image, with its darkest level on the left and its brightest level on the right. The vertical axis shows how many pixels exist for each level of brightness in each color. If there are too many pixels on the far left, then that particular color will be darker and less intense. If there are too many pixels on the far right, then the respective color will be brighter, but may lose detail through over-saturation.

When reviewing single images in Playback, you can jump more than one file at a time by rotating the ⌘ Main Dial. The method of jumping will depend on what is set in ▶ Playback Menu 2 via the **Image jump w/** ⌘ feature. To select this feature, *see page 82.*

You can choose to:
- Display images one by one
- Jump 10 images
- Jump 100 images
- Display by date
- Display by folder
- Display movies only
- Display stills only
- Display by image rating (Rotate the ⌘ Main Dial to select the rating.)

2

› Slide show

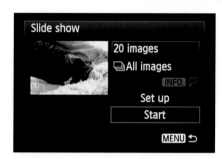

Images stored on the memory card can be viewed as a slide show.

1) Press **MENU**. Rotate the ⚙ Main Dial or use ◄► on the Multi-controller to highlight the ▶ Playback Menu 2 tab.

2) Rotate the ◯ Quick Control Dial or use the ▲ ▼ on the Multi-controller to highlight **Slide show**. Press **SET**.

3) Rotate the ◯ Quick Control Dial or use ▲ ▼ on the Multi-controller to highlight **All images**. Press **SET**.

4) Rotate the ◯ Quick Control Dial or use ▲ ▼ on the Multi-controller to select one of the desired options from ▣ All images, ▦ Date, ▪ Folder, ▐▇ Movies, ▣ Stills, or ★ Rating.

5) The ▦ Date, ▪ Folder, and ★ Rating options will allow you to press the **INFO**

button to specify which date, folder, or image rating you want to include in the slideshow.

6) Once you have selected the desired category for the slideshow, press **SET**.

7) Rotate the ◯ Quick Control Dial or use ▲ ▼ on the Multi-controller to select **Set up**. Press **SET**. Now you can set the still image Display time for **1**, **2**, **3**, **5**, **10**, or **20** seconds; **enable** or **disable** Repeat to make the slideshow continuous; select one of the Transition effects from **Off**, **Slide in**, **Fade 1**, or **Fade 2**. Press **MENU** to confirm the settings.

8) Rotate the ◯ Quick Control Dial or use ▲ ▼ on the Multi-controller to select **Start**. Press **SET**. The message **Loading image...** will appear and then the slideshow will begin.

9) To pause the slideshow, press **SET**. During pause, rotate the ◯ Quick Control Dial to scroll through still images. Press **SET** again to resume.

10) Press **MENU** to stop the slideshow and return to the setting screen.

> **Note:**
> During the slideshow, Auto power off will not occur.

› Rating images

Rating images makes it easy to group them together and select them for different functions. It is possible to give one of five ratings: [*], [**], [***], [****], or [*****].

1) Press **MENU**. Rotate the 🔆 Main Dial or use ◀▶ on the Multi-controller to highlight the ▶' Playback Menu 2 tab.

2) Rotate the ◯ Quick Control Dial or use ▲▼ on the Multi-controller to highlight **Rating**. Press **SET**.

3) Rotate the ◯ Quick Control Dial or use ◀▶ on the Multi-controller to scroll through the images or movies.

4) Press the ▦ Index button to display three images at once. Press the ⊕ Magnify button to return to a single image.

5) Use ▲▼ on the Multi-controller to give the image a rating. A running total of

the number of images in each rating will be recorded along the top of the screen.

6) To rate other images or movies, repeat steps 3–5.

7) Press **MENU** to exit and return to the menu.

> **Note:**
> The number of images and movies counted for each rating will only go up to 999. Beyond this figure, ### will be displayed.

› Control over HDMI

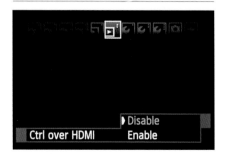

You can use HDMI cable HTC-100 (available separately) to play images on an HD TV. To use this feature, *see page 241.*

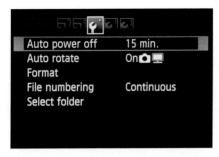

The Set-up menus are color-coded yellow. To set options in 🖐 Set-up menu 1:

1) Press **MENU**. Rotate the Main Dial or use ◀▶ on the Multi-controller to highlight the 🖐 Set-up menu 1 tab.

2) Rotate the ◯ Quick Control Dial or use ▲▼ on the Multi-controller to highlight the desired item. Press **SET** to select it.

3) When a secondary menu or dialog box appears, rotate the ◯ Quick Control Dial or use ▲▼ on the Multi-controller to highlight your selection. Press **SET** to save it.

4) Press **MENU** to go back one level.

› Auto power off

To save the battery, the camera can switch off after 1–30 minutes, or can remain on by selecting this feature **Off**. To restore power after switch-off, press the shutter-release button. To select this feature, *see page 82*.

› Auto rotate vertical images

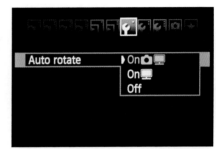

Portrait images can be rotated to appear correctly oriented on the 📷🖥 computer and camera LCD monitor, or on the 🖥 computer only. Selecting **Off** will disable the function. To select this feature, *see page 82*.

› Formatting the card

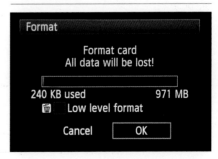

Formatting a memory card will remove all of the data, making it a fast way of deleting files. To use this feature, *see pages 34–5*.

› File numbering

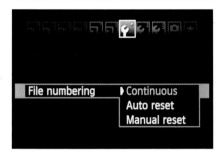

New photographs are allocated a sequential file number from 0001 to 9999 and stored in a folder. Following the file number, the suffix is .JPG for JPEG, .CR2 for RAW, and .MOV for movie. When a folder contains 9999 images, a new folder is created, with the first image in that folder reverting to 0001. The EOS 60D offers three numbering options (to select, *see page 82):.*

Continuous The sequence continues even if you replace the memory card or create a new folder.
Auto reset When a memory card is replaced or a folder created, file numbering restarts from 0001.
Manual reset A new folder is created and returns to Continuous or Auto reset file numbering. Any new images captured will be placed in the new folder, starting with a file number of 0001.

Common error

When the file numbering system is set to Continuous or Auto reset, inserting a memory card with images already stored on it may cause the camera to continue the sequential file numbering from the last image shot on that card. To avoid this, ensure the replacement memory card has been formatted.

› Creating and selecting a folder

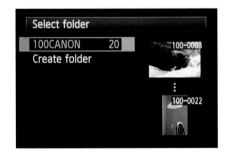

You can create new folders in which to store images—when there is more than one folder, you can select which one receives each new picture. To the right of each folder, the number of images contained will be displayed, along with pictures of the lowest and highest file numbered images in that folder. To select this feature, *see page 82.*

2 » SET-UP MENU 2

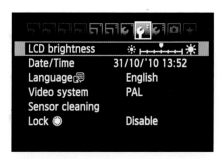

› LCD brightness

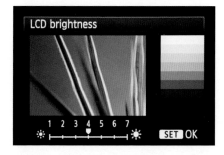

Selecting this function displays three items: a grayscale, a slider control, and the last image recorded. By rotating the ◯ Quick Control Dial or using ◀ ▶ on the Multi-controller, you can move the arrow along the slider to make the LCD monitor lighter or darker. Observe the changes in the displayed image and set the preferred level. To select this feature, *see page 82,* highlighting the ♥ˀ Set-up menu 2 tab instead.

› Setting the Date and Time

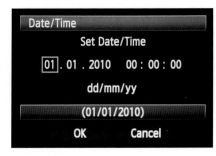

The first time you turn the power switch **ON**, the Date/Time screen will appear. To set this feature, *see page 33.*

› Setting the Language

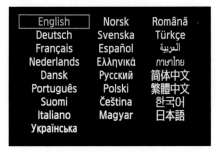

There are 25 interface languages on the EOS 60D. To set this feature, *see page 34.*

› Setting the Video system

This enables you to set the video system to match your TV and display images correctly. Choose PAL or NTSC. To select, *see page 82*, highlighting the ♈ Set-up menu 2 tab.

› Sensor cleaning

The low-pass filter of the EOS 60D is fitted with a Self Cleaning Sensor Unit. This function can be disabled, or manually activated. To use this feature, *see pages 245–6*.

› Locking the Quick Control Dial

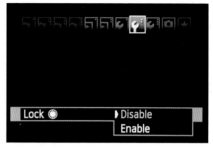

To prevent the Quick Control Dial from being knocked out of place—potentially altering exposure settings—it can be locked. To use this feature, *see page 33*.

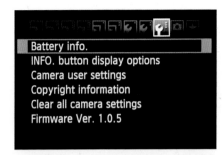

› Battery information

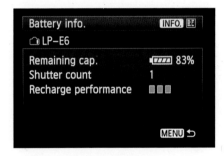

This function allows you to check the current condition of the battery.

1) Press **MENU**. Rotate the Main Dial or use ◀▶ on the Multi-controller to highlight the ♥⁼ Set-up menu 3 tab.

2) Rotate the Quick Control Dial or use ▲▼ on the Multi-controller to highlight **Battery info**. Press **SET**.

Remaining cap. displays the remaining capacity of the battery in 1% increments.

Shutter count keeps track of the shots taken with the current battery. When the battery is recharged, the count is reset to 0.

Recharge performance measures the recharging ability of the battery in three performance levels. When only a single bar is lit in red, buying a new battery is recommended.

Registering the battery to the camera:

You can register up to six LP-E6 batteries to the camera, making it easier to keep track of the recharge history, without having to insert each and every battery.

1) Follow steps 1–2 under Battery Information, left. Press **INFO** to display the battery history screen. An unregistered battery will be grayed out.

2) Highlight **Register** and press **SET**.

3) Rotate the Quick Control Dial or use ◀▶ on the Multi-controller to highlight **OK** in the dialog box. Press **SET**.

4) The battery is now registered, with its information colored white.

Checking the battery recharge history:

An adhesive label with the battery's internal serial number can be attached to the relevant unit to help match the information on the screen to the battery. Write the serial number displayed on the battery history screen in step 1 (left) on a label measuring approximately 1 x 0.6in. Attach the label to the bottom end of the battery—the side that has no electrical contacts.

You can now check the recharge history and remaining capacity of any registered battery without having to insert it in the camera. To do this, match the serial number on the label to the battery on the battery history screen, which will give the remaining capacity and the date when it was last used.

Deleting the registered battery information:

1) Press **MENU**. Rotate the ⌂ Main Dial or use the ◄► on the Multi-controller to highlight the ♀ Set-up menu 3 tab.

2) Rotate the ⊙ Quick Control Dial or use ▲▼ on the Multi-controller to highlight **Battery info**. Press **SET**.

3) Press **INFO** to display the battery history screen, and highlight **Delete**. Press **SET**.

4) Highlight the battery pack to be deleted and press **SET** to make a check mark appear. Repeat for each battery you wish to delete.

5) Press the 🗑 Erase button. Highlight **OK** in the dialog box and press **SET** to unregister the battery.

Warning!

To avoid malfunction, always use Battery Pack LP-E6 in your EOS 60D.

2

› Button display options

Pressing the **INFO** button when ready to shoot cycles through up to three displays on the LCD: camera settings, shooting functions, and the Electronic level. This function setting determines which displays appear.

1) Press **MENU**. Rotate the 🗦 Main Dial or use ◄► on the Multi-controller to highlight the ♥³ Set-up menu 3 tab.

2) Rotate the ⊙ Quick Control Dial or use ▲ ▼ on the Multi-controller to select **INFO. Button display options**. Press **SET**.

3) Rotate the ⊙ Quick Control Dial or use ▲ ▼ on the Multi-controller to highlight the desired option. Press **SET** to add or remove a check mark. Press the **INFO** button to display checked options.

4) Rotate the ⊙ Quick Control Dial or use ▲ ▼ on the Multi-controller to highlight **OK** and press **SET** to return to the menu.

› Camera settings

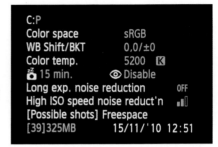

The Camera settings screen displays from top to bottom: the shooting mode registered to **C** on the Mode Dial, Color space, White balance Shift /Bracketing, Color temperature, Auto power off, Red-eye reduction, Long exposure noise reduction, High ISO speed noise reduction, the number of shots left on the card, the space available on the card in MB or GB, and the date and time.

2

› Shooting settings

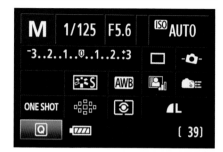

› Electronic level

In the Creative Zone, this screen displays all the relevant shooting settings of the camera. Pressing the **AF**, **DRIVE**, **ISO**, ⊡, or ⊞ buttons will bring up the respective menu screens for setting AF and Drive modes, ISO, Metering mode, and AF point selection. Rotate the ⚙ Main Dial or ◯ Quick Control Dial, or use ◄► on the Multi-controller to change the settings. You can also change the selected AF point with the ✳ Multi-controller. Pressing the **Q** button will make the Quick Control screen appear.

The Electronic level displays two lines across the LCD monitor. The red line reflects the tilt of the camera in 1° increments; the gray line represents horizontal. When the two lines match, a single green line will appear to indicate the camera is level. This function is especially useful for straightening horizons or when setting the camera on a tripod. A simplified electronic level can also be displayed in the Viewfinder and LCD panel when C.Fn IV-2 is set to option 5 *(see page 134)*.

> **Note:**
> If you turn the power off while the Shooting settings screen is displayed, the same screen will appear when the power is turned back on again. To prevent this, press the **INFO** button to turn off the display before turning off the power.

Warning!

Even when the Electronic level turns green and the tilt is corrected, there is still a +/- 1° margin of error.

› Camera user settings

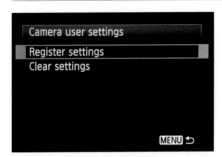

Registering Camera user settings

1) Most current camera settings, and most menu functions, can be registered to **C** on the Mode Dial. Check the shooting mode, shutter speed, aperture, ISO speed, AF point, metering mode, drive mode, Exposure compensation, and Flash exposure compensation.

2) Press **MENU**. Rotate the 🔆 Main Dial or use ◄► on the Multi-controller to highlight the ♥³ Set-up menu 3 tab.

3) Rotate the ○ Quick Control Dial or use ▲ ▼ on the Multi-controller to highlight **Camera user settings**. Press **SET**.

4) Rotate the ○ Quick Control Dial or use ▲ ▼ on the Multi-controller to highlight **Register settings**. Press **SET**.

5) Highlight **OK** in the dialog box and press **SET** to register the camera settings.

Clearing the Camera user settings

1) Press **MENU**. Rotate the 🔆 Main Dial or use ◄► on the Multi-controller to highlight the ♥³ Set-up menu 3 tab.

2) Rotate the ○ Quick Control Dial or use ▲ ▼ on the Multi-controller to highlight **Camera user settings**. Press **SET**.

3) Rotate the ○ Quick Control Dial or use ▲ ▼ on the Multi-controller to highlight **Clear settings**. Press **SET**.

4) Highlight **OK** in the dialog box and press **SET** to return **C** on the Mode Dial to the default setting.

› Copyright information

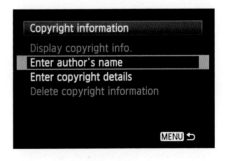

Set your copyright information and have it added to the EXIF (Exchangeable Image File Format) data of all images.

1) Press **MENU**. Rotate the ⚙️ Main Dial or use ◀▶ on the Multi-controller to highlight the 🔧 Set-up menu 3 tab.

2) Rotate the ◯ Quick Control Dial or use ▲▼ on the Multi-controller to highlight **Copyright information**. Press **SET**.

3) Rotate the ◯ Quick Control Dial or use ▲▼ on the Multi-controller to highlight **Enter author's name** or **Enter copyright details**. Press **SET**. A screen will appear for adding text.

Text entry procedure
1) Press **Q** to toggle between the text box and "keyboard."

2) Rotate the ◯ Quick Control Dial or use ◀▶ on the Multi-controller to move the cursor.

3) In the "keyboard" area, use ◀▶ or ▲▼ on the Multi-controller to highlight a character (up to 63 characters). Press **SET** to select it. Press 🗑 to delete a character.

4) Press **MENU** to confirm text entry and return to the Copyright information screen. Press **INFO** to cancel text entry and return to the Copyright information screen.

5) Select **Display copyright info.** to check the information. To delete the information, select **Delete copyright information** then **OK** in the dialog box.

› Clearing all camera settings

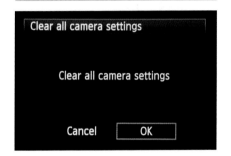

All of the camera's settings can be reset to default by using this function.

1) Press **MENU**. Rotate the ⚙️ Main Dial or use ◀▶ on the Multi-controller to highlight the 🔧 Set-up menu 3 tab.

2) Rotate the ◯ Quick Control Dial or use ▲▼ on the Multi-controller to highlight **Clear all camera settings**. Press **SET**.

3) Highlight **OK**. Press **SET**. The camera will return to the default settings.

» CUSTOM FUNCTIONS MENU

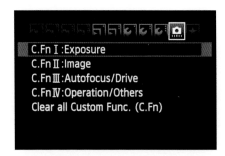

The Custom Functions menu allows you to fine-tune the way the camera works in the Creative Zone modes. The functions are divided into four groups covering Exposure, Image, Autofocus/Drive, and Operation/Others. Each group is abbreviated to C.Fn and allocated a figure in the form of a Roman numeral: C.Fn I, C.Fn II, and so on. Within each group are the custom options, and each option is given a figure referring to its respective position: C.Fn III-4, for example. There are many different functions, but the procedure for setting them is always the same and is detailed below.

1) Press **MENU**. Rotate the 🗇 Main Dial or use ◄► on the Multi-controller to highlight the 🗖 Custom Functions menu tab.

2) Rotate the 🗇 Quick Control Dial or use ▲▼ on the Multi-controller to highlight C.Fn I, C.Fn II, C.Fn III, or C.Fn IV. Press **SET** to select one and display the respective sub-menus.

3) Rotate the 🗇 Quick Control Dial or use ◄► on the Multi-controller to scroll through the various sub-menus. The number of the sub-menu will appear in the top right corner as it is selected. Press **SET** to enter one of the sub-menus.

4) Rotate the 🗇 Quick Control Dial or use ▲▼ on the Multi-controller to highlight the desired setting and press **SET** to select it. At the bottom left of the screen, the selected setting is displayed beneath the relevant sub-menu number.

5) Press **MENU** to exit and return to the main Custom Functions menu.

To reset all of the Custom Functions to the default setting, select **Clear all Custom Func. (C.Fn)** in step 2. Highlight **OK** in the dialog box and press **SET** to confirm.

› C.Fn I: Exposure

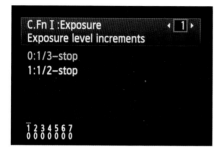

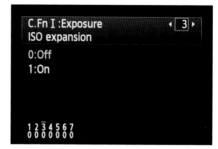

C.Fn I-1 Exposure level increments

This function allows you to select $^1/_3$- or ½-stop increments for the exposure settings. To set, follow the procedure on *page 128*.

C.Fn I-3 ISO expansion

The normal ISO range for the EOS 60D is 100–6400, but it can be expanded to ISO 12,800 (symbol H) when this function is switched to **On**. To set, *see page 128*.

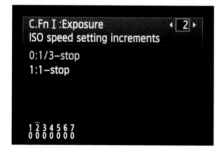

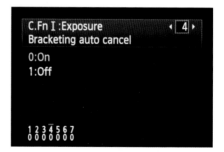

C.Fn I-2 ISO speed setting increments

This function allows you to select $^1/_3$- or 1-stop increments for ISO speed settings. To set this option, follow the procedure on *page 128*.

C.Fn I-4 Bracketing auto cancel

With this function set to **On**, Autoexposure Bracketing and White balance Bracketing are canceled if the camera is turned off or the settings are cleared. AEB will be canceled just

before the flash is fired or when Movie mode is selected. When set to **Off**, the AEB and WB-BKT settings will be retained even if the camera is switched off, though AEB will still be canceled, if only temporarily, before the flash is fired. To set, *see page 128*.

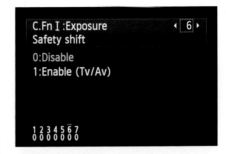

C.Fn I :Exposure ‹ 6 ›
Safety shift

0:Disable
1:Enable (Tv/Av)

1 2 3 4 5 6 7
0 0 0 0 0 0 0

C.Fn I-6 Safety shift

Tv Shutter Priority and **Av** Aperture Priority modes only, enabling automatic adjustment to exposure if lighting conditions change. To set, follow the procedure on *page 128*.

C.Fn I :Exposure ‹ 5 ›
Bracketing sequence

0:0, −, +
1:−, 0, +

1 2 3 4 5 6 7
0 0 0 0 0 0 0

C.Fn I-5 Bracketing sequence

This function allows you to choose the order of the bracketing sequence for AEB and WB-BKT. Selecting 0 for AEB captures the correct exposure first, followed by the under- and overexposed images. For WB-BKT, it captures a standard White balance image, followed by the Blue or Magenta bias, then the Amber or Green bias. Selecting 1 captures the images in order of exposure value. For WB-BKT, it produces an image with a Blue or Magenta bias first, then the White balance image, and finally the Amber or Green bias image. To set, *see page 128*.

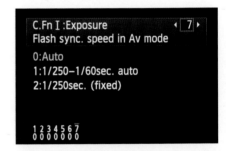

C.Fn I :Exposure ‹ 7 ›
Flash sync. speed in Av mode

0:Auto
1:1/250–1/60sec. auto
2:1/250sec. (fixed)

1 2 3 4 5 6 7
0 0 0 0 0 0 0

C.Fn I-7 Flash sync. Speed/Av mode

Av Aperture Priority mode and use of flash only. On Auto, sync speed is set between 1/250sec. and 30sec. but can be limited to 1/60sec. (option 1). Option 2 fixes sync speed at 1/250sec. To set, *see page 128*.

› C.Fn II: Image

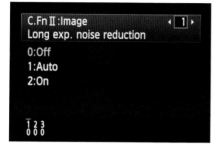

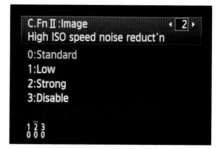

C.Fn II-1 Long exposure noise reduction

The default setting for this function is **Off**. When Auto is selected, the camera applies noise reduction to images with a 1sec. or longer exposure, provided it detects noise in the image. When **On** is selected, noise reduction is applied to any exposure of 1sec. or longer. To set this option, follow the procedure on *page 128.*

C.Fn II-2 High ISO speed noise reduction

This function applies noise reduction to all ISO speeds, but is most effective at high sensitivities. To use this feature, *see page 128.*

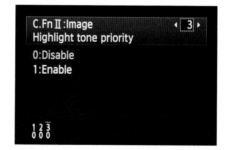

Warning!

Noise reduction is applied after the image has been captured, effectively doubling the recording time. Only when the noise reduction process is completed will you be able to take another picture.

C.Fn II-3 Highlight tone priority

Enabling this function will improve highlight detail by expanding the dynamic range, but it may increase noise. To set this option, *see page 128.*

› C.Fn III: Autofocus/Drive

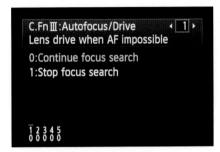

C.Fn III-1: Lens drive when AF impossible

If the autofocus system struggles to "lock" on a subject, this feature instructs the camera to continue trying to focus, or to stop. The stop setting is useful for super telephoto lenses. To set, *see page 128.*

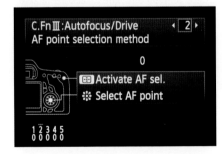

C.Fn III-2: AF point selection method

This function offers two ways to set an AF point. If you select option 0, you will need to press the button to activate AF point selection. Rotating the Main Dial or Quick Control Dial, or using the Multi-controller will then select the desired AF point. With option 1 selected, the AF point can be set by the Multi-controller without pressing the button first. The button is used instead for switching to automatic AF point selection. To set this option, follow the procedure on *page 128.* This function can also be set via the Quick Control screen, under Custom Controls.

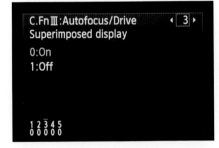

C.Fn III-3: Superimposed display

This function switches the lighting of AF points on or off when focusing. The **Off** setting stops the AF points from lighting up in the viewfinder when focus is achieved. However, AF points will still light up when being selected. To set this option, follow the procedure on *page 128.*

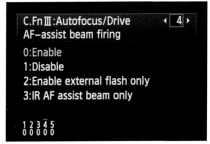

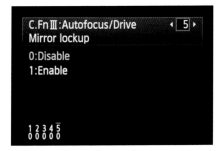

C.Fn III-4: AF-assist beam firing

This function selects where the AF-assist beam is emitted. With **Enable** selected, either the built-in flash or an attached EX Speedlite will use the AF-assist beam to aid focusing. If **Disable** is selected, neither will use it. Options 2 and 3 will favor an EX Speedlite over the built-in flash, with option 3 specifying an EX Speedlite with infrared AF-assist beam. To set this option, follow the procedure on *page 128*.

C.Fn III-5: Mirror lockup

Vibrations can be caused by the reflex mirror flipping up during shooting. To prevent this, **Enable** Mirror lockup. Focus, frame, and set the exposure before pressing the shutter-release button. The mirror will swing up and lock into place. Press the shutter-release button for a second time to take the picture and release the mirror. Continuous shooting cannot be used with Mirror lockup. The Remote switch RS-60E3 or remote controller can be used to further reduce the risk of vibration. To set this option, *see page 128*.

Warning!

Bright sunlight can scorch and damage the shutter curtains when using mirror lockup. Take the picture quickly when this function is engaged, and do not point the camera directly at the sun.

› C.Fn IV: Operation/Others

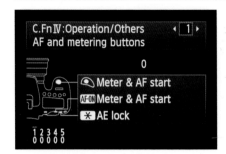

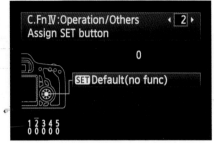

C.Fn IV-1: AF and metering buttons

This sub-menu assigns functions to the halfway pressing of the shutter-release button, **AF•ON** button, and ✱ button. Metering and AF start, AE lock, Metering start, AF stop, and No function can be assigned in one of 10 possible combinations. To set this option, follow the procedure on *page 128*. This function can also be set on the Quick Control menu, under Custom Controls.

C.Fn IV-2: Assign SET button

Frequently used shooting functions can be assigned to the **SET** button for easy access. Choose between **Image quality**, **Picture Style**, **White balance**, **Flash exposure compensation**, and **Viewfinder**. Pressing **SET** will display the function on the LCD monitor, except for Viewfinder, which will display the simplified Electronic level in the viewfinder and on the LCD panel. To set this option, follow the procedure on *page 128*. This function can also be set on the Quick Control menu, under Custom Controls.

Warning!

If C.Fn III-2-1 AF point selection method is set, the Assign SET button setting will be disabled.

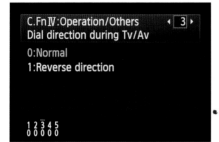

C.Fn IV-3: Dial direction during Tv/Av

Use this function to reverse the turning direction of the 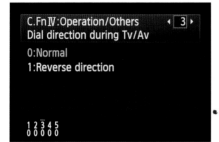 Main Dial when setting the shutter speed and aperture. In Manual mode, the effects of rotating both the Main Dial and Quick Control Dial are reversed. To set this option, follow the procedure on *page 128*.

C.Fn IV-4: Focusing Screen

If you change the focusing screen *(see page 228)*, you can select the new one being used via this sub-menu *(see page 128)*.

C.Fn IV-5: Add image verification data

Enabling this function will add data to each new image. To verify the originality of an image, the Original Data Security Kit OSK-E3 must be used. To set, *see page 128*.

Notes:
The following Custom Functions do not take effect during Live View: C.Fn III-2 AF point selection method, C.Fn III-3 Superimposed display, C.Fn III-5 Mirror lockup, C.Fn IV-2-5 Assign SET button–Viewfinder, and C.Fn IV-4 Focusing Screen.

Custom Functions do not apply to movie shooting.

Chapter 3
SHOOTING MOVIES

3 SHOOTING MOVIES

Budding filmmakers will be delighted to discover that the EOS 60D offers Standard and Full HD (High Definition) movie capabilities.

Providing both automatic and manually adjustable settings, movie mode has a maximum recording time of 29min. and 59sec. (depending on file size, internal temperature of the camera, and the capacity of the memory card). For maximum quality, it's best to use an SD card of Speed Class 6 or higher. Using a card with a slow writing speed will result in a five-level indicator appearing on the LCD screen during shooting. This illustrates how much data is waiting to be written to the card. If the indicator becomes full, the camera will cease shooting automatically. To avoid camera shake, it's best to use a tripod when the EOS 60D is set to ▶🎥 Movie mode.

» MOVIE MODE

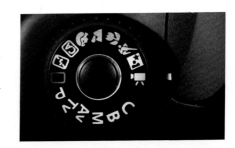

› Autoexposure shooting

The camera automatically sets the ISO, shutter speed, and aperture, making this the ideal setting for beginners.

1) Turn the Mode Dial to ▶🎥 Movie mode. You will hear the sound of the mirror flipping up, and shortly afterwards a "live" image will appear on the LCD monitor.

2) Select one of the focusing modes: Live mode, Face Detection Live Mode ☺, Quick mode, Manual focus. You can also use the **AF-ON** button to focus. Continuous focusing is not possible in Movie mode.

3) Press the shutter-release button halfway to focus. A green rectangle will appear on the LCD monitor when focus

Warning!

Prolonged use of the ▶🎥 Movie mode can cause the internal temperature of the camera to increase. When levels are high, a white icon will appear on the screen advising you to stop shooting. If the red icon appears and begins to blink, the camera is too hot and movie shooting will cease. In both instances, it is advisable to switch off the camera and allow it to cool down before you resume.

has been achieved. In addition, you will hear a beep sound.

4) To start shooting a movie, press the ⬛ Movie Shooting button. While the movie is "live," a red dot will appear in the top right-hand corner of the monitor.

5) To stop the movie, press the ⬛ Movie Shooting button again.

> **Note:**
> By rotating the ⬭ Quick Control Dial in Autoexposure shooting mode, you can set Exposure compensation *(see page 93)*. By pressing the ✱ AE lock button, you can also use Auto Exposure (AE) lock. To cancel this function, press the ⊞ AF point selection button while shooting the movie.

› Manual exposure shooting

This advanced setting allows you to adjust the ISO, shutter speed, and aperture manually. Any changes to the exposure will be recorded in the movie clip, so try not to adjust these settings once the movie is underway. If you use a zoom lens with a maximum aperture that changes with the focal length, avoid zooming the lens while shooting the movie.

1) Turn the Mode Dial to 🎥 Movie mode. You will hear the sound of the

FAIRGROUND ATTRACTION　　　　　　　　⌃
Using the Manual Exposure shooting feature in 🎥 Movie mode allows you to adjust shutter speed and aperture—ideal for situations where the meter might under- or overexpose a scene.

mirror flipping up, and shortly afterwards a "live" image will appear on the monitor.

2) Press **MENU**. Use the Main Dial or ◄ ► on the Multi-controller to select 🎥 Movie Shooting menu 1.

3) Rotate the ⬭ Quick Control Dial or use ▲ ▼ on the Multi-controller to highlight **Movie exposure**. Press **SET**.

4) Rotate the ⬭ Quick Control Dial or use ▲ ▼ on the Multi-controller to highlight **Manual**. Press **SET**. Press **MENU** to return to the "live" image.

5) Use the Main Dial to adjust the shutter speed, and rotate the ⬭ Quick Control

Dial to alter the aperture. (If the ⬡ Quick Control Dial is locked, press the **UNLOCK** button to release it.)

6) Press the **ISO** button. The ISO speed setting screen will appear on the LCD monitor. Rotate the ⬡ Quick Control Dial or use ◀ ▶ on the Multi-controller to set the desired ISO speed. (In both Auto and Manual shooting modes, the ISO range is 100–6400.) Press the **ISO** button to return to the "live" image.

7) Select Live mode, Face Detection Live mode ⬚, Quick mode, or Manual focus, or use the **AF-ON** button to focus.

8) Press the shutter-release button halfway to focus. A green rectangle will appear on the LCD monitor when focus has been achieved and a beep will sound.

9) Press the 📷 Movie Shooting button. While the movie is "live" a red dot appears in the top right-hand corner of the LCD.

10) To stop the movie, press the 📷 Movie Shooting button again.

> **Note:**
> The shutter speeds available in Manual Exposure shooting mode depend on the frame rate you have selected: ⬚60 and ⬚50 will allow speeds of 1/4000–1/60sec.; ⬚30, ⬚25, and ⬚24 will allow speeds of 1/4000–1/30sec.

› **Final image simulation**

When the camera is set to 🎥 Movie mode, the Live View image will instantly reflect Picture styles, White balance alterations, exposure adjustments, changes to depth of field, the use of Peripheral illumination correction, Highlight tone priority, and the effects of the Auto Lighting Optimizer. As a result, you will have a clear idea of how the movie will look, before pressing 📷.

› **Shooting still pictures**

The EOS 60D can capture still images at the same time as shooting a movie (except in Movie crop mode). To use this feature, press the shutter-release button down fully during filming. Bear in mind that unless you use an external microphone, the sound of the shutter firing will be recorded in the movie, as will the sound of the lens moving or any dials being altered. The movie will freeze for about 1sec. while the picture is taken. The photograph and the movie will be recorded on the memory card as two separate files. In addition, you can extract a still image from a movie clip using the ZoomBrowser EX/ImageBrowser software (provided).

Shooting functions are limited for still shots in 🎥. While the drive mode can be adjusted, the built-in flash is unavailable. Auto Exposure Bracketing is canceled.

» INFORMATION DISPLAY

Pressing the **INFO** button when the camera is ready to shoot in 🎥 Movie mode cycles through up to four displays on the monitor. The first screen shows basic exposure settings; the second presents more detailed information, such as the drive and focusing mode; the third option adds a brightness histogram to the mix; and the fourth screen brings up the Electronic level (although this is unavailable when the AF mode is set to 🙂.

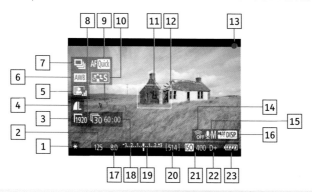

1	AE lock	13	Recording movie
2	Shutter speed	14	Eye-Fi card transmission status
3	Movie recording size	15	Recording level: Manual
4	Image-recording quality	16	Movie exposure: Autoexposure/Manual exposure
5	Auto Lighting Optimizer	17	Aperture
6	White balance	18	Movie shooting remaining time/Elapsed time (applies to a single movie clip)
7	Drive mode	19	Exposure compensation amount
8	Frame rate	20	Possible shots
9	AF mode: Live mode/Face detection Live mode/Quick mode	21	ISO speed
10	Picture Style	22	Highlight tone priority
11	AF point (Quick mode)	23	Battery check
12	Magnifying frame		

To switch between autofocus modes, press the AF button. To change the drive mode, press the DRIVE button. In both cases, the respective screens will appear; you can make adjustments by rotating the ⊙ Quick Control Dial or using ◀ ▶ on the Multi-controller, before pressing **SET**. When using the Manual Exposure Shooting function, you can adjust the ISO speed by pressing the ISO button and rotating the ⊙ Quick Control Dial, or by using ◀ ▶ on the Multi-controller, before pressing **SET**.

› Using the Quick Control Screen

Pressing the **Q** Quick Control button while the LCD monitor is reviewing a "live" image will allow you to adjust the AF mode, drive mode (still pictures), White balance, Picture Style, Auto Lighting Optimizer, image recording quality (still pictures), and movie recording size (movie clips only).

1) Press the **Q** Quick Control button. All of the functions that can be adjusted will be lit in blue. (When it is possible to select **AF Quick**, the AF points will appear on the screen.)

2) Press ▲ ▼ on the Multi-controller to select a setting to adjust.

3) Rotate the ⊙ Quick Control Dial, use ◀ ▶ on the Multi-controller, or turn the ⚙ Main Dial to alter the settings.

› Setting the movie recording size

The size of the movie and the number of frames per second (fps) can be adjusted under ▐🎥 Movie Shooting menu 2. Bear in mind that if the file size of the movie reaches 4GB, the camera will cease shooting. In addition, each of the image sizes *(see table opposite)* has a maximum single clip recording time. If the movie should stop, try pressing the 📷 to start a new movie.

1) Press **MENU**. Use the ⚙ Main Dial or ◀ ▶ on the Multi-controller to select ▐🎥 Movie Shooting menu 2.

2) Rotate the ⊙ Quick Control Dial or use ▲ ▼ on the Multi-controller to highlight **Movie rec. size**. Press **SET**.

3) Rotate the ⊙ Quick Control Dial or use ▲ ▼ on the Multi-controller to highlight the desired movie size. Press **SET**.

Movie image sizes

Image size	Description
1920 x 1080	Full HD (High Definition)
1280 x 720	HD (High Definition)
640 x 480	Standard definition (aspect ratio 4:3)
Movie crop 640 x 480	Standard definition (aspect ratio 4:3). Telephoto effect (7x)

Frames per second (FPS)	Region
60	
50	Areas where TV format is NTSC
30	
25	Areas where TV format is PAL
24	Mainly for motion pictures

Maximum recording times

Image size	Frames per second (fps)	8GB memory card
1920 x 1080	30	22min.
	25	22min.
	24	22min.
1280 x 720	60	22min.
	50	22min.
640 x 480	60	46min.
	50	46min.

When the Mode Dial is set to ▶🎥 Movie mode, three shooting menus replace three of the four still image shooting menus. To select a menu option, proceed as follows:

1) Press **MENU**. Rotate the 🎛 Main Dial or use ◀ ▶ on the Multi-controller to scroll through the menu tabs.

2) Rotate the ◯ Quick Control Dial or use ▲ ▼ on the Multi-controller to highlight the desired menu item. Press **SET**.

3) Rotate the ◯ Quick Control Dial or use ▲ ▼ ◀ ▶ on the Multi-controller to highlight the desired setting. Press **SET**.

4) You can press **MENU** at any stage to go back one level.

› Movie Shooting menu 1

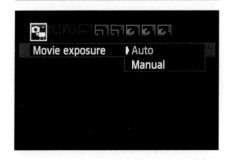

Most of the shooting operations are carried out through ▶🎥 Movie Shooting menu 1. Here you can manually adjust the

ISO, shutter speed, and aperture, as well as changing the AF mode. You can also enable the autofocus, but this feature is not recommended while shooting a clip, since it can dramatically throw the focus out and/or alter the exposure.

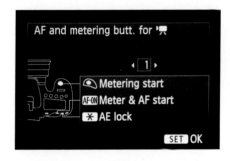

Using ▶🎥 Movie Shooting menu 1, you can also assign various functions to the shutter button (when pressed halfway), the AF start button, and the AE lock button. In addition, this menu provides access to the Highlight tone priority feature.

Tip

Once you have pressed the 📷 Movie Shooting button, the time remaining will change to the elapsed time. However, if there is insufficient space on the memory card, the time remaining will be shown in red.

› Movie Shooting menu 2

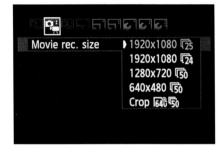

In ▶🎥 Movie Shooting menu 2, you can adjust the size of the movie and alter sound recording features. While the built-in microphone will record monaural sound, this can be avoided by using an external microphone (available separately). There are four sound recording options. The first two are Auto and Manual: in Auto mode, the camera automatically sets the sound level. In Manual mode, you can choose between 64 levels. To use this feature, select **Rec.level** and rotate the ⚙ Quick Control Dial while looking at the level indicator. When the bars on the meter reach 12 (12dB), the sound will be loudest. However, if the bars reach 0, the sound may become distorted. The final two sound recording options are **Disable**, where no noise will be recorded, and **Wind filter**, where the sound of outdoor noise (mainly wind) will be minimized.

(When there is no wind, it is best to disable this feature). In addition, this menu allows you to set Silent Shooting (for still images), as well as adjust the Metering timer (dictating how long the exposure setting appears on screen). Finally, using ▶🎥 Movie Shooting menu 2, you can select one of two Grid display options.

› Movie Shooting menu 3

The third menu, ▶🎥 Movie Shooting menu 3, provides access to Exposure compensation. (It's worth noting that for movie clips, this can only be set up to +/- 3 stops.) Here you will also find the Auto Lighting Optimizer. (However, if Highlight tone priority has been set in ▶🎥 Movie Shooting menu 1, the Auto Lighting Optimizer will be unavailable.) This menu also houses the Picture Style settings and all of the adjustable White balance features.

> **Note:**
> Movie clips can be identified on the card by the file suffix .MOV.

There are three ways to enjoy the movies you have created: you can watch them on a TV, on the camera, or on a computer.

Playback using a TV set

By using the AV cable provided (or purchasing HDMI Cable HTC-100), you can connect the camera directly to a TV set. If you have an HD (High Definition) TV set, you can use HDMI Cable HTC-100 to watch the movies in Full HD (1920 x 1080) and HD (1280 x 720), offering superior image quality.

Playback using a computer

Movies can be transferred from the camera to a computer using the USB cable provided. You can then play or edit the clips with the ZoomBrowser EX or ImageBrowser software supplied.

Playback using the camera

Movie clips can be reviewed on the LCD monitor of the EOS 60D as follows.

Playing movies

1) Press the ▶ Playback button to display the images on the LCD monitor.

2) Rotate the ◯ Quick Control Dial to select a movie to be played. A 🎬 SET Movie set icon will appear in the top left corner of the screen to indicate that the chosen file is a movie. (If you are using Index display, *see page 39*, after pressing the ▦ Index display button, you will see a perforated edge on all movie files. Press **SET** to return the index display to a single image, otherwise the movie will not play.)

3) Press **SET** on the single image display to make the movie playback panel appear at the bottom of the screen.

4) Rotate the ◯ Quick Control Dial to select the ▶ Play icon. Press **SET** to play the movie. Press **SET** again if you want to pause the movie at any time. Rotate the ♒ Main Dial to adjust the volume.

Function		Description
↺	Exit	Returns to single-image display.
▶	Play	Pressing **SET** toggles between play and pause.
▮▶	Slow motion	Adjust the slow-motion speed by turning the ◯ Quick Control dial. The slow-motion speed is indicated on the upper right.
◄◄	First frame	Displays the movie's first frame.
◄◗◗	Previous frame	Each time you press **SET**, a single previous frame is displayed. If you hold down **SET**, it will rewind the movie.
◗◗▶	Next frame	Each time you press **SET**, the movie will play frame by frame. If you hold down **SET**, it will fast-forward the movie.
▶▶◗	Last frame	Displays the movie's final frame.
✂	Edit	Displays the editing screen.
▬▬▬▬▬		Playback position.
mm' ss"		Playback time.
�📶	Volume	Adjust the built-in speaker's volume by turning the ⚙ dial.

› Movie editing

You can edit the length of a clip by removing footage at the start or end of the movie (in 1sec. increments).

1) Follow steps 1–3, left.

2) On the movie playback screen, rotate the ◯ Quick Control Dial to highlight the ✂ Editing icon. Press **SET**.

3) Rotate the ◯ Quick Control Dial to select either ◱ Cut beginning or ◲ Cut end. Press **SET**.

4) To select the part to cut, either rotate the ◯ Quick Control Dial to move through frame by frame or use ◄ ▶ on the Multi-controller to fast forward. Press **SET** to confirm the cut point.

5) To check the edited movie, rotate the ◯ Quick Control Dial to highlight ▶ Play icon. Press **SET**.

6) To make fresh adjustments to the movie, repeat steps 3 and 4. To cancel the edits, select ↺, highlight **Cancel**, and press **SET**.

7) To save the movie, highlight ⏏ and press **SET**. To save it as a new movie, highlight **New file**. To save it and replace the original movie, highlight **Overwrite**. Press **SET** to confirm.

Chapter 4
IN THE FIELD

4 IN THE FIELD

Successful photographs are a mixture of technical ability and creative input. While modern technology provides us with the tools to take sharper, punchier pictures, how we use those tools will depend on personal style and vision. Before we release the shutter, we need to determine what attracted us to the subject in the first place; then, and only then, can we use technology to bring out those elements.

Developing a creative eye comes from studying the work of other artists, whether painters, photographers, or musicians. Each discipline requires precision, technical ability, and, most of all passion. There is much to be learned from observing the reaction we have to a piece of art or music, regardless of whether it is positive or negative. By understanding what pricks our emotions, we can bring this knowledge to our own photography, helping us to develop a personal style.

To communicate our vision, we need to become familiar with the tools at our disposal—just as a painter knows which brush to use to create a certain effect, a successful photographer knows which lens, aperture, and shutter speed will best deliver his/her message. In time, this choice becomes instinctive.

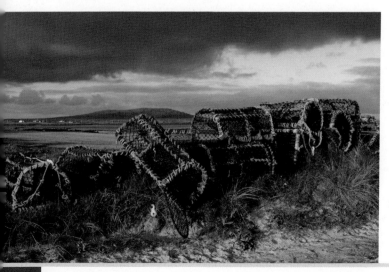

APPROACHING ≪ STORM
To convey the drama of an approaching storm over North Uist in Scotland, I adopted a low viewpoint and allowed the sky to occupy almost half of the frame.

» DEPTH OF FIELD

SHALLOW DEPTH OF FIELD ⌃
By using a wide aperture (f/4), depth of field is reduced, throwing the background out of focus.

EXTENSIVE DEPTH OF FIELD ⌃
By using a narrow aperture (f/22), depth of field is increased, bringing the background into focus.

Depth of field is a term applied to the area of acceptable sharpness within a photograph. Only the element you have chosen to focus on—and anything else that falls on the same plane—will be perfectly sharp, but an area in front of and behind your subject will also appear to be sharp. The range of sharpness depends on the aperture of the lens, the chosen focal point, the subject-to-camera distance, and the focal length of the lens.

A wide aperture (indicated by a low f-number) will generally result in shallow depth of field, whereas a narrow aperture (indicated by a high f-number) will result in extensive depth of field. The exact point at which you focus the lens will not increase or decrease depth of field per se, but it will affect where the acceptable zone of sharpness begins and ends. The closer you are to the subject, the less depth of field you will obtain in your pictures, and vice

versa. The longer your lens (in terms of focal length), the shallower the depth of field, whereas the shorter your lens, the more extensive the depth of field.

Depth of field extends from about one-third in front of the point you choose to focus on to roughly two-thirds behind it. There may be occasions when you want to maximize the depth of field without changing the aperture, subject-to-camera distance, or the focal length of the lens. In these instances, try focusing roughly one-third from the bottom of the frame for optimum depth of field.

Thankfully, determining depth of field is not a matter of guesswork. The EOS 60D features a depth-of-field preview button, which allows you to see exactly what is in focus. In addition, many lenses have a distance scale on the lens barrel, to help you make an assessment.

» CAPTURING MOTION

Conveying a sense of movement in your photographs requires anticipation, solid technique, quick reactions, and a willingness to experiment. There are three main ways to suggest motion: freezing, blurring, and panning. When faced with an action sequence, it's easy to respond by selecting a fast shutter speed (or selecting the Sports mode, *see page 54*) to freeze the motion, but this is not always the best solution. The human eye views movement as a flowing sequence, therefore to isolate one part of this sequence and freeze it can make the subject appear static. Try to visualize the effects of freezing, blurring, and panning before making a decision on how to shoot a moving subject. If the action really can't be described in a single photograph, consider using the Movie mode *(see pages 137–47)*.

Freezing

To freeze motion, you need a fast shutter speed. The figure you choose will depend on several factors: the speed at which your subject is moving across the frame; the direction in which it is moving; and the

focal length of the lens. For example, a man running parallel to the camera will move more slowly across the frame than, say, a moving car. As a result, the shutter speed required to freeze the runner will be slower than that needed to pause the motion of the car. If the man is running toward the camera, however, he will be crossing less of the sensor plane and will require a slower shutter speed than he would if running parallel to the camera. Furthermore, using a long-focal-length lens will mean that the subject appears larger within the frame, and will take less

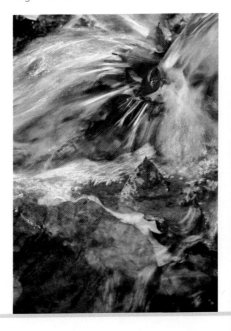

FREEZING WATER »
When shooting water, it's a good idea to include a static object (such as a stone or leaf) in the frame to provide a point of reference for the viewer. The first shot was taken at 1/40sec. and the second at 0.3sec.

time to cover the sensor plane than if you were using a wide-angle lens. It is common practice to select the highest shutter speed possible to prevent blur from occurring.

Blurring

Blur is most commonly employed in landscape photography to show water as a milky wash (indicating movement), but it can also be used with other subjects. The most important tool for this type of photography is a tripod to allow slow shutter speeds, while preventing camera shake. Again, the shutter speed required

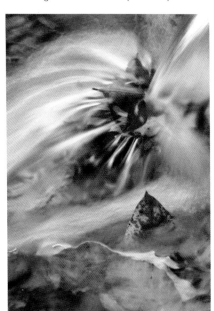

will depend on the speed of the subject. Blur can also be combined with flash—try using a slow shutter speed to create a sense of movement, and then freezing the main subject with a burst of light.

Panning

Panning involves using a medium shutter speed, tracking your subject through the viewfinder, and pressing the shutter button at the desired point, while following the action smoothly. As a result, the subject will remain sharp while the background appears blurred—perfect for eliminating distracting crowds at sporting events. Panning takes practice and may require experimenting with various shutter speeds to achieve the desired effect. The result will depend on the speed of the subject and your distance from the action.

Note:
The EOS 60D can "lock on" to moving subjects using either AI Focus AF or AI Servo AF modes *(see page 35).* The camera has nine AF points, which can be selected individually in the Creative Zone.

4 » PERSPECTIVE

Considered use of perspective (the perceived spatial relationship between objects) can give a photo a sense of depth, distance, scale, and, ultimately, three-dimensionality. Wide-angle and telephoto lenses do not record perspective differently. The effects they produce are an optical illusion. Telephoto lenses appear to reduce the distance between objects on different planes, compressing perspective. Conversely, wide-angle lenses appear to increase the space between objects on different planes, stretching perspective. There are only two things that truly alter perspective: viewpoint and subject-to-camera distance.

For example, if you stand in exactly the same position and photograph the same object, at the same distance, with a variety of different-focal-length lenses, the perspective will remain the same; only the angle of view and the size of the object in the frame will change. However, if you photograph the same object, with the same selection of lenses, but move each time so that the object stays exactly the same size in the frame, the perspective will change.

Photographers use their knowledge of perspective to create a sense of distance and depth. When one plane partially obscures another (e.g., two hills), this implies that distance exists between them. If a line of objects (e.g., a row of trees) leads toward the horizon, the smallest tree is understood to be farthest away from the camera.

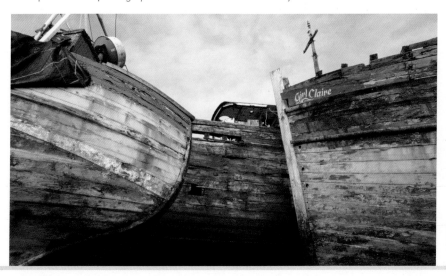

» COMPOSITION

IN THE FIELD » PERSPECTIVE / COMPOSITION

The way that elements are arranged in the frame can have a powerful emotional impact on the viewer. Learning how to balance light and shade with color, shape, and form is crucial to a successful picture, but, more importantly, it enables you to communicate your feelings about the scene or subject to a third party, strengthening the relationship between subject, photographer, and viewer.

Point of view

Many photographers take pictures from standing height, using a focal length that best replicates how they see with the naked eye (50mm). Consequently, their pictures look remarkably similar, even when the subject matter is significantly different. Luckily, there are one or two simple techniques you can use to give your images impact.

Even the most familiar landmarks can be photographed in a new way if you spend a few minutes looking at them from every

angle. Experiment with unusual angles. Start by walking around the subject, perhaps kneeling down, and looking up at it to obtain a fresh perspective. Perhaps use a stepladder or wall to raise yourself above it. Ask yourself what it is that you like, or even dislike, about the subject. Is there a way that you can emphasize these characteristics? Move closer, or zoom in and isolate certain parts of the scene. Alternatively, maybe you can step farther back and include some of the surroundings?

Everything in the frame must earn its place. Anything that does not contribute to the story should be played down, or

LOW LEVEL VIEWPOINT »
By assuming a low viewpoint, I gave the fishing buoy prominence in the frame, while allowing the patterns in the sand to lead the eye toward the horizon.

DIFFERENT PERSPECTIVE «
Telephoto lenses appear to compress perspective, making objects seem closer together than they are in reality.

THE EXPANDED GUIDE 155

eliminated. Before you call it a day, make sure that you have recorded the subject using both portrait (vertical) and landscape (horizontal) formats. At home, consider which works best, and ask yourself why.

Foreground and background

To give a photograph a sense of depth, consider it as having three distinct layers: foreground, middle ground, and background. Ideally, each layer will include an object, color, or other element that relates to the main subject. An image of a mountain, for example, might feature a river at the bottom, a rock in the center, and a towering peak in the background. For this technique to work effectively, each element must relate to the others.

Landscape photographers are great proponents of "foreground interest." With the help of wide-angle lenses, they emphasize and/or exaggerate elements in the immediate foreground, while using a small aperture (such as f/16 or f/22) to keep everything in the middle ground and background sharp. This technique offers the viewer an entry point to the image and helps to add a sense of depth to the scene.

Macro photographers stress the importance of an uncluttered background. Shooting objects at close range means

LEADING THE EYE ⌄
Landscape photographers often use rivers, pathways, or walls to link foreground, middle ground, and background. These elements also offer an entry point for the viewer.

that every line, color, or texture behind the main subject has the potential to distract the viewer. To counteract this, close-up aficionados often use macro lenses to fill the frame with their subject, while employing a wide aperture (such as f/2.8 or f/4) to throw the background, and often the foreground, out of focus.

Lines

Lines can also have a psychological effect on the viewer. Horizontal lines evoke a feeling of calmness; vertical lines indicate strength; zigzags suggest rapid motion; and curves connote slowness. In short, lines help to direct the viewer around the frame, suggest which areas of an image are more important, and propose how we should feel about those areas once we get there.

RULE OF THIRDS ≈
The rule of thirds suggests that you should place key elements of your composition where a series of imaginary lines intersect.

Rule of thirds

The rule of thirds is a popular compositional technique used by painters, designers, and photographers. It states that if you imagine the viewfinder divided into a grid using two horizontal and two vertical lines, you should place the key elements of your composition where these lines intersect. Rather handily, the EOS 60D features a grid function *(see page 105)* that brings up a rule-of-thirds grid in the viewfinder.

Color

Color is a powerful component in almost every photograph. Just as the presence of diagonal lines or curves can have a psychological effect on the viewer, colors can also prick our emotions. Harmonious colors such as green and yellow are considered reassuring, whereas conflicting colors such as violet and green create

DYNAMIC DIAGONALS ≈
Diagonal lines add a sense of dynamism to a picture, and help to direct the eye to the important areas of the frame—in this instance, the name of the boat.

PATTERNS OF NATURE »
Images featuring rhythm or pattern appeal to our sense of order and balance, and can often be found in nature.

tension. Warm colors such as red and orange suggest heat, whereas cool colors such as blue and green make us feel cold.

While blocks of color can create a bold statement, small splashes of primary shades such as red or blue can dominate a composition. Outdoor magazines, for example, often dress their models in red jackets to make them stand out against the landscape. Color can vary in hue, intensity, and tone, giving the picture a different mood each time.

CONTRASTING COLORS ☆
Using colors such as blue and orange together can create pictures with striking vibrancy due to the extreme color contrast.

Rhythm and pattern
Rhythm is used to describe the flow and repetition of elements within a photograph or painting. The eye naturally follows similar shapes, lines, textures, and colors, especially if they recur at regular intervals. Images featuring patterns appeal to our sense of order and balance.

However, the most effective rhythms and patterns are often interrupted: e.g., a field of yellow corn broken by a single red poppy. Perfect arrangements can make an image appear two-dimensional and boring, so it's important to add a note of variation.

In the same way, symmetry can be used effectively: e.g., to capture mirror-like reflections in a lake. But used slavishly, it can be ineffective: e.g., two flowers arranged in a vase will force the viewer to decide which to look at first. Using odd numbers helps to suggest the order in which elements of the picture should be viewed.

» LIGHTING

No photograph can exist without light. Whether a subject is illuminated by the harsh rays of the midday sun or the soft glow of a candle, the direction, diffusion, and strength of this light determines how we interpret a scene. The amount of light that enters the camera and reaches the sensor is controlled by a combination of aperture (the size of the lens opening) and shutter speed (the period of time that the aperture remains open). The aperture is expressed in f-stops: f/8, f/11, etc, and the shutter speed in seconds, or fractions of a second: 1/250sec., 1/30sec., etc. How sensitive the sensor is to light is determined by a third setting: the ISO. The lower the figure—ISO 100, 200, etc—the more light the sensor needs to obtain an accurate exposure.

Of course, none of this matters unless you know how much light is being reflected from the subject in the first place. Thankfully, due to a clever system known as through-the-lens metering (TTL), the EOS 60D performs this calculation for you. All you have to do is interpret the results.

The direction of light can have a significant effect on the look of a subject. Side lighting, for example, is perfect for bringing out textures and emphasizing form, since it creates deep shadows. The effects of side lighting are best observed

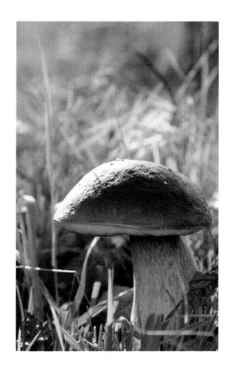

ACCENT LIGHTING ⌃
Side lighting is ideal for bringing out textures and emphasizing form.

when the sun is low in the sky and to one side of the camera. (Landscape photographers often describe the hours just after dawn and before dusk as the "Golden Hours," due to the warmth of the light and the long, raking shadows.)

Front lighting, as its name suggests, occurs when the sun (or alternative light

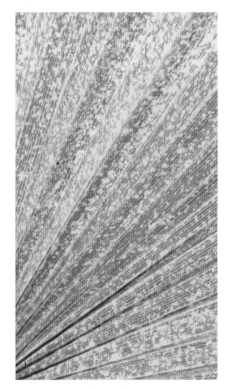

illumination is often used to create bold
silhouettes, but it can also be applied to
translucent subjects, such as petals and
leaves, to highlight their fragility.

Top lighting, unsurprisingly, occurs
when the light source hits the subject from
directly above. Like front lighting, it can
produce a rather flat, two-dimensional
image, but is occasionally used to
accentuate colors.

Photographers often describe light as
being either "hard" or "soft." Hard light
mostly originates from a single source,
such as the sun or a naked bulb. As a result,
it creates dense, hard-edged shadows and
high contrast. Soft light has the opposite
effect and often comes from more than
one source or direction. Any shadows that
do appear have a noticeably soft edge.
Hard light can easily be softened,
producing more subtle results.

source) hits the subject head-on. This
type of light can make the scene appear
flat and rather two-dimensional. Also, if
you are shooting a portrait, it will force
your subject to look toward the sun,
which might cause him/her to squint.
On the plus side, front lighting is great
for revealing detail.

Backlighting, on the other hand,
occurs when a light source emanates
from behind the subject. This form of

» IMAGE PROPERTIES, OPTICAL

Flare

Flare usually manifests itself as colored streaks or shapes in the final image, and is often the result of shooting toward a strong light source, such as the sun. The effect is caused by light entering the lens and scattering in the barrel before hitting the sensor. It can be reduced by using a lens hood, or by changing position so that no direct light enters the lens barrel.

Vignetting

Vignetting (otherwise known as lens fall-off) appears as dark corners in the frame and mostly occurs when using maximum apertures. In this instance, the problem can be solved by stopping down the lens. However, vignetting also appears when filters are teamed with wide-angle lenses and wide apertures. To minimize this condition, some filter manufacturers sell extra-thin filters, or special holders, for wide-angle lenses. Alternatively, you can use the Peripheral Illumination Correction feature on the EOS 60D *(see page 90)*.

Distortion

Pincushion and barrel distortion can be seen where straight lines, such as the horizon, appear slightly curved in the final image. Pincushion is the term used when the lines bow inward, and barrel when the lines curve outward. This effect is caused

VIGNETTING ⌃
Using filters on a wide-angle lens can cause vignetting when combined with wide apertures.

by the optical properties of a lens and can be corrected with RAW conversion software programs.

Chromatic aberration

Chromatic aberration is signified by magenta/green or red/cyan fringing, and is most evident in areas of high contrast. The effect can be caused by poor-quality optics, and is most frequently seen when using extreme wide-angle lenses. The cause of this aberration lies in the inability of a lens to bring spectrum colors into focus at one point. It can be corrected with RAW conversion software programs.

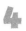

Dynamic range

Dynamic range is the term used to describe the expanse of tones, from light to dark, that a sensor can record. Sometimes this will result in making a compromise between retaining detail in the highlights or the shadows. Where information is lost, it is said to have been "clipped." To expand the dynamic range of the EOS 60D, use the Highlight tone priority command in the Custom Functions menu *(see page 131)*.

Noise

Noise appears as grain (sometimes featuring green and pink/purple colors) in areas of even tone, such as light skies or dark shadows. The effect is exaggerated by using high ISO speeds. To minimize the problem, use the lowest ISO possible, or employ High ISO speed noise reduction in the Custom Functions menu *(see page 131)*. If the condition persists, it can be eased with RAW conversion software programs.

Aliasing

Digital files are displayed as a series of pixels arranged in a mosaic of regular squares. Due to the nature of this design, sometimes you can see the steps between the squares—a condition known as aliasing or "jaggies." This effect is particularly noticeable when low-resolution files are enlarged. To avoid the problem, shoot high-resolution files and keep sharpening to a minimum.

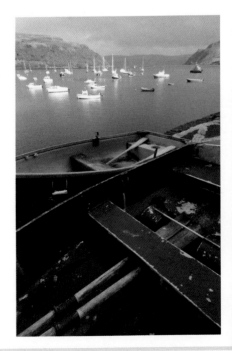

RETAINING DETAIL »
In high contrast scenes such as this one, it can be difficult to retain detail in both areas of shadow and highlights.

Normal sharpening applied.

The result of over-sharpening. ⌃

Compression artifacts

Working on, and repeatedly re-saving, JPEG files can lead to blocky or patchy areas in the image. This effect is most noticeable in areas of uniform color or tone, such as light skies, and areas of fine detail. To minimize the problem, shoot RAW or TIFF files and carry out any post-production work before saving them as JPEGs.

Interpolation artifacts

Occasionally, you might need a file to be larger than the one captured in-camera. Post-production software will enable you to interpolate a file to increase its size, but the technique should be used with care. Upsizing the file can result in intrusive artifacts leading to image softness and "jaggies" *(see Aliasing, opposite).*

Sharpening

When an image has been over-sharpened, areas of high contrast often exhibit unsightly artifacts. If you're shooting JPEG files, the camera automatically applies a small amount of sharpening. However, if you're shooting RAW files, you will need to sharpen them yourself using post-production software. The amount of sharpening you apply will depend on how you plan to use the final file (print, web site, etc).

When we look at an image, we tend to "read" the visual information from left to right, or from the bottom to the top of the frame. Based on this knowledge, photographers frequently use a device known as a lead-in line. This can be anything from a dry-stone wall to the

S-shape of a river—anything that "leads" the viewer into the picture and then around the frame in a particular route. Generally speaking, an S-shape (as shown here) promotes a slow, leisurely viewing of the elements within a scene.

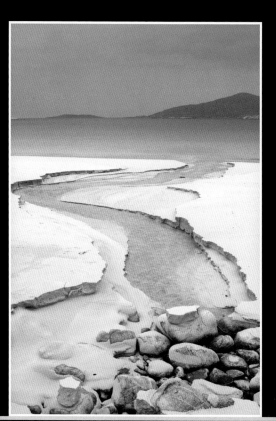

Settings
> Lens: 24–105mm
> Mode: Manual
> Sensitivity: ISO 200
> Shutter speed: 1/100sec.
> Aperture: f/13
> Support: tripod

SENSE OF DRAMA »
An approaching storm brought dramatic light to the island of Harris in Scotland, and I was keen to make the most of the conditions. Framing the shot to include the S-shape of the stream, I balanced the mountain in the distance with a pile of sand and stones in the foreground.

» ABSTRACT CLOSE-UPS

Macro photography requires an understanding of depth of field, lighting, focus, and working distance. It's possible to achieve abstract compositions by moving in close, but even the smallest aperture will result in just millimeters of acceptable focus. To maximize depth of field, keep your subject level with the focal plane mark on the camera and use the depth-of-field preview button to check which areas are sharp. If the lens repeatedly moves backward and forward, struggling to "lock" focus, either move farther away from your subject or switch to manual focus (MF).

Settings
> Lens: 105mm
> Mode: Manual
> Sensitivity: ISO 100
> Shutter speed: 1/2sec.
> Aperture: f/22
> Support: tripod

DELICATE VEINS »
The leaves of *Disanthus cercidifolius* turn orange and red in the autumn. When held against the light, the intricate veins resemble rivers. Despite using an aperture of f/22, depth of field was minimal at such close quarters. To maximize sharpness, I taped the leaf to a window and aligned the focal plane of the camera to the pane of glass.

Heat, dust, and extremes of temperature pose serious threats to your camera, but by taking a few precautions your kit will have a long and productive life. The secret to a successful outdoor shoot, however, lies in taking care of yourself as well as your equipment. Always pack more clothes, food, and water than you think you need. Don't rely on a GPS system to pinpoint your position; learn how to use a map and compass instead. Always check the weather forecast before setting out, and let someone know your planned route and estimated time of return.

EXPOSED TO THE ELEMENTS ⌄
High winds and stormy seas often strike the wild, empty beaches of the island of Coll in Scotland, creating an inhospitable environment for photographers. By wrapping up warm, and letting someone know where I was and when I expected to return, I was able to relax and concentrate on photographing Bàgh an Trailleich.

Settings
> Lens: 10-20mm
> Mode: Manual
> Sensitivity: ISO 200
> Shutter speed: 1/50sec.
> Aperture: f/32
> Support: tripod

» CAPTURING REFLECTIONS

Reflections can be found in lakes, windows, and puddles, creating symmetrical compositions and mirror-like abstracts. When photographing water, the deepest pools generally have the most surface disturbance, so it helps to find a shallow basin. The reflection will almost always be darker than the subject itself, so it's important to take an exposure reading from the water, and not the landscape or sky. If the contrast is too great, you may need to use a neutral-density filter to balance the exposure. Finally, by selecting a narrow aperture, you will be sure of front-to-back sharpness.

MIRROR IMAGE　　　　　　　　　　　❯❯
Loch Coruisk on the island of Skye in Scotland is a deep and imposing body of water. To obtain a reflection of the surrounding Black Cuillin mountains, I looked for a shallow pool of water with few ripples. The grass breaking through the surface helped to add interest to empty areas of the sky.

Settings
> Lens: 10–20mm
> Mode: Manual
> Sensitivity: ISO 100
> Shutter speed: 1/30sec.
> Aperture: f/18
> Support: tripod

More often than not, landscape photographs include a natural line: the horizon. The placement of this line is of great significance. If the horizon is positioned toward the top of the image (such as this one), it suggests that the photographer wishes to draw attention to what's going on at the bottom of the frame. If, however, the horizon is placed toward the bottom of the image, the reverse is true. Many newcomers to photography position the horizon in the middle, which, generally speaking, is the least effective option.

Settings
> Lens: 10–20mm
> Mode: Manual
> Sensitivity: ISO 100
> Shutter speed: 1/50sec.
> Aperture: f/20
> Support: tripod

PERFECT BALANCE «
Patience was required to capture this shot of sky, sea, and sand at Hough Bay on the island of Tiree in Scotland. Placing the horizon near the top of the frame helped to balance the natural layers. With the composition decided, it was a simple case of waiting for the surf to draw a neat line between the sections.

» COMMUNICATING YOUR VISION

A successful picture is the result of a series of decisions made by the photographer. To begin with, you must choose a subject and mood you wish to convey. Next, you must select the most appropriate equipment and settings to communicate your vision to the viewer. Finally, you must eliminate anything that threatens to dilute your message. Before pressing the shutter button, you must be certain that everything you see in the viewfinder has earned the right to be there. Any rogue objects, colors, or shadows must be played down using the technology at your disposal.

ESSENTIAL INGREDIENTS ⌄
Every element in this composition has a clear purpose: the well-worn boat and scruffy creels indicate that fishing is an important part of life at this location—the island of Berneray in Scotland. Meanwhile, the backdrop echoes the color and movement of the sea. By cropping the picture tightly, nothing is allowed to dilute the message.

Settings
> Lens: 24–105mm
> Mode: Manual
> Sensitivity: ISO 100
> Shutter speed: 1/125sec.
> Aperture: f/14
> Support: tripod

Relying on the automatic settings offered by the Basic Zone will eventually limit your creativity. These shooting modes may add extra punch to landscapes, and enhance the skin tones of portraits, but when it comes to tricky lighting conditions, you will obtain far better results by taking control of the camera in the Creative Zone. Here you will find six advanced settings that allow you to alter the shutter speed, aperture, and exposure. In addition, by employing Exposure compensation you can override the camera's meter and use your own judgment to record the scene accurately.

Settings
> Lens: 10-20mm
> Mode: Manual
> Sensitivity: ISO 100
> Shutter speed: 1/125sec.
> Aperture: f/14
> Support: tripod

STANDING STONES **«**
Callanish, on the island of Lewis in Scotland, is home to three main groups of standing stones. Photographing these ancient sites often means including large areas of sky. In these instances the lightmeter can be fooled into underexposing, so it's important to use your own judgment—here I altered the exposure by +1 stop.

» POINT OF VIEW

When you first approach a photogenic subject it's tempting to take a picture from standing height, using a focal length that best replicates how you see with the naked eye (50mm). To gain a fresh perspective, however, try lying down on the ground and looking up, or use a stepladder to gain a bird's-eye view of your subject. Ask yourself what it is that you like, or even dislike, about the object and how you can emphasize these points by selecting an alternative viewpoint. Perhaps you can move closer, or zoom in and isolate certain aspects of the scene.

Settings
> Lens: 24-105mm
> Mode: Manual
> Sensitivity: ISO 200
> Shutter speed: 1/85sec.
> Aperture: f/14
> Support: tripod

LEAFY CANOPY **«**
To give the impression of being high up in the leafy canopy, I used a stepladder to gain a higher vantage point—a short model with just two steps is ideal, since it's light enough to take on location, low enough to feel safe, yet high enough to significantly alter your viewpoint.

Chapter 5
FLASH

5 FLASH

Contrary to popular belief, flash photography is not a technique reserved for professional photographers. Furthermore, the tools required to master the process have never been easier to use. Whether you want to reduce red-eye, soften shadows, add catchlights to eyes, bring out background detail, or create striking light trails, learning how to control a flashgun will take your photography to the next level.

» E-TTL FLASH METERING

The EOS 60D has two main features that make flash photography accessible to all: E-TTL II (evaluative through-the-lens) flash exposure metering and a large LCD

monitor. The first of these benefits lies at the heart of the camera. Using multiple metering zones, the EOS 60D measures both the ambient light and the brightness of the scene during a burst of pre-flash. Then the camera compares the results, and automatically determines the ideal exposure and flash output. When making this calculation, the metering system considers the lens-to-subject distance (if this information is available) and sometimes even the size of the sensor.

Notes:

It's easy to find the Guide Number of an EX-series Speedlite, since the clue is in the name: 580EX II has a GN of 58 (meters at ISO 100), for example.

Flash settings can only be adjusted in the Creative Zone.

BALANCING ACT «

Mixing a burst of flash with the light produced by the fairground lamps has allowed the sign of the helter-skelter to stand out against the inky night sky.

Using E-TTL II metering in conjunction with Canon's EX-series Speedlites allows you to forget complicated exposure calculations and leave the hard work to the camera. The second feature, the 7.7cm color LCD monitor allows you to review images instantly, enabling lighting adjustments to be made within seconds.

The power of a flash is expressed in meters and is known as its Guide Number (GN). This figure will determine the reach of the light (the higher the figure, the greater the coverage), and it is governed by the sensitivity of the sensor. As a result, the GN is often accompanied by an ISO speed. Once you know the GN of a flash, you can use a calculation (GN/distance) to work out the ideal aperture for a subject at various distances. If, for example, the GN of your flash is 58 (at ISO 100) and your subject is sitting 7 meters away from it, the ideal aperture would be f/8 (58/7=8.2). Similarly, the calculation can be adapted (GN/f-stop) to ascertain the distance to the subject to enable a certain aperture. If, for example, the GN of your flash is 43 (at ISO 100) and you wish to use an aperture of f/18, you will need to position your subject 2 meters away from the flash (43/18=2.3).

Once you've familiarized yourself with the basics, flash photography has the potential to become so much more than just a light in the dark. Careful, considered use of flash can add depth or mood to an image, or even allow you to create multiple exposures. Furthermore, it doesn't have to be dark to call upon the services of this portable device: a burst of flash can be used to balance the light difference between a subject and its background in the middle of the day, too.

How the E-TTL flash metering system works

1) When the shutter button is pressed halfway down, the camera takes a meter reading of the scene to determine the ambient light level.

2) When the shutter button is pressed fully down, a pre-flash is fired and the reflected light is measured by the metering system in the EOS 60D.

3) The camera compares the two readings taken in steps 1 and 2, and calculates the optimum flash output before storing it in memory.

4) The reflex mirror flips up. As the first shutter curtain begins to open, the external flash fires, the sensor is exposed, the second shutter curtain closes, and the mirror drops back down. The picture has been taken.

The EOS 60D features a pop-up flash with a guide number of 13 (meters at ISO 100) and a beam wide enough to cover the field of view of a 17mm (27mm equivalent) lens. While it may not be as far reaching as an EX-series Speedlite, this flash blends well with ambient light and is ideal for situations where the subject is relatively close to the camera. In addition, unlike an external unit, the built-in flash will add no extra weight to your bag. In the Basic Zone, the flash will pop up automatically when the shutter-release button is pressed halfway (unless

you are in 🔲 Flash Off mode, in which case it is always disabled), but it can be pushed back down or switched off if necessary. In the Creative Zone, the flash needs to be manually activated by pressing the ⚡ button next to the lens.

On the flip side, the light produced by the built-in flash tends to be quite harsh, and since the unit is fixed in position, the beam cannot be directed or adjusted in any way. By contrast, the light from some EX Speedlites can be maneuvered, bounced off the ceiling, reduced in strength, or diffused for more natural results. These external flashguns can be mounted in the hotshoe (or, in the case of the Macro Ring Lite MR-14EX and Macro Twin Lite MT-24EX, attached to the lens), but for the best results they are used apart from the camera, and controlled by a master unit or a transistor.

> **Note:**
> To obtain the best results with the built-in flash, the subject should be at least a meter away from the camera. In addition, the lens hood should be removed to prevent it from blocking light from the flash, resulting in dark areas in the image.

AMBIENT BLEND «
The beam produced by the built-in flash on the EOS 60D tends to be quite harsh, but it mixes well with ambient light.

Settings using built-in flash

The EOS 60D uses E-TTL autoflash control (flash autoexposure) in all shooting modes by default. The shutter speeds and apertures set can be seen in the table below.

Shooting Mode	Shutter Speed	Aperture
⬜ CA 🌷 🌺	Automatically set within 1/250sec. – 1/60sec.	Automatically set
🌆	Automatically set within 1/250sec. – 2sec.	Automatically set
P	Automatically set within 1/250sec. – 1/60sec.	Automatically set
Tv	Set manually within 1/250sec. – 30sec.	Automatically set
Av	Automatically set	Set manually
M	Set manually within 1/250sec. – 30sec.	Set manually
B	While you hold down the shutter button, the exposure will continue.	Set manually

Effective range of Built-in flash (meters/feet)

The sync speed of the built-in flash is normally set between 1/250 and 30sec. As a result, in bright conditions, the camera generally relies on the aperture to obtain a correct exposure. The aperture, as can be seen below, makes a huge difference to the range of the flash.

Aperture	ISO Speed							
	100	200	400	800	1600	3200	6400	H: 12800
f/3.5	3.5/12	5.5/17	7.5/24	11/34	15/49	21/69	30/97	42/138
f/4	3/11	4.5/15	6.5/21	9/30	13/43	18/60	26/85	36/121
f/5.6	2.5/7.5	3.5/11	4.5/15	6.5/22	9.5/30	13/43	19/61	26/86

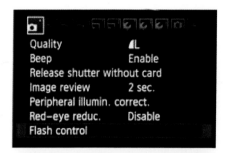

In Creative Zone modes, settings for both the built-in flash and an external EX-series Speedlite can be adjusted via the menu system of the EOS 60D.

1) Press **MENU** and use the 🕸 Main Dial or ◄► on the Multi-controller to select ◘ Shooting Menu 1.

2) Rotate the ◯ Quick Control Dial or use ▲ ▼ on the Multi-controller to highlight **Flash control**. Press **SET**.

3) Rotate the ◯ Quick Control Dial or use ▲ ▼ on the Multi-controller to highlight **Flash firing**. Press **SET**.

4) Rotate the ◯ Quick Control Dial or use ▲ ▼ on the Multi-controller to highlight **Enable**. Press **SET**. (If Flash firing is set to Disable, the built-in flash or external Speedlite will not fire—this is helpful if you only want to use the AF-assist beam to aid focus.)

5) Follow steps 2–4 (highlighting the relevant feature) to set another flash item. When the main Flash control screen is displayed, you can choose between built-in flash (**Built-in flash func. setting**) and external flash (**External flash func. setting**). The options available for the external flash will depend on the Speedlite model you are using—any command that is not shown in gray can be altered.

Built-in flash and external flash settings

```
Built-in flash func. setting
Flash mode          E-TTL II
Shutter sync.       1st curtain
[flash]exp. comp.   ¯3..2..1..0..1..2.:3
E-TTL II meter.     Evaluative
Wireless func.      Disable

[INFO] Clear flash settings
```

Flash mode

Choose between **E-TTL II** (automatic flash shooting) and **Manual** (which allows you to alter the **Flash output**). For explanations of any other modes that might appear on the screen, you will need to refer to the manual of your particular Speedlite.

Shutter sync

Select between **1st curtain** (where the flash fires as soon as the exposure starts) and **2nd curtain** (where the flash will fire right before the exposure ends). When **2nd curtain** is set, the flash will fire twice. With shutter speeds faster than 1/30sec., **1st curtain** will be used automatically. You can also set the Shutter sync to ♭ **H High-Speed** if the external Speedlite you are using supports this facility. For full details on Flash synchronization, *see page 182*.

Flash exposure compensation

This can be set up to +/- 3 stops in $1/3$-stop increments. For full details on Flash exposure compensation, *see page 180*.

E-TTL II flash metering

Choose between **Evaluative** (for standard flash exposures) and **Average** (where the flash exposure will be averaged out for the entire metered scene).

Wireless flash

The built-in flash can be used as a master unit with wireless slaves. For details on master and slave devices, and wireless flash, *see pages 183–6*. Always be sure to read the instruction manual of the Speedlite fully.

Clear flash settings

With either of the flash function setting screens displayed, press **INFO**, and rotate the ◯ Quick Control Dial or use ◀▶ on the Multi-controller to highlight **OK** to clear all flash settings. Press **SET**.

If other options appear on the settings screen (**Flash exposure bracketing**, for example), refer to the manual of your particular Speedlite for details.

» FILL-IN FLASH

When you are using an EX-series Speedlite, you can display and set Custom Functions via the menu system on the EOS 60D. The number of Custom Functions available will depend on the individual Speedlite you are using.

1) With the camera and flash ready to shoot, press **MENU**. Use the 🖇 Main Dial or ◄ ► on the Multi-controller to select 📷 Shooting Menu 1.

2) Rotate the ⬡ Quick Control Dial or use the ◄ ► on the Multi-controller to highlight External flash **C.Fn setting**. Press **SET**.

3) Use ◄ ► on the Multi-controller to select the desired function number. (The procedure is the same as that used for setting standard Custom Functions on the camera.)

4) To clear all Custom Function settings, follow steps 1 and 2, selecting **Clear ext. flash C.Fn**.

Great for revealing detail in shadow areas, fill-in flash is often used for portraits, particularly when the subject is set against a bright background. The trick here is to use enough light to soften the shadows without allowing it to flood the entire scene. This delicate balance is achieved by adjusting the power output of the external flashgun (where possible). If the flash is instructed to fire at half its normal output, the balance between flash and daylight will be 1:2. For an even subtler effect, set the flash to fire at a quarter of its standard output (1:4). Alternatively, you can achieve similar effects by using the Flash exposure compensation feature with the built-in flash on the EOS 60D (in the Creative Zone). In this instance, -1 stop will be the same as half power, and -2-stops will be equivalent to quarter power.

› Using Flash exposure compensation with the built-in flash

You can set Flash exposure compensation up to +/-3-stops in ⅓-stop increments.

1) Press the **Q** Quick Control button.

2) Use ▲ ▼ ◄ ► on the Multi-controller to highlight 🔢 Flash exposure compensation. Press **SET**.

Note:
If you set Flash exposure compensation on both the camera and an EX-series Speedlite, the setting on the Speedlite will override that of the camera.

3) Rotate the ⟳ Quick Control Dial to the right to increase the exposure, and to the left to decrease the exposure.

4) When you press the shutter-release button halfway to achieve focus, the 🔃 Flash exposure compensation icon will appear in the Viewfinder and on the LCD panel.

5) Press the shutter-release button down fully to take the picture. The exposure compensation amount will remain, even after the Power switch has been turned to **OFF**. To cancel it, repeat steps 1–3 and return the indicator to 0.

› **Flash exposure bracketing**

Flash exposure bracketing (FEB) is not directly settable with the EOS 60D, but Speedlites 580EX II, Macro Ring Lite MR-14EX, and Macro Twin Lite MT-24EX all offer the facility. By shooting a sequence of three shots with varying amounts of Flash exposure compensation applied (between 0.5 and 3 stops), this feature has similarities with the Auto Exposure Bracketing (AEB) function. The sequence is usually one standard exposure, one under, and one over, but this order can be changed via the Custom functions on the EX-series Speedlite. If you are using a flashgun that does not offer this facility, you can manually apply Flash exposure compensation to a series of three shots to achieve similar results.

› **Using Flash exposure lock**

Just as the AE (Autoexposure) lock on the EOS 60D enables you to reframe a shot while maintaining the original exposure, the FE Lock allows you to recompose an image while locking the original FE (Flash Exposure) for the built-in flash. The feature uses spot (or partial) metering to obtain the exposure reading.

To use FE Lock:

1) Press the button to raise the built-in flash. Press the shutter-release button halfway down to check that the ⚡ icon appears in the Viewfinder, and to focus.

2) Aim the center of the Viewfinder over the area where you want to lock the flash exposure. Press the ✱ button. The flash will fire a pre-flash and the camera will calculate the flash output required.

5 » FLASH SYNCHRONIZATION

The EOS 60D uses a shutter made of two thin metal blades (or curtains), which sit one in front of the other. When the shutter-release button is pressed down fully, the first (front) curtain opens, exposing the sensor to light. Soon afterwards—the exact time will depend on the shutter speed you have selected—the second (rear) curtain closes, ending the exposure.

When you are using fast shutter speeds, such as 1/500sec., the second curtain starts to close before the first curtain has completed its movement. As a result, the gap through which light enters becomes more of a slit, which exposes the sensor to light gradually. If you use a shutter speed faster than the recommended flash sync speed, some areas of the image will be black, since the second curtain will block out the light. The sync speed of the built-in flash on the EOS 60D is 1/250sec.

› First- and second-curtain synchronization

When an external flash is set to first-curtain synchronization, the flash will fire at the beginning of the exposure, when the first curtain begins to rise. When you pair this setting with a relatively long exposure and a subject that is moving across the frame, a blur of light will appear in front of the subject. Conversely, when the flash is set to second-curtain synchronization, the flash will fire at the end of the exposure, when the second curtain has begun to move. In the same situation, the blur of light will appear behind the subject, which is generally thought to be preferable.

› Slow- and high-speed synchronization

With the flash left in Auto mode, the camera will default to a fast shutter speed to help balance the light. However, if you're using the flash indoors, your foreground subject may be perfectly exposed, but the background may be too dark due to the brevity of the exposure. On these occasions, set the flashgun to slow-sync speeds to force the camera into making a longer exposure, revealing the background detail. Alternatively, when using the built-in flash in low-light, the camera will set a slow sync speed automatically.

By contrast, there may be occasions when the default shutter speed is too slow to suit the subject—when trying to fill in shadows on a bright day, for example. In this instance, you can set the flashgun to high-speed sync mode. Alternatively, you can set the EOS 60D to Aperture Priority (Av) mode and use Custom Function I-7 *(see page 130)* to force the camera into using a faster shutter speed.

» RED-EYE REDUCTION

In dark conditions, the pupils of the human eye dilate. When a flash is used to take a portrait, the light reflects off the retina, revealing the blood vessels in the eye. To reduce this "red-eye," the EOS 60D features a red-eye reduction lamp, which glows orange prior to the flash firing. It's most effective when the subject is looking directly at the lamp, when the room is well lit, or the subject is close to the camera.

To enable red-eye reduction:

1) Turn the Mode Dial to any mode except 🄵, 🏞, 🔧, or 🎥. Press the ⚡ to extend the built-in flash, if required.

2) Press **MENU**. Use the 🎛 Main Dial or ◀▶ on the Multi-controller to select 📷 Shooting Menu 1.

3) Rotate the ◯ Quick Control Dial or use ▲ ▼ on the Multi-controller to highlight **Red-eye reduc.** Press **SET**.

4) Rotate the ◯ Quick Control Dial or use ▲ ▼ on the Multi-controller to highlight **Enable**. Press **SET**.

5) Press the shutter-release button halfway to focus. The Red-eye reduction lamp will glow orange. Press the button fully to take the picture. To cancel Red-eye reduction, follow steps 1–4 and select **Disable**.

» MASTER & SLAVE UNITS

When multiple flashguns are used with the EOS 60D, one unit becomes the master while the others are known as slaves. The master is mounted on the hotshoe of the camera and is responsible for issuing instructions to the secondary slave units. When the flashguns are being used wirelessly, they are controlled by light pulses or infrared signals. As a result, it is important that the signals do not become obscured by walls, large items of furniture, etc. In addition, the master unit should always be set before the secondary units. Speedlites 580EX II, Macro Ring Lite MR-14EX, and Macro Twin Lite MT-24EX, and the built-in flash can all be used as master units. Alternatively, the slaves can be controlled using Speedlite Transmitter ST-E2.

COMBINED LIGHTING ❯❯
Flash can be combined with other light sources to produce the desired mood.

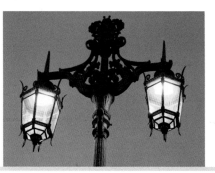

» WIRELESS FLASH

While it is possible to link a flashgun to the EOS 60D via cords and adapters, the E-TTL II flash exposure metering system is incompatible with wired flash accessories, so the features available will be limited. As a result, the camera is best suited to wireless flash units, controlled either by a master device or a transistor. Multiple units can be placed around the subject, and then fired remotely (at various strengths), using the master or transistor unit. You will be able to control shadows and highlights, or adjust the atmosphere of a scene, resulting in extensive creative expression.

Using wireless flash

In Creative Zone modes, the built-in flash can be used as a master unit to trigger wireless slave EX-series Speedlites. Most slave flash features can be set via the camera. (check the manual of your flashgun for instructions.) You will also need to follow the setup instructions at right.

Tip

To cancel the automatic power-off feature on the slave unit, press the ✱ button on the camera. (If you are using Manual flash, press the test button on the slave unit to cancel the automatic power-off feature.)

1) Set the EX-series Speedlite as a slave unit.

2) Set the transmission channel on the EX-series Speedlite to that of the camera.

3) If you want to set the flash ratio manually, set the slave unit ID.

4) Position the camera and slave unit as desired (taking into account the GN of the flashgun and the desired lighting effect).

5) Point the wireless sensor on the EX-series Speedlite toward the camera.

Fully automatic shooting with one external Speedlite

1) Press the ⚡ button to extend the built-in flash.

2) Press **MENU** and use the 🕸 Main Dial or ◄► on the Multi-controller to select ▢ Shooting Menu 1.

3) Rotate the ◯ Quick Control Dial or use ▲ ▼ on the Multi-controller to highlight **Flash control**. Press **SET**.

4) Rotate the ◯ Quick Control Dial or use ▲ ▼ on the Multi-controller to highlight **Built-in flash func. setting**. Press **SET**.

5) Rotate the ◯ Quick Control Dial or use ▲ ▼ on the Multi-controller to

highlight **Flash mode**. Press **SET**. Select **E-TTL II** (set to **Evaluative**). Press **SET**.

6) Rotate the ⊙ Quick Control Dial or use ▲ ▼ on the Multi-controller to highlight **Wireless func.** Press **SET**. Select ⬆. Press **SET**.

7) Rotate the ⊙ Quick Control Dial or use ▲ ▼ on the Multi-controller to highlight **Channel**. Press **SET**. Alter the number (between 1 and 4) to match that of the wireless EX-series Speedlite. Press **SET**.

8) Rotate the ⊙ Quick Control Dial or use ▲ ▼ on the Multi-controller to highlight **Firing group**. Press **SET**. Select ⬆. Press **SET**.

9) Take a picture in the usual way.

10) To cancel Wireless flash shooting, follow steps 1–6, selecting **Disable**.

Fully automatic shooting with one external Speedlite and the built-in flash

Using this setting, the flash ratio between Speedlite and built-in flash can be adjusted for more precise control of the shadows.

1) Follow steps 1–5 for shooting with one external Speedlite.

2) Rotate the ⊙ Quick Control Dial or use ▲ ▼ on the Multi-controller to

highlight **Wireless func.** Press **SET**. Select ⬆ ⬇. Press **SET**.

3) Rotate the ⊙ Quick Control Dial or use ▲ ▼ on the Multi-controller to highlight ⬆ ⬇. Press **SET**. Set the flash ratio between 8:1 and 1:1. (If the built-in flash output is not sufficient, select a higher ISO speed.)

Fully automatic shooting with multiple external Speedlites

Instruct multiple slave units to perform as one device or be separated into groups with different flash ratios. Using the Firing group function, you can shoot with various wireless flash setups. The Flash mode must be set to **E-TTL II** (**Evaluative**), the Wireless function must be set to ⬆, and the Channel must be adjusted to match that of the wireless slave units.

Using multiple slave Speedlites as one flash unit

By using multiple Speedlites as one unit, you can obtain a large flash output. To choose this feature, change the Firing group to ⬆ **All** via the built-in flash functions screen.

Using multiple slave units in groups

The wireless slave units can be divided into groups—A and B—allowing different flash

ratios to be assigned to each group to obtain the desired lighting effects. (Refer to the manual of each Speedlite to set the slave unit ID to either A or B before you proceed.) Change the Firing group to 🔫 **A:B** via the built-in flash functions setting screen. Select **A:B fire ratio** and set the flash ratio.

Fully automatic shooting with the built-in flash and multiple external Speedlites

When using wireless slave units, the built-in flash can also be employed as an extra light source. Using the Firing group function, shoot with various wireless flash setups complemented by the built-in flash. The Flash mode must be set to **E-TTL II** (set to **Evaluative**), the Wireless function must be set to ⊐🔫 ⊒🔼, and the Channel adjusted to match that of the wireless slave units. Change the Firing group to the desired setting, alter the flash ratio or Flash exposure compensation (if required). Shoot as usual.

Using Flash exposure compensation with wireless Speedlites

When the Flash mode is set to **E-TTL II** metering, you can apply Flash exposure compensation to the wireless EX-series Speedlites and the built-in flash. (The features available depend on the Wireless functions and Firing group settings you have

selected.) You can choose between 🔼, where the Flash exposure compensation is applied to the built-in flash; 🔫, where the Flash exposure compensation is applied to all external EX-series Speedlites; or **A,B exp. Comp.**, where Flash exposure compensation is applied to both groups A and B. Press the ✳ button to set **Flash Exposure (FE) Lock**.

Setting the flash output manually

When the Flash mode is set to Manual flash, you can select the desired flash output manually. The features available will depend on the Wireless functions you have previously chosen.

Under **Wireless func:** ⊐🔫, you can choose between **Firing group:** 🔫 **All**, where the flash output setting will apply to all external EX-series Speedlites; and **Firing group:** 🔫 **A:B**, where you can set the flash output separately for slave groups A and B.

Alternatively, under **Wireless func:** ⊐🔫 ⊒🔼, you can choose between **Firing group:** 🔫 **All and** 🔼 (where the flash output can be set separately for the external EX-series Speedlite(s) and Built-in flash and **Firing group:** 🔫 (A:B) 🔼 (where you can set the flash output separately for slave groups A and B. You can also set the flash output for the built-in flash.)

» BOUNCE FLASH

Bounce flash is a technique for reflecting light off a wall, ceiling, or reflector. As the light hits one of these surfaces, it spreads, reaching the subject as a softer, more flattering source, eliminating red-eye and reducing deep shadows. For the best results, use an external flashgun.

Most of the EX-series Speedlites listed on *pages 188–90* can be tilted or swiveled, making them ideal for this technique. If the Speedlite is mounted in the hotshoe, adjust the head so that it points at the ceiling, wall, or other surface before it bounces back onto the subject. For greater precision, detach the unit and control it wirelessly, so it can be positioned at the angle required. If the reflective surface is colored, the light may take on a color cast. This can be used to advantage to produce warmer or cooler tones (using a gold or silver reflector). To avoid the effect, choose a white surface. The strength of the illumination depends on the distance between the wall or ceiling and flash unit: the greater the distance, the softer the light.

Tip

Using bounce flash for portraiture can result in shadows under the subject's nose and chin. Ask the subject to hold a reflector under their chin to direct the light into the shadows.

» DIFFUSING FLASH

Another way to soften and spread the light of the flash is to use a diffuser. This will result in lighter and more natural looking shadows, as well as lower contrast. A diffuser is a translucent material placed between the flash unit and the subject. Many flashguns have a diffuser built into the flash head.

» EX-SERIES SPEEDLITES

The EOS 60D features an E-TTL II flash exposure metering system compatible with Canon's full range of EX-series Speedlites (external flashes). The system uses lens-to-subject distance information (when available) and combines it with a reading of ambient light levels and pre-flash results to calculate the required strength of the flash output. The maximum output of the flash is easily identified by the name: Speedlite 580EX II, for example, has a reach of 190ft (58 meters) at ISO 100.

› Attaching and removing an EX-series Speedlite

The 580EX II and 430EX II Speedlites *(see overleaf)* have a locking lever to secure them to the hotshoe. The 270EX, Macro Ring Lite MR-14EX, and Macro Twin Lite MT-24EX use different systems. As a result,

the following instructions only apply to the 580EX II and the 430EX II—for details of the other models, refer to their manuals.

1) Make sure that the power switch on the camera and the power switch on the EX-series Speedlite are both turned **OFF**.

2) Mount the Speedlite on the hotshoe. Secure by sliding the locking lever from left to right until it clicks.

3) Turn the camera's power switch to **ON**. Turn the Speedlite **ON**.

4) Choose the camera settings (these will be limited in the Basic Zone) and then select the required sync speed, etc on the flash.

› Speedlite 270EX

The 270EX is Canon's entry-level EX-series Speedlite, which was designed specifically for EOS and Powershot cameras. Launched in May 2009, the 270EX replaced the popular 220EX and, while retaining the pocket-friendly size of its predecessor, it offers more power and near silent recharging. Powered by two AA batteries, it features a zoom head (improving light distribution) and a bounce flash head (enabling light to be bounced off a ceiling for softer, more flattering tones).

Maximum Guide number (GN)
 27 (meters at ISO 100)
Minimum recycling time
 Approximately 3.9 seconds
AF-assist beam
 Yes
Dimensions (w x h x d)
 2½ x 2⅝ x 2⅞in (64 x 65 x 72mm)
Weight
 5.1oz (145g) without batteries

› Speedlite 430EX II

› Speedlite 580EX II

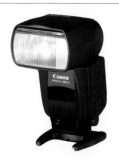

The 430EX II replaced the 430EX, reducing recycling times by 20%. This all-purpose flash features a built-in wide panel, allowing coverage for wide-angle lenses up to 14mm. Thanks to redesigned pins in the mounting foot, Canon also improved the connection between camera and flash. When the 430EX II is mounted to a compatible EOS camera, it detects whether the sensor is full-frame or APS-C (like the EOS 60D) and adjusts the zoom position to maximize coverage.

Maximum Guide number (GN)
43 (meters at ISO 100)
Minimum recycling time
Approximately 0.1 second
AF-assist beam
Yes
Dimensions (w x h x d)
2⅞ x 4⅞ x 4in (72 x 122 x 101mm)
Weight
11.6oz (330g) without batteries

Billed as Canon's first weather-resistant flash, the 580EX II was designed to match the dust- and water-resistance of the EOS-1D Mark III. These, and other high-end features, make it a popular choice with sports and photojournalists. The most powerful of the EX-series Speedlites, the 580EX II replaced the 580EX, offering faster and quieter recycling times. It can be used as both a master and slave unit. This is Canon's top-of-the-range external flash.

Maximum Guide number (GN)
58 (meters at ISO 100)
Minimum recycling time
Approximately 0.1 second
AF-assist beam
Yes
Dimensions (w x h x d)
3 x 5¼ x 4½in (76 x 134 x 114mm)
Weight
13.2oz (375g) without batteries

› Macro Ring Lite MR-14EX

Designed to create even, shadowless lighting for close-up subjects, the Macro Ring Lite MR 14EX is compatible with all EOS bodies, but is best suited to EF Macro lenses *(see page 198)*. It consists of two semicircular flash tubes housed in a ring that fits around the lens, and a separate controller mounted in the camera's hotshoe. The flash tubes can fire together or independently, offering precise control over shadows. In addition, the Macro Ring Lite MR-14EX can be used as a master unit for wireless flash photography.

Maximum Guide number (GN)
 14 (meters at ISO 100)
Minimum recycling time
 Approximately 0.1 second
AF-assist beam
 Yes
Dimensions (w x h x d)
 3 x 5 x 3⅞in (74 x 125.9 x 97.4mm), control unit
Weight
 15.1oz (430g) without batteries

› Macro Twin Lite MT-24EX

Offering superior shadow control in close-up photography, the Macro Twin Lite MT-24EX features two adjustable flash heads and a separate controller that slides into the camera's hotshoe. The twin heads can be rotated through 80° around the lens in 5° increments, or removed from the mounting ring for precise control. The unit is suited to all Canon EF Macro lenses (although EF 180mm f/3.5L will require the Macro Lite Adapter 72C to make it compatible).

The Macro Twin Lite MT-24EX has the same wireless capabilities as the Macro Ring Lite MR-14EX, but with added flexibility.

Maximum Guide number (GN)
 24 (meters at ISO 100)
Minimum recycling time
 Approximately 0.1 second
AF-assist beam
 Yes
Dimensions (w x h x d)
 3 x 5 x 3⅞in (74 x 125.9 x 97.4mm), control unit
Weight
 20.6oz (585g) without batteries

» FLASH ACCESSORIES

To use flash effectively, you need to consider its position in relation to the camera. While the built-in flash is excellent for general photography *(see pages 176–8)*, it can throw harsh and uneven light on close-up subjects. Purchasing an external flash will improve matters—often allowing you to control shadows and bounce light—but mounting it to a hotshoe will eventually limit your options. As a result, it's worth considering off-camera flash. With the help of various accessories, you can position the flash away from the camera and direct light exactly where you want it.

Speedlite Transmitter ST-E2
Compatible with E-TTL II flash exposure metering systems, the Speedlite Transmitter ST-E2 is a wireless transmitter that enables you to control the brightness and lighting ratio of multiple flash heads (including the 580EX II and the 430EX II). The transmitter has a built-in AF assist beam and simple controls. However, it requires a lithium battery (2CR5) that cannot be recharged and, although it can act as a master unit, you will gain far greater flexibility by employing the 580EX II in this role.

Compact battery pack CP-E4
Designed as a companion to the 580EX II, the Compact Battery Pack CP-E4 is weather-resistant and dustproof, offering invaluable protection at key contact points. The device holds eight AA batteries and features a removable magazine for fast changeovers. Using Compact Battery Pack CP-E4 will enable faster recycling times, while also increasing the number of occasions the flash can be fired before the batteries need to be replaced.

Speedlite Bracket SB-E2
Popular with portrait photographers, Speedlite Bracket SB-E2 allows a flash head to be positioned to the side of the camera, reducing red-eye and preventing unnatural shadows. The bracket is compatible with 580EX II and 430EX II Speedlites, and offers three levels of height adjustment. To stand up to the rigors of professional use, Speedlite Bracket SB-E2 is dustproof and water-resistant.

> **Note:**
> Wired accessories are incompatible with the E-TTL II flash exposure metering system used in the EOS 60D. As a result, the camera should be paired with wireless transmitters and accessories.

Chapter 6
CLOSE-UP

6 CLOSE-UP

More often than not, the textures, structure, and patterns of the natural world go unnoticed, but thanks to a few relatively inexpensive accessories, this unseen universe can be explored and captured with the EOS 60D.

» MACRO PHOTOGRAPHY

Macro photography is an exciting prospect, but there are three areas to consider before moving in too close: depth of field, focus, and lighting. When shooting at close range, depth of field is minimal, and even the smallest aperture will result in just millimeters of acceptable focus. When depth of field is limited, accurate focusing is essential. Working at close range, autofocus can struggle to lock on a subject—the lens often "hunts" backward and forward—resulting in blurred images. This condition is exacerbated

by the addition of macro accessories such as extension tubes. The solution is to mount the camera on a tripod, switch the lens to Manual focus (MF), choose your point of focus carefully, and make any adjustments by hand. To reduce any vibrations caused by pressing the shutter, you can use a cable release, remote control, or the self-timer function *(see pages 70–71)*. Finally, to cut down on vibrations caused by the mirror flipping up in the camera, you can use the mirror lockup facility *(see page 133)*.

The third obstacle, limited light, is largely due to the use of small apertures, chosen in an attempt to maximize depth of field. Small apertures result in slow shutter speeds, meaning every movement—either of the camera or the subject—will be exaggerated. To combat this problem, you can use electronic flash *(see pages 176–8)*, boost the ISO *(see page 36)*, or use reflectors to bounce light back onto the subject.

FRUITING BODY　　　　　　　　　　　**«**
To avoid camera shake and vibrations, mount the EOS 60D on a tripod and use the mirror lockup function, as I did to capture this image of fly agaric *(Amanita muscaria)*.

» CLOSE-UP ATTACHMENT LENSES

Close-up attachment lenses are best used with fixed-focus (prime) lenses such as 50mm. These tools screw to the front of the lens and work by reducing the minimum focusing distance of the lens, allowing you to focus closer to your subject. The power of these lenses is measured in diopters, the most common being +1, +2, +3, and +4—the higher the number, the closer you can get to your subject, and the higher the magnification. Two or more close-up attachments may be used together, but it's worth remembering that the more glass you put in front of the lens, the greater the chance of image degradation.

Close-up attachments may not offer the sharpness and clarity of dedicated macro lenses *(see page 198)*, but they are excellent value for money, and since they do not reduce the amount of light reaching the sensor, they allow you to retain a relatively fast shutter speed (depending on your chosen ISO and aperture).

Canon produces two strengths of close-up lens: the CU 250D and CU 500D—the number indicates the farthest working distance (from the front of the lens to the subject in millimeters), while the "D" stands for double element. Lenses without "D" in the title have a single element and tend to be cheaper, but they don't offer the optical quality of their double-element equivalents. Generally speaking, the CU 250D is intended for lenses with focal lengths between 35 and 135mm, whereas the CU 500D is optimized for 70–300mm lenses. There are four filter thread sizes: 52mm, 58mm, 72mm, and 77mm, but not every EF or EF-S lens is catered for.

ABSTRACT SHOT OF BOAT HULL ⌃
By attaching a close-up filter to the front of your lens, you can reduce the minimum focusing distance and move in closer to your subject.

> **Note:**
> Close-up attachments are often called close-up filters. Since these lenses do not filter light, this name is somewhat misleading.

6 » EXTENSION TUBES

Usually supplied in sets of three, extension tubes or "rings" fit between the lens and the camera body, and can be used individually or combined to produce different reproduction ratios. Canon produces two extension tubes: Extension Tube EF 12 II, which offers 12mm of extension, and Extension Tube EF 25 II, which gives 25mm of extension. These tubes contain no optical elements, but they do maintain the electrical connection between the lens and camera.

Extension tubes work by moving the lens physically farther away from the focal plane (the sensor), reducing the minimum focusing distance and increasing magnification. Fitting one of these accessories leads to a certain degree of light loss, but since autoexposure remains active, this is handled automatically by the EOS 60D. However, with Extension Tube EF 25 II, in particular, autofocus may become unpredictable. As a result, Canon recommends employing Manual Focus (MF) when using either of the tubes.

HEATHER AND BIRD'S-FOOT TREFOIL ⌄
Extension tubes fit between the lens and camera body, reducing the minimum focusing distance between the sensor and the subject.

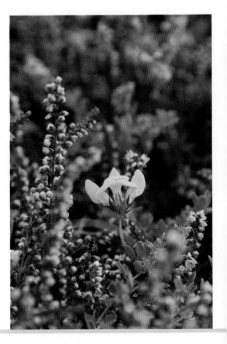

Extension tubes EF 12 II and EF 25 II

» BELLOWS

Bellows fit between the lens and the camera body, and work in much the same way as extension tubes—by moving the lens physically farther away from the focal plane (the sensor) to reduce the minimum focusing distance and increase magnification. However, unlike extension tubes, bellows are flexible and allow precise control over the results. Since they do not contain any glass elements, these accessories do not affect image quality, but they do create a significant light loss—this is catered for automatically by the EOS 60D. For the best results, bellows should be used in conjunction with a tripod and focusing rail. Canon does not produce any bellows, but they can be purchased from third-party manufacturers such as Novoflex, www.novoflex.com.

Reproduction ratio

Reproduction ratio describes the relationship between the size of your subject in real life and the size it is recorded on the sensor. For example, a reproduction ratio of 1:2 means that the subject will appear half its actual size in the final image.

» REVERSING RINGS

Reversing rings enable you to reverse a lens on your EOS 60D. As a result, it will focus much closer to the subject. These rings contain no glass elements, so image quality is unaffected. There is also no light loss for the camera to contend with. However, the electronic contacts will now be on the outside, dramatically reducing communication between the lens and camera. This leads to the loss of metering systems and automatic aperture stop-down. (There are rings on the market, however, that enable you to retain full lens functions. *See* Novoflex, www.novoflex.com) Despite these drawbacks, reversing rings are a light and inexpensive way to experiment with macro photography.

REVERSING RINGS ☆
Mounting your lens back to front with these handy accessories will enable closer focusing on the subject.

6 » MACRO LENSES

The word "macro" is commonly misused in photography. Technically speaking, only a reproduction ratio of 1:1, or a magnification of 1x (life size) can be classed as macro, but the term has come to describe close-up work. While many zoom lenses boast a macro setting, the likely reproduction ratio obtained will be 1:4 (quarter life size).

Dedicated macro lenses are the best choice for close-up photography, offering superior image quality at close focusing distances. Canon produces six macro lenses:

EF-S 60mm f/2.8 Macro USM This lens was designed for EOS cameras with APS-C sensors, such as the EOS 60D. The lens offers 1:1 (life size) reproduction and boasts a minimum focusing distance of 20cm. It can also be used for portraiture, since the maximum aperture of f/2.8 creates satisfying background blur.

EF 100mm f/2.8 Macro USM Aside from the obvious increase in working distance, this medium telephoto lens offers 1:1 (life size) reproduction, and a focusing limiter to prevent the lens from hunting backward and forward in an attempt to lock on to a subject. It's a relatively lightweight option (21.1oz/600g) with a decent build quality.

EF 100mm f/2.8L Macro IS USM As the red stripe on the barrel denotes, this lens is one of Canon's top-of-the-range L series, and it offers 1:1 (life size) reproduction. The high-end technology includes an Image Stabilizer capable of angle and shift detection, as well as UD lens elements and a three-position focusing limiter switch, which can be set for both close-up and distant subjects.

EF 180mm f/3.5L Macro USM This high-spec, albeit hefty (38.4oz/1090g), optic offers 1:1 (life size) reproduction and has a minimum focusing distance of 0.48m. Thanks to the generous working distance, it is ideal for insect photography. Being one of the L-series models, it offers superb optical performance.

EF 50mm f/2.5 Macro While this lens only produces a reproduction ratio of 1:2 (half life size), it offers a minimum focusing distance of 0.23m and weighs just 9.8oz (280g). It also makes an ideal general-purpose lens.

MP-E 65mm f/2.8 1-5x Macro This unusual optic offers reproduction ratios from 1:1 through to 5:1 (five times life size). It is a manual-focus lens, featuring UD glass elements to reduce chromatic aberration *(see page 161)*. It has a minimum focusing distance of 0.24m and weighs 25oz (710g).

» MACRO FLASH

Small apertures require slow shutter speeds, a fact that causes countless difficulties for macro photographers. The built-in flash of the EOS 60D is excellent in most situations, but it will often throw harsh and uneven light on close-up subjects. Mounting an external flashgun in the hotshoe is another option, but these often have minimum working distances and, due to their position in relation to the lens, much of the light will miss the main area of the subject.

To solve these problems, macro photographers sometimes use off-camera flash. With the flashgun positioned apart from the camera, it can be tilted, or moved closer or farther away from the subject. To achieve even illumination, try using two or more flash heads. Alternatively, you could consider a twin-head flash unit such as Canon's Macro Twin Lite MT-24EX, or a ring flash such as Canon's Macro Ring Lite MR-14EX.

TRUE MACRO ☆
Dedicated macro lenses are the best choice for close-up photography, offering superior image quality at close focusing distances.

MACRO LIGHT «
Macro Ring Lite MR-14EX creates even, shadowless lighting for close-up subjects.

6 » LENS MAGNIFICATION TABLE

Magnification possible using EF and EF-S lenses with Extension Tube 12 II or Extension Tube 25 II.

Lens	Maximum magnification	With EF 12 II	With EF 25 II
Fixed focal length lenses			
EF 14mm f/2.8L USM	0.10	Incompatible	Incompatible
EF 14mm f/2.8L II USM	0.15	Incompatible	Incompatible
EF 15mm f/2.8 Fisheye	0.14	0.94–0.80	Incompatible
EF 20mm f/2.8 USM	0.14	0.72–0.60	Incompatible
EF 24mm f/1.4L II USM	0.17	0.67–0.50	Incompatible
EF 24mm f/2.8	0.16	0.64–0.50	1.22–1.11
EF 28mm f/1.8 USM	0.18	0.61–0.43	1.13–0.96
EF 28mm f/2.8	0.13	0.56–0.43	1.09–0.95
EF 35mm f/2	0.23	0.58–0.35	1.00–0.77
EF 35mm f/1.4L USM	0.18	0.54–0.36	0.97–0.79
EF 50mm f/1.2L USM	0.15	0.39–0.24	0.67–0.53
EF 50mm f/1.4 USM	0.15	0.39–0.24	0.68–0.53
EF 50mm f/1.8 II	0.15	0.39–0.24	0.68–0.53
EF 85mm f/1.2L II USM	0.11	0.25–0.15	0.42–0.33
EF 85mm f/1.8 USM	0.13	0.27–0.15	0.44–0.32
EF 100mm f/2 USM	0.14	0.27–0.13	0.42–0.28
EF 135mm f/2L USM	0.19	0.29–0.09	0.41–0.20
EF 135mm f/2.8 Soft Focus	0.12	0.22–0.09	0.33–0.20
EF 200mm f/2L IS USM	0.12	0.19–0.6	0.26–0.14
EF 200mm f/2.8L II USM	0.16	0.23–0.06	0.32–0.14
EF 300mm f/2.8L IS USM	0.13	0.18–0.04	0.24–0.09
EF 300mm f/4L IS USM	0.24	0.30–0.04	0.37–0.09
EF 400mm f/2.8L IS USM	0.15	0.19–0.03	0.23–0.06
EF 400mm f/4 DO IS USM	0.12	0.16–0.03	0.20–0.07
EF 400mm f/5.6L USM	0.12	0.16–0.03	0.21–0.07
EF 500mm f/4L IS USM	0.12	0.15–0.03	0.18–0.05
EF 600mm f/4L IS USM	0.12	0.14–0.02	0.17–0.05
EF 800mm f/5.6L IS USM	0.14	0.16–0.02	0.19–0.04
Zoom lenses			
EF-S 15-85mm f/3.5-5.6 IS USM	0.21	0.44–0.155	Not recommended
EF-S 17-55mm f/2.8 IS USM	0.17	0.45–0.23	1.71–0.51
EF-S 17-85mm f4-5.6 IS USM	0.20	0.43–0.14	0.72–0.33

EF-S 18-200mm f/3.5-5.6 IS	0.24	0.39-0.06	0.56-0.14
EF 8-15mm f/4L Fisheye USM	0.39	Incompatible	Incompatible
EF-S 10-22mm f/3.5-4.5 USM	0.17	0.77-0.58	1.51-1.28
EF-S 15-85mm f/3.5-5.6 IS USM	0.21	0.44-0.155	Not recommended
EF 16-35mm f/2.8L II USM	0.22	0.62-0.36	1.11-0.80
EF 17-40mm f//4L USM	0.24	0.83-0.32	1.02-0.70
EF-S 18-135mm f/3.5-5.6 IS	0.21	0.38-0.09	0.59-0.21
EF 24-70mm f/2.8L USM	0.29	0.63-0.18	0.75-0.40
EF 24-105mm f/4L IS USM	0.23	0.40-0.12	0.61-0.27
EF 70-200mm f/2.8L USM	0.16	0.22-0.06	0.41-0.14
EF 70-200mm f/4L USM	0.21	0.29-0.06	0.39-0.13
EF 75-300mm f/4-5.6 III	0.25	0.31-0.04	0.39-0.09
EF 75-300mm f/4-5.6 III USM	0.25	0.31-0.04	0.39-0.09
EF 100-300mm f/4.5-5.6 USM	0.20	0.26-0.04	0.37-0.09
EF 100-400mm f/4.5-5.6L IS USM	0.20	0.25-0.03	0.35-0.07
EF 28-90mm f/4-5.6 II	0.30	0.56-0.42	1.13-0.94
EF 28-135mm f/3.5-5.6 IS USM	0.19	0.53-0.09	1.09-0.21
EF 28-300mm f/3.5-5.6L IS USM	0.06	Compatible	Only in Tele mode
EF 35-350mm f/3.5-5.6L USM	0.25	0.43-0.04	0.82-0.08
EF-S 55-250mm f/4-5.6 IS	0.31	0.6-0.05	0.47-0.11
EF 70-200mm f/2.8L IS II USM	0.21	0.28-0.06	0.36-0.14
EF 70-300mm f/4.5-5.6 DO IS USM	0.19	0.26-xyx	0.46-xyx
EF 70-300mm f/4-5.6 IS USM	0.26	0.32-0.04	0.39-0.09
EF 70-300mm f/4-5.6L IS USM	0.21	0.29-0.04	0.38-0.09
EF 75-300mm f/4-5.6 III	0.25	0.31-0.04	0.39-0.09
EF 75-300mm f/4-f/5.6 III USM	0.25	0.31-0.04	0.39-0.09
EF 75-300mm f/4-5.6 IS USM	0.26	0.32-0.04	0.39-0.09
EF 100-400mm f/4.5-5.6L IS USM	0.20	0.25-0.03	0.35-0.07

Tilt and shift lenses

TS-E 17mm f/4L	0.14	Incompatible	Incompatible
TS-E 24mm f/3.5L II	0.34	0.85-0.51	1.47-1.12
TS-E 45mm f/2.8	0.16	0.44-0.27	Incompatible
TS-E 90mm f/2.8	0.29	0.43-0.14	0.60-0.31

Macro lenses

EF-S 60mm f/2.8 Macro USM	1.00	1.28-0.20	1.61-0.44
EF 100mm f/2.8 Macro USM	1.00	1.19-0.12	1.39-0.26
EF 100mm f/2.8L Macro IS USM	1.00	1.17-0.12	1.37-0.27
EF 180mm f/3.5L Macro USM	1.00	1.09-0.07	1.21-0.15
EF 50mm f/2.5 Macro	0.50	0.74-0.24	1.04-0.54
MP-E65 f/2.8 1-5 x Macro	5.00	Incompatible	Incompatible

Chapter 7
LENSES

7 LENSES

Your camera is only as good as the lens you attach to it, so invest in the best you can afford. Canon offers the largest range of interchangeable lenses in the world, ranging from ultra-wide-angle to super-telephoto optics. There are three types of lens in the lineup—EF, EF-S, and L—many of them sporting ultrasonic motors (USM) and image stabilization (IS).

» LENS RANGES

EF lenses

The EF lens mount was introduced in 1987, taking the place of Canon's mechanical FD mount. Unlike its predecessor, this Electro Focus (EF) mount has electrical contacts to transfer power and information from the camera to the motor, which now is housed inside the lens. Any EF lens can be used on any EOS camera.

EF-S lenses

Launched in 2003, the EF-S lens mount appears on cameras with an APS-C sensor, such as the EOS 60D. The mount was designed to work with EF lenses too, although EF-S lenses are not compatible with full-frame sensors. Optics in the EF-S range cast a smaller image circle than those in the EF lineup, resulting in smaller elements and a lighter, more compact package.

L-series lenses

Despite having a rugged, heavy build quality, Canon's L-series lenses are packed with finely tuned technology. These professional optics use Super Low Dispersion and UD glass, with fluorite and aspherical elements *(see page 213)* to achieve superior image quality. Typically, these lenses feature wide apertures throughout the entire zoom range, making them popular with sports and nature photographers. Unfortunately, this top-end technology is reflected in a top-end price.

> **Note:**
> The EOS 60D will accept many lenses made by third-party manufacturers, such as Sigma and Tamron.

» FOCAL LENGTH AND ANGLE OF VIEW

Focal length

The focal length of a lens is measured in millimeters, and describes the distance between the optical center of the lens and the focal plane (in this case, the sensor) when the lens is focused at infinity. The focal length determines how much the lens can see (angle of view) and how magnified the subject will appear in the frame. Focal length can be divided into three categories: wide-angle, standard, and telephoto. Wide-angle lenses have a short focal length and a wide angle of view, whereas telephoto lenses have a long focal length and a narrow angle of view. The physical focal length of a lens never changes. Due to the crop factor, the apparent field of view changes, making the lens appear to increase in focal length.

Crop factor

Like many DSLRs, the EOS 60D has a sensor that is smaller than full-frame 35mm format (22.3 x 14.9mm compared to 36 x 24mm). As a result, any lens attached to the camera experiences a reduction in the angle of view, making it appear to have a longer focal

Note:
The focal plane of the EOS 60D is illustrated by the ⊖ Focal Plane mark, situated toward the back of the camera body.

POINTS OF VIEW ⌃
The inner rectangle shows the angle of view obtained with an APS-C sensor, compared to a full-frame sensor.

length. The difference between the two formats is 1.6x. This figure is often referred to as the crop or magnification factor. When using telephoto lenses, this 1.6x factor is a blessing, since it can effectively turn a zoom lens into a telephoto. On the flip side, photographers using wide-angle lenses may need to invest in ultra-wide-angle optics just to obtain a standard wide-angle effect.

Angle of view

The angle (or field) of view is measured in degrees (°), and describes how much of the subject is "seen" by the lens and projected onto the sensor. This figure is determined by the focal length of the lens and the size of the sensor. Wide-angle lenses have a wide angle of view, enabling you to include more in the frame than with a telephoto lens, which has a narrow angle of view.

7 » WIDE-ANGLE LENSES

Thanks to their ability to exaggerate foreground features while offering extensive depth of field, wide-angle lenses are especially popular with landscape photographers. Generally speaking, any optic with a focal length of less than 35mm is classed as a wide-angle. However, due to the crop factor on the EOS 60D *(see page 205)*, photographers wishing to take full advantage of the effects may need to purchase an ultra-wide-angle lens. In 2004, Canon released the EF-S 10-22mm f/3.5-4.5 wide-angle lens (offering a 35mm equivalent of 16-35mm), which provides a good starting point for those wishing to stay loyal to the brand. However, lens manufacturers such as Sigma and Tamron offer excellent alternatives.

Despite their benefits, wide-angle lenses should be used with care. One of their main advantages is that they appear to exaggerate perspective. As a result, elements in the frame seem to be miles apart, even when they are very close together. This optical illusion is great for architectural photography or shooting interiors, but it can leave your subject floating in acres of space—the shorter the focal length of the lens, the more extreme this distortion will be.

FISHEYE ⌃
An ultra-wide optic with a focal length of 16mm or less (with its distortion left uncorrected) is known as a fisheye lens.

IN FULL BLOOM »
Moving in close with a wide-angle lens allowed the primroses in the foreground to dominate the frame.

» TELEPHOTO LENSES

Telephoto lenses have a narrow angle of view: they appear to magnify objects in the frame and give the appearance of compressing perspective—perfect for sports and wildlife photographers. These optics also reduce depth of field, especially at wide apertures such as f/5.6, making them ideal for isolating a subject against a soft, blurry background. With such a narrow zone of sharpness, accurate focusing is critical. Unfortunately, telephotos tend to be rather large and heavy, making handholding difficult. Thankfully, many of these lenses come with image stabilization (IS), but this superior technology is matched by a superior price tag. If you don't want to blow the budget, invest in a tripod or other form of support *(see pages 226-7)*.

In 35mm terms, any lens with a focal length greater than 50mm is classed as a telephoto, but due to the crop factor on the EOS 60D *(see page 205)*, shorter, more affordable lenses can be used to achieve similar results. The most popular focal length for a telephoto lens is 80-200mm, but Canon produces an extensive range, including the EF-S 55-250mm f/4-5.6 IS and EF 100-400mm f/4.5-5.6L IS USM.

The Canon EF 800mm f/5.6 L IS USM telephoto lens

7 » PRIME LENSES

» STANDARD LENSES

As the name suggests, fixed-focal-length (or prime) lenses have no zooming function, restricting them to a single focal length. These optics, however, tend to feature larger maximum apertures than zooms (covering the same focal length range), making them ideal for handholding. Canon produces a number of prime lenses, ranging from the EF 14mm f/2.8L USM (ideal for shooting interiors) to the EF 800mm f/5.6L IS USM (perfect for sports photography). Limiting yourself to a single prime lens is a great way to get your feet moving!

In the past, a 50mm (or standard) lens was often supplied as a kit lens for film cameras, since its angle of view roughly matches that of the human eye. Standard lenses offer generously wide apertures and do not exaggerate foregrounds or compress focal planes. However, due to the crop factor on the EOS 60D *(see page 205)*, you will need a 35mm lens to get the same effect. Zoom lenses that include the standard focal length within their range are often referred to as standard zooms.

GET MOVING ❯❯
Fixed-focal-length lenses force you to move your feet. Here I positioned myself close to the boat so that I could create a tight composition.

PRIME LENS ❯❯
One of the two 35mm prime lenses Canon produces that can be used on the EOS 60D to mimic the standard lens effect.

» ZOOM LENSES

Due to their variable focal length, zoom lenses allow you to make the subject appear larger or smaller in the frame by turning a ring on the barrel. Aside from compositional benefits, a zoom lens can take the place of two or three prime lenses, saving space and reducing weight in your kit bag. For general use, focal ranges of 24–70mm and 70–200mm are ideal; Canon produces the EF 24–70mm f/2.8L USM and EF 70–200mm f/2.8L USM for this purpose. However, due to the crop factor on the EOS 60D *(see page* 205)*, you will need to purchase shorter lenses to achieve the same range. In the past, photographers chose primes over zooms because of their superior optical quality, but thanks to modern lens technology this is no longer the case. However, zoom lenses tend to have smaller apertures than primes in the same focal range, forcing slower shutter speeds. In addition, these lenses can make photographers lazy—to get closer to a subject, move your feet first, and then the zoom ring.

STAY BACK ⌄
Zoom lenses allow you to frame distant objects with precision. Here I was unable to move closer to the subject, so I took advantage of the variable focal length to compose my shot.

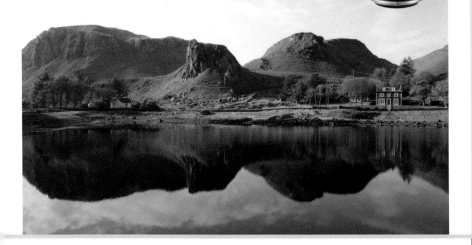

The Canon EF-S 15-85mm f3.5-5.6 IS USM zoom lens

7 » MACRO LENSES

Many zoom lenses allow focusing at close distances, but few enable genuine life-size reproductions (1:1). Similarly, while the EOS 60D features a close-up mode *(see pages 52–3)*, it does not offer the creative control obtainable with a dedicated macro lens. Canon produces six such optics: EF-S 60mm f/2.8 Macro USM, EF 100mm f/2.8 Macro USM, EF 100mm f/2.8L Macro IS USM, EF 180mm f/3.5L Macro USM, EF 50mm f/2.5 Macro, and MP-E65 f/2.8 1-5 x Macro. Although these lenses are costly, all

of them—with the exception of the MP-E65—can focus to infinity, making them suitable for general photography as well as macro subjects.

Fans of insect photography should consider using a macro lens with a long focal length, such as 90mm, 100mm, 105mm, or 180mm. These will enable frame-filling photographs at comfortable working distances, minimizing any disturbance to wildlife. Shorter focal lengths, such as 50mm, 55mm, 60mm, or 65mm are ideal for moving in close to static objects such as leaves, paintwork, or jewelry—they also make excellent lenses for portraiture. For details of close-up attachments, lighting, and accessories, see Chapter 6 *(pages 194–201)*.

TICK TOCK �
Macro lenses with shorter focal lengths are ideal for static subjects such as jewelery.

The Canon EF 100mm f/2.8L IS USM macro lens

» TILT-AND-SHIFT LENSES

Tilt-and-shift (or perspective control) lenses are often used in architectural photography to solve the problem of converging verticals—a condition caused by tilting the camera up to include all of a building in the frame. The problem can be overcome by adopting a higher viewpoint, but this is not always possible. In addition, these clever lenses can be used to obtain very precise focusing—either transforming the scene into a strange miniature world or enabling extensive depth of field (even at wide apertures). These dramatic effects are made possible by tilting or shifting the front section of the lens in relation to the focal plane of the sensor (marked on the camera body). The tilting movement alters focus and depth of field, while the shift movement corrects converging verticals.

Canon produces four tilt-and-shift lenses: TS-E 17mm f/4L, TS-E 24mm f/3.5L II, TS-E 45mm f/2.8, and TS-E 90mm f/2.8, all of which must be manually focused. These lenses are relatively expensive, and some of their effects can be mimicked with post-processing software. In addition, the EOS 60D features a set of Creative filters that will allow you to experiment with focus and depth of field (see pages 224–5).

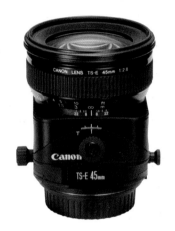

Canon TS-E 45mm f/2.8 tilt-and-shift lens

MAKING CORRECTIONS «
Converging verticals, such as those seen here, can be corrected using a tilt-and-shift lens.

7 » TELECONVERTERS

Teleconverters (or extenders) fit between the lens and the camera body, and work by increasing the focal length of the lens. These extenders are popular with wildlife and sports photographers, since they take up less room than telephoto lenses and are relatively inexpensive. In addition, the minimum focusing distance of the lens remains the same, making a teleconverter suitable for close-up work. Unfortunately, when using lenses with relatively narrow maximum apertures (such as f/5.6), the loss of light caused by the teleconverter can cause the autofocus to struggle or stop working altogether. The most common types of teleconverter are 1.4x (increasing focal length by 40%) and 2x (increasing focal length by 100%). Due to the crop factor on the EOS 60D *(see page 205)*, a 200mm lens coupled with a 2x extender can effectively become a 640mm lens.

Canon recently launched two new teleconverters: the Extender EF 1.4x III and the Extender EF 2x III, both of which are intended to improve autofocus accuracy, and increase communication between the camera and lens. As with previous models, these extenders are not compatible with all EF lenses.

MINIMUM FOCUSING DISTANCE ^
Teleconverters extend the focal length of the lens while leaving the minimum focusing distance unchanged, making them suitable for close-up work.

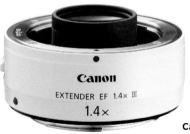

Canon Extender EF 1.4x III teleconverter

» MODERN LENS TECHNOLOGY

Canon lenses are often accompanied by complex technological terms and mystifying abbreviations. Here are 10 of the most common, with brief explanations.

Aspherical elements If left uncorrected, light rays entering a lens will converge at slightly different focal points, a condition known as spherical aberration. To correct this, Canon uses an element with a specially curved surface in its lenses. The first lens to feature this technology was the Canon FD 55mm f/1.2AL in 1971.
Main benefit Sharper images with higher contrast.

EF (Electro Focus) Launched in 1987 to replace the old mechanical FD lenses, the EF range is compatible with all of Canon's EOS SLR cameras. However, when these lenses are fitted to a digital camera with an APS-C sensor, the subject appears magnified in the frame due to the crop factor *(see page 205)*.
Main benefit EF lenses work on all Canon EOS SLRs.

EF-S Canon's EF-S lens range (launched in 2003) is designed for digital cameras using APS-C sensors, such as the EOS 60D. While these lenses do not eliminate the crop factor *(see page 205)*, they are produced at affordable prices, allowing ultra-wide-angle lenses to be used as wide-angles, and zooms as telephotos.
Main benefit Increased wide-angle options for APS-C sensors.

IF (Internal Focusing) To achieve focusing, lenses with IF move a series of internal parts, without rotating the front element of the lens. This technology is ideal when shooting macro subjects, or using a polarizer or petal-shaped lens hood.
Main benefit Makes polarizers and petal-shaped lens hoods easier to use.

IS (Image stabilizer) Lenses featuring IS units sense camera shake or vibration and promptly move a group of internal elements to correct the condition. Pentax, Olympus, and Sony use in-camera technology to reduce camera shake, but Canon and Nikon employ image stabilizer units in the lenses themselves.
Main benefit Sharper, crisper images.

L-series Canon's ultimate EF lens range is called the L-series and can be recognized by the red stripe on the barrel. The optics in this range feature the company's most advanced lens technology, including fluorite, aspherical, and Super UD elements, and Super Spectra Coating.
Main benefit Combines the best of Canon's lens technology.

7 » CANON LENS CHART

Lens name	Angle of view (horizontal)	Minimum focus (meters)
Fixed focal length lenses		
EF 14mm f/2.8L USM	104°	0.25
EF 14mm f/2.8L II USM	81°	0.20
EF 15mm f/2.8 Fisheye	141°54'	0.20
EF 20mm f/2.8 USM	84°	0.25
EF 24mm f/1.4L II USM	74°	0.25
EF 24mm f/2.8	74°	0.25
EF 28mm f/1.8 USM	65°	0.25
EF 28mm f/2.8	65°	0.30
EF 35mm f/2	54°	0.25
EF 35mm f/1.4L USM	54°	0.30
EF 50mm f/1.2L USM	40°	0.45
EF 50mm f/1.4 USM	40°	0.45
EF 50mm f/1.8 II	40°	0.45
EF 85mm f/1.2L II USM	16°	0.95
EF 85mm f/1.8 USM	24°	0.85
EF 100mm f/2 USM	20°	0.90
EF 135mm f/2L USM	15°	0.90
EF 135mm f/2.8 SF (Soft Focus)	15°	1.30
EF 200mm f/2L IS USM	10°	1.90
EF 200mm f/2.8L II USM	10°	1.50
EF 300mm f/2.8L IS USM	6°50'	2.50
EF 300mm f/4L IS USM	6°50'	1.50
EF 400mm f/2.8L IS USM	5°10'	3.00
EF 400mm f/4 DO IS USM	5°10'	3.50

Minimum aperture	Maximum magnification (x)	Filter thread size (mm)	Dimensions (max.diam. x length: mm)	Weight (g)
f/22	0.10	Filter holder	77.0 x 89.0	560
f/22	0.15	Filter holder	80.0 x 84.0	645
f/22	0.14	Filter holder	73.0 x 62.2	330
f/22	0.14	72	77.5 x 70.6	405
f/22	0.17	77	93.5 x 86.9	650
f/22	0.16	58	67.5 x 48.5	270
f/22	0.18	58	73.6 x 55.6	310
f/22	0.13	52	67.4 x 42.5	185
f/22	0.23	52	67.4 x 42.5	210
f/22	0.18	72	79.0 x 86.0	580
f/16	0.15	72	85.8 x 65.5	580
f/22	0.15	58	73.8 x 50.5	290
f/22	0.15	52	68.2 x 41.0	130
f/16	0.11	72	91.5 x 84.0	1025
f/22	0.13	58	75.0 x 71.5	425
f/22	0.14	58	75.0 x 73.5	460
f/32	0.19	72	82.5 x 112.0	750
f/32	0.12	52	69.2 x 98.4	390
f/32	0.12	52 (drop in)	128.0 x 208.0	2520
f/32	0.16	72	83.2 x 136.2	765
f/32	0.13	52 (drop in)	128.0 x 252.0	2550
f/32	0.24	77	90.0 x 221.0	1190
f/32	0.15	52 (drop in)	163.0 x 349.0	5370
f/32	0.12	52 (drop in)	128.0 x 232.7	1940

Lens name	Angle of view (horizontal)	Minimum focus (meters)
EF 400mm f/5.6L USM	5°10'	3.50
EF 500mm f/4L IS USM	4°	4.50
EF 600mm f/4L IS USM	3°30'	5.50
EF 800mm f/5.6L IS USM	2°35'	6.00

Zoom lenses

EF-S 15-85mm f/3.5-5.6 IS USM	74°10'-15°25'	0.35
EF-S 17-55mm f/2.8 IS USM	48°-15°40'	0.35
EF-S 17-85mm f4-5.6 IS USM	68°40'-15°25'	0.35
EF-S 18-200mm f/3.5-5.6 IS	64°30'-6°30'	0.45
EF 8-15mm f/4L Fisheye USM	180°-142°	0.15
EF-S 10-22mm f/3.5-4.5 USM	97°10'-54°30'	0.24
EF-S 15-85mm f/3.5-5.6 IS USM	74°10'-15°25'	0.35
EF 16-35mm f/2.8L II USM	98°-54°	0.28
EF 17-40mm f//4L USM	93°-49°20'	0.28
EF-S 18-135mm f/3.5-5.6 IS	64°30'-9°30'	0.45
EF 24-70mm f/2.8L USM	84°-34°	0.38
EF 24-105mm f/4L IS USM	74°-19°20'	0.45
EF 70-200mm f/2.8L USM	29°-10°	1.40
EF 70-200mm f/4L USM	29°-10°	1.20
EF 75-300mm f/4-5.6 III	27°-6°50'	1.50
EF 75-300mm f/4-5.6 III USM	27°-6°50'	1.50
EF 100-300mm f/4.5-5.6 USM	20°-6°50'	1.50
EF 100-400mm f/4.5-5.6L IS USM	20°-5°10'	1.80
EF 28-90mm f/4-5.6 II	65°-22°40'	0.38

Minimum aperture	Maximum magnification (x)	Filter thread size (mm)	Dimensions (max.diam. x length: mm)	Weight (g)
f/32	0.12	77	90.0 x 256.5	1250
f/32	0.12	52 (drop in)	146.0 x 387.0	3870
f/32	0.12	52 (drop in)	168.0 x 456.0	5360
f/32	0.14	52 (drop in)	163.0 x 461.0	4500
f/22-38	0.21	72	81.6 x 87.5	575
f/22	0.17	77	85.5 x 110.6	645
f/22-32	0.20	67	78.5 x 92.0	475
f/22-38	0.24	72	78.6 x 102.0	595
f/22	0.39	Filter holder	78.5 x 83.0	540
f/22-27	0.17	77	83.5 x 89.9	385
f/22-38	0.21	72	81.6 x 87.5	575
f/22	0.22	82	88.5 x 111.6	635
f/22	0.24	77	83.5 x 96.8	500
f/22-38	0.21	67	75.4 x 101.0	455
f/22	0.29	77	83.2 x 123.5	950
f/22	0.23	77	83.5 x 107.0	670
f/32	0.16	77	84.6 x 193.6	1310
f/32	0.21	67	76.0 x 172.0	705
f/32-45	0.25	58	71.0 x 122.0	480
f/32-45	0.25	58	71.0 x 122.0	480
f/32-38	0.20	58	73.0 x 121.5	540
f/32-38	0.20	77	92.0 x 189.0	1380
f/22-32	0.30	58	67.0 x 71.0	180

7

Lens name	Angle of view (horizontal)	Minimum focus (meters)
EF 28-135mm f/3.5-5.6 IS USM	65°-15°	0.50
EF 28-300mm f/3.5-5.6L IS USM	65°-6°50'	0.70
EF 35-350mm f/3.5-5.6L USM	54°-6°	0.60
EF-S 55-250mm f/4-5.6 IS	23°20'-5°20'	1.10
EF 70-200mm f/2.8L IS II USM	29°-10°	1.20
EF 70-300mm f/4.5-5.6 DO IS USM	29°-6°50'	1.40
EF 70-300mm f/4-5.6 IS USM	29°-6°50'	1.50
EF 70-300mm f/4-5.6L IS USM	29°-6°50'	1.20
EF 75-300mm f/4-5.6 III	27°-6°50'	1.50
EF 75-300mm f/4-f/5.6 III USM	27°-6°50'	1.50
EF 75-300mm f/4-5.6 IS USM	27°-6°50'	1.50
EF 100-400mm f/4.5-5.6L IS USM	20°-5°10'	1.80

Tilt and shift lenses

TS-E 17mm f/4L	93°	0.25
TS-E 24mm f/3.5L II	74°	0.21
TS-E 45mm f/2.8	44°	0.40
TS-E 90mm f/2.8	22°37'	0.50

Macro lenses

EF-S 60mm f/2.8 Macro USM	20°40'	0.20
EF 100mm f/2.8 Macro USM	20°	0.31
EF 100mm f/2.8L Macro IS USM	19.8°	0.30
EF 180mm f/3.5L Macro USM	11°25'	0.48
EF 50mm f/2.5 Macro	40°	0.23
MP-E65 f/2.8 1-5 x Macro	15°40'	0.24

Minimum aperture	Maximum magnification (x)	Filter thread size (mm)	Dimensions (max.diam. x length: mm)	Weight (g)
f/22-36	0.19	72	78.4 x 96.8	540
f/22-38	0.06	77	92.0 x184.0	1670
f/22-32	0.25	72	85.0 x 167.4	1385
f/22-32	0.31	58	70.0 x 108.0	390
f/32	0.21	77	88.8 x 199.0	1490
f/32-38	0.19	58	82.4 x 99.9	720
f/32-45	0.26	58	76.5 142.8	630
f/32-45	0.21	67	89.0 x 143.0	1050
f/32-45	0.25	58	71.0 x 122.0	480
f/32-45	1.50	58	71.0 x 122.0	480
f/32-45	0.26	58	78.5 x 138.2	650
f/32-38	0.20	77	92.0 x 189.0	1380
f/22	0.14	77	88.9 x 106.9	820
f/22	0.34	82	88.5 x 106.9	780
f/22	0.16	72	81.0 x 90.1	645
f/32	0.29	58	73.6 x 88.0	565
f/32	1.00	52	73.0 x 69.8	335
f/32	1.00	58	79.0 x 119.0	600
f/32	1.00	67	77.7 x 123.0	625
f/32	1.00	72	82.5 x 186.6	1090
f/32	0.50	52	67.6 x 63.0	280
f/16	5.00	58	81.0 x 98.0	710

Chapter 8
ACCESSORIES

8 ACCESSORIES

Contrary to popular belief, you don't need a bag full of gadgets and gizmos to take a decent photograph. However, there are one or two accessories that no self-respecting photographer should be without.

» EXTERNAL FILTERS

Some photographers argue that external filters have no place in digital photography, since so many of their effects can be recreated with post-production software. In addition, any glass placed in front of the lens inevitably will reduce image quality to some extent. However, getting it right in the field saves valuable time in front of the computer, and it can also provide valuable lessons. While it may be true that color correction filters have been superseded by white balance settings *(see pages 97–9)*, there are some effects that simply cannot be replicated convincingly in-camera or by using post-production software.

› Filter systems

Generally speaking, filters are either circular or square/rectangular, and they can be screwed to the front of the lens, or slotted into a special holder attached to the lens by means of an adapter ring. The system you choose will depend on personal preference and the number of lenses you possess. If you own just one or two optics, you might prefer the ease and convenience of the circular screw-thread option, but if later you decide to buy a lens with a larger or smaller filter thread, you might need to purchase the same filter again. To solve the problem, you can buy stepping rings, but the extra thickness can cause vignetting when used with wide-angle lenses. By contrast, photographers using the slot-in system can use the same filter on different threads by purchasing relatively inexpensive, and thin, adapter rings. In addition, several filters can be slotted into the holder, allowing precise control over the end result.

Tip

Canon produces a range of filters designed specifically for EF lenses, including Protect filters (for deepening blue skies and preventing the front of the lens from becoming dusty or scratched), UV filters (for reducing haze on sunny days), ND filters (for balancing contrast), and polarizers (for reducing reflections and glare).

PROTECTIVE COVER ⌃
Ultra-violet (UV) filters are often used to protect the front element of a lens from sand, sea spray, and scratches.

Skylight and Ultra-violet (UV) filters

Photographers often use a Skylight or Ultra-violet (UV) filter to protect the front element of a lens, leaving it in place at all times. Both of these filters absorb ultra-violet light, cutting out the blue cast experienced at high altitudes and reducing atmospheric haze. The Skylight also has a warming effect.

Polarizing filters

Perfect for deepening blue skies, reducing glare on non-metallic surfaces, and eliminating reflections from water and glass, polarizers should be a staple of every kit bag. These versatile filters are available in two types: linear or circular—the EOS 60D requires the circular variety. The strongest results are achieved by using the filter at 90° to the sun. To eliminate reflections from water and glass, keep the angle between the lens axis and the reflective surface at about 30°. Rotate the polarizer while looking through the viewfinder until you find the most natural result.

Neutral Density (ND) graduated filters

ND (Neutral Density) graduated filters feature a strong shaded area at the top that fades to clear at the bottom. The filter is mainly used in landscape photography to reduce the contrast between bright skies and dark foregrounds, enabling the sensor to record detail in both areas. As the name suggests, the ND grad has a neutral effect on skies—unlike a gray grad, it will not produce a color cast. These filters come in a variety of densities, most commonly 0.3, 0.6, and 0.9. If you can only afford one, go for the 0.6.

DEEP BLUE SKIES ⌃
Polarizing filters deepen blue skies and reduce reflections on water, an effect that's difficult to reproduce in-camera or even with post-processing software.

8

» USING BUILT-IN FILTERS

Neutral Density (ND) filters

ND (Neutral Density) filters are shaded all over, but they will not create a color cast. The filter is mainly used to lengthen shutter speeds, when a low ISO and small aperture are not enough to produce the desired result, which is useful when shooting moving water. These filters come in a variety of densities, most commonly 0.3, 0.6, and 0.9—you can even buy a 10-stop version.

Special-effect filters

Often dismissed as gimmicks, special-effect filters can add starbursts, rainbows, or soft focus to photos. While the results may be clichéd, it's fun to experiment. Take a look at filters available in post-production software programs; for a more modern selection, see the Creative Filters on the EOS 60D.

REDUCING CONTRAST ≋
Neutral Density graduated filters are used in landscape photography to reduce the contrast between land and sky.

The EOS 60D features four Creative Filter settings: **Grainy B/W**, **Soft focus**, **Toy camera effect**, and **Miniature effect**. These filters are applied after the image has been taken, with the result saved as a separate image. (Creative Filters cannot be applied to **M**RAW and **S**RAW files.)

1) Press **MENU** and use the 🔆 Main Dial or ◄► on the Multi-controller to select 📷 Playback Menu 1.

2) Rotate the ◌ Quick Control Dial or use ▲ ▼ on the Multi-controller to highlight **Creative filters**. Press **SET**. All suitable images will be displayed.

3) Rotate the ◌ Quick Control Dial or use ◄ ► on the Multi-controller to select an image. (Press the 🔲/🔍 button to view multiple images in the index display. Rotate the ◌ Quick Control Dial or use ◄ ► on the Multi-controller to select an image.) Press **SET**. The filter choices will appear.

4) Rotate the ◌ Quick Control Dial or use ◄► on the Multi-controller to highlight an effect. Press **SET**. The altered image will appear on the LCD monitor.

5) To adjust the effect of a filter, rotate the ◌ Quick Control Dial or use ◄ ► on the Multi-controller. Press **SET**. To adjust the **Miniature effect** filter, use ▲ ▼ on the Multi-controller to move the white frame

TIMELESS BLACK & WHITE ⩔
Using the Grainy B/W Creative Filter, you can give your pictures a timeless monochrome look.

to an area that you would like to remain sharp. Press **SET**.

6) To save the new image, rotate the ⟳ Quick Control Dial or use ◀▶ on the Multi-controller to highlight **OK**. Press **SET**. The message **Image saved in folder with number ------. Returning to original image**. **OK** will be displayed on the LCD monitor. Press **SET**. The original, unaltered image will reappear.

7) To apply a Creative filter to another image, repeat steps 3–6. To return to the menu, press **MENU**.

» CREATIVE FILTER EFFECTS

Grainy B/W This filter turns the image black and white, adding fake film grain. The contrast can be adjusted using the Quick Control Dial or Multi-controller.

Soft focus This filter adds a soft focus look to the image. The level of blur can be adjusted using the Quick Control Dial or Multi-controller.

Toy camera effect This filter darkens the corners of the image and adds a color cast similar to that achieved with toy cameras. The color tone can be adjusted using the Quick Control Dial or Multi-controller.

Miniature effect This filter adds a three-dimensional diorama look to the image. The orientation of the white frame can be switched between vertical and horizontal by pressing the **INFO** button.

> **Note:**
> When applying a Creative filter effect to RAW+JPEG files, the RAW version will be altered and saved as a JPEG. When adjusting **M RAW** + JPEG and **S RAW** + JPEG files, the effect will be applied to the JPEG image.

8 » SUPPORTING THE CAMERA

Many perfectly composed, excellently exposed photographs are ruined by camera shake. There's no denying that holding your camera steady is tricky, but there are many products available to help you achieve pin-sharp pictures.

Before you head for the camera store, however, try perfecting your posture. Grip the camera firmly with your right hand and support the lens from below with your left hand. Stand with your legs slightly apart, one foot in front of the other, to increase stability (or, if you are crouching, rest one knee on the ground). Keep your elbows tucked into your body. Rest the forefinger of your right hand on the shutter-release button. Press the camera lightly against your face (unless using the Live View function) and look through the viewfinder. Take the picture after breathing out. If you are still struggling to keep still, lean your body against a support such as a wall or pillar. When handholding the camera, try to use a shutter speed that at least matches the focal length of the lens. For instance, if your lens is 50mm, use a shutter speed of 1/60sec.

Selecting a tripod

If you're using long lenses and/or slow shutter speeds, a tripod is a must. Aside

from the technical advantage (sharper pictures), using a tripod will slow you down and force you to consider your compositions. When it comes to choosing a three-legged support, you need to consider maximum height, size, and load. When fully extended, the tripod should comfortably reach your eye level, or preferably a few inches higher. If you plan to carry your tripod long distances, it's worth checking its minimum size when collapsed. Crucially, you will need to determine its maximum load—add the weight of your camera body (675g) to that of your longest lens, and multiply the

© Daniel Calder

STEADY PARTNERSHIP »
Keeping your camera steady is simple if you team a tripod with a cable release.

result by two. Finally, look at the head and feet options, and the materials and weight. If you shoot a lot of portrait-format photographs, consider investing in a ball head. Similarly, if you regularly shoot on rough or uneven terrain, look for spiked tips on the feet. When it comes to weight, carbon-fiber tripods are lighter than aluminum, but this advantage is reflected in the price. Before choosing one material over another, consider how well each absorbs vibration, and how durable it is.

A LEG TO STAND ON
Extendable monopods are lighter and more compact than tripods.

© Daniel Calder

Selecting a monopod

While a monopod is no substitute for a well-built tripod, this one-legged support can offer anything up to a four-stop advantage over handholding. In addition, monopods are lighter and more compact than tripods, regardless of the material used in their construction. Furthermore, they can be extended and ready for action in seconds. Many models can accommodate a ball head, while some offer the option of attaching a pan-and-tilt head with a built-in spirit level. The bottom of the leg is commonly fitted with a rubber foot, but some monopods also feature a spiked tip for extra stability on rough or uneven surfaces. In a few instances, the bottom of the monopod even splays out to create a three-legged base, mimicking a tripod.

Beanbags and other supports

There will be occasions when a tripod or monopod is impractical (e.g., shooting from a vehicle while on safari), and for this reason the market is full of clamps and supports to help steady your gear. For low-level shooting, a beanbag is ideal, and can also be balanced on fence posts and car windows. Choosing a beanbag is simple—just decide how much surface area you require, look for tough, showerproof material, and choose a filling that does not hold moisture (such as plastic beads).

8 » OPTIONAL ACCESSORIES

Canon manufactures a wide range of accessories to support the EOS 60D—from Speedlite flash units to wireless file transmitters and battery grips. To find out more, visit www.usa.canon.com or www.canon.co.uk.

AC Adapter kit ACK-E6
This AC adapter kit enables the EOS 60D to run off household power instead of the LP-E6 battery.

Car battery charger CBC-E6
By plugging this charger into a car's power socket, your LP-E6 battery can be recharged while on the road.

Battery grip BG-E9
This grip enables two LP-E6 batteries to be used simultaneously for extended shooting sessions. In addition, the BGM-E9A battery magazine slots inside to allow the use of AA batteries. The device also doubles as a vertical control grip, with key controls such as Exposure compensation and AF point selection conveniently placed for vertical operation.

Angle finder C
Attached to the EOS 60D eyepiece, this angle finder makes low-viewpoint photography more comfortable by allowing the image to be viewed, correctly oriented, from above. In addition, Angle finder C allows precise manual focus, thanks to its 2.5x magnification feature.

Focusing screens
The focusing screen in the viewfinder of the EOS 60D is interchangeable. The camera comes with an Ef-A Standard Precision Matte focusing screen, but this can be changed for an Ef-D Precision Matte screen with a grid, or an Ef-S Super Precision Matte optimized for wide-aperture lenses of f/2.8 or faster.

Eyepiece extender EP-EX15

Using this accessory, the camera eyepiece is extended by 15mm to create more comfortable viewing and less contact with the LCD screen.

Remote switch RS-60E3

This switch can be used to release the shutter from a distance of up to 60cm. When combined with a tripod, it can reduce camera shake caused by pressing the shutter button.

Remote controller RC-6

Using this wireless remote control, the shutter can be operated from a distance of up to 5m. You can either shoot immediately, or with a 2-second delay. (Remote Controllers RC-1 and RC-5 are also compatible with the EOS 60D.)

EX Speedlites

Canon's wide range of flashguns, designed to work intelligently with EOS camera bodies, are known as EX Speedlites. For full details, *see Chapter 5.*

SD Memory card

The EOS 60D accepts standard SD memory cards with a capacity of 2GB. The camera is also compatible with SDHC (High Capacity) cards with a maximum capacity of 32GB, and SDXC (Extended Capacity) cards for anything greater. When shooting movies, it is advisable to use one of the higher-capacity cards.

Portable storage devices

These compact portable hard drives are great for backing up your pictures while traveling or on a long shoot. Canon manufactures the Media Storage M30 (30GB) and M80 (80GB) storage devices, each with a 3.7in (9cm) LCD screen for comfortable image viewing.

OFF

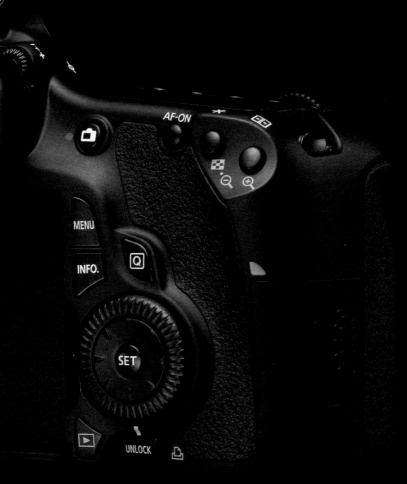

Chapter 9
CONNECTION

9 CONNECTION

To realize the full potential of your camera, you need to connect it to a computer, printer, or television. Doing so, will enable you to view, organize, and manipulate your images, display them on the web, show them to others, or present them in the form of a print.

» INSTALLING THE SOFTWARE

Before downloading your images to a computer, it's worth making the effort to calibrate the monitor. Without knowing the true color of the image, you will not be able to adjust or publish it with 100% accuracy. A good place to start is a software calibrator, such as QuickGamma (for PC) or SuperCal (for Mac). If you intend to print a large number of images, it's worth investing in a hardware color calibrator, such as Eye-One Display 2 or Spyder 3, to provide consistent, accurate results.

› Installing the CD-ROMs

The EOS 60D comes with a number of software programs that need to be installed via a CD-Rom drive on your computer.

EOS Digital Solution Disk
This disk contains the various programs for downloading, editing, and organizing the images taken with your camera.

1) Ensure that the camera is NOT connected to the computer.

2) Insert the EOS Digital Solution Disk into the CD/DVD drive and follow the onscreen instructions.

EOS Digital Software Instruction Manuals Disk
This disk contains all of the manuals for the various programs on the EOS Digital Solution Disk. Each manual is in the form of a PDF, so ensure you have the necessary reader installed from www.adobe.com.

1) Insert the EOS Digital Software Instruction Manuals Disk into the CD/DVD drive.

2) Open the CD in My Computer on a PC, or in Finder on a Mac.

3) Click to open the Manuals folder and select the appropriate language.

4) Open the desired PDF manual for PC or Mac. Save to your computer if you wish.

» CANON SOFTWARE

The software that accompanies the EOS 60D has been designed by Canon and is intended specifically for Canon cameras. For an in-depth guide to the bundled software, consult the PDF manuals included on the EOS Digital Software Instruction Manuals Disk.

Digital Photo Professional

Digital Photo Professional (DPP) is a sophisticated RAW processing program. It can stand alone or be used in conjunction with other Canon programs, such as PhotoStitch and Picture Style Editor. RAW images downloaded to DPP can be adjusted with advanced color correction techniques and then converted to JPEG or TIFF files, either individually or as a batch.

EOS Utility

EOS Utility allows you to select images from the camera for download as a single image or as a batch. Using this software, you can also control the camera directly from your computer. In addition, images can be displayed immediately on the computer monitor, without the need for a memory card. The captured shots can also be linked with DPP.

ZoomBrowser EX (PC) and ImageBrowser (Mac)

ZoomBrowser EX and ImageBrowser are used for viewing, editing, and organizing pictures. The editing suite supports basic adjustments to brightness, color, cropping, etc, but is also useful for adding text to images, inserting pictures in emails, or using them as wallpaper or screensavers. It can also be used for playing and editing movies, plus extracting still images from clips. The software facilitates the printing of images with a Canon inkjet printer.

Picture Style Editor

Picture Style Editor allows each Picture Style to be adjusted to your exact requirements before being saved and applied to images. Changes to color tones, saturation, contrast, sharpness, and gamma characteristics can all be applied. Picture Styles that have been defined in the EOS 60D can, in turn, be saved to the computer.

PhotoStitch

PhotoStitch allows the merging of up to 26 images into a single image. It is particularly useful for creating panoramas.

9 » CONNECTING TO A COMPUTER

Before connecting the camera to a computer, install the EOS Digital Solution Disk and make sure the camera battery is fully charged.

1) Make sure the camera power switch is **OFF**.

2) Connect the USB cable (provided) to the DIGITAL terminal of the camera.

3) Connect the other end of the cable to a USB port on the computer.

4) Turn the camera power switch **ON**.

5) Select the program you wish to use for downloading the images.

› Using Eye-Fi cards

With an Eye-Fi card (available separately), you can transfer images to a computer or upload them to an online service via a wireless Local Area Network (LAN). Be aware that the EOS 60D is not guaranteed to support Eye-Fi card functions. Also, approval is required to use Eye-Fi cards in many countries and regions.

1) In ♥ Setup Menu 1, highlight **Eye-Fi settings.** Press **SET**. (This option will only be displayed when an Eye-Fi card has been inserted into the camera.)

Warning!

Even if **Eye-Fi trans.** is set to **Disable**, it may still transmit a signal. In hospitals, airports, and other places where wireless transmissions are prohibited, remove the Eye-Fi card from the camera.

2) Highlight **Eye-Fi trans.** and select **Enable**. Press **SET**.

3) Select **Connection info.** Press **SET**.

4) Check that an access point is displayed for **Access point SSID:**.

5) Press **MENU** three times to exit the menu.

» USING A PRINTER

The EOS 60D can be connected to a PictBridge-compatible printer. Images can then be selected individually or in a batch for direct printing from the memory card. The camera can also use Digital Print Order Format (DPOF) to apply certain printing instructions to pictures.

› Connecting to a printer

When you print directly from the camera, the LCD monitor is used to view the operation.

1) Check that the battery is fully charged in the camera or use the AC Adapter Kit ACK-E6 (sold separately) to connect to a household power supply.

2) Ensure that both the camera and the printer are switched off.

3) Plug the USB cable provided into the DIGITAL terminal on the EOS 60D, with the ⟵ symbol facing the back of the camera.

4) Connect the other end of the USB cable to the printer according to the printer's manual.

5) Turn on the printer, then the camera.

Note:
The EOS 60D cannot be used with printers that are only compatible with CP Direct or Bubble Jet Direct.

› Printing an image

6) Press the ▶ Playback button to display the image on the LCD monitor. The 🖉 PictBridge logo will appear in the top left-hand corner to indicate that the camera is connected to the printer.

7) Rotate the ⬡ Quick Control Dial to select the image to be printed.

8) Press **SET** to display the **Print Setting** screen on the LCD. Alongside the thumbnail image is a list of settings covering printing effects, date, file number, quantity, trimming, paper size, type, and layout. (Not all options will be available for every type of printer.)

9) Rotate the ⊙ Quick Control Dial to highlight **Paper settings**. Press **SET** to display the **Paper size** screen.

10) Rotate the ⊙ Quick Control Dial to select the dimensions of the paper to be printed on. Press **SET** to display the **Paper type** screen.

11) Rotate the ⊙ Quick Control Dial to select the type of paper to be printed on. Possible types of paper include Photo, Plain, and Default. Press **SET** to display the **Page layout** screen.

12) Rotate the ⊙ Quick Control Dial to select the page layout to be used. Press **SET** to return to the **Print setting** screen.

› Printing Effects

13) On the Print Setting screen, rotate the ⊙ Quick Control Dial to highlight the ⊠ Print effects option. Press **SET**.

14) Rotate the ⊙ Quick Control Dial to select each item you want to change. Press **SET**. Refer to the following table for the possible options, although not all of the effects will be available on all printers.

If the ⊞ icon is displayed next to **INFO**, additional options are available by pressing the camera's **INFO** button. The options available will depend on the printing effects you have selected.

Page layout options

Bordered Produces white borders along the edge of the print.

Borderless The print will have no borders unless your printer cannot print borderless prints.

Bordered **INFO** The shooting information from the EXIF data will be imprinted on 9 x 13cm and larger prints.

xx-up Select to print 2, 4, 8, 9, 16, or 20 images on one page.

20-up **INFO** and **35-up** Using Digital Print Order Format (DPOF), 20 or 35 thumbnail images will be printed on A4 or Letter-size paper. The 20-up **INFO** images will also have their EXIF data imprinted.

Default The page layout depends on the printer model and its settings.

Preset printing effects

Item	Description
⊠ Off	No automatic correction will be applied.
⊠ On	The image will be printed according to the printer's standard colors. The image's EXIF data is used to make automatic corrections.
⊠ Vivid	The image will be printed with higher saturation to produce more vivid blues and greens.
⊠ NR	Image noise is reduced before printing.
B/W B/W	Prints in black and white with true blacks.
B/W Cool Tone	Prints in black and white with cool, bluish blacks.
B/W Warm Tone	Prints in black and white with warm, yellowish blacks.
◘ Natural	Prints the image in the actual colors and contrast. No automatic color adjustments will be applied.
◘ Natural M	Using the same printing characteristics as Natural, this setting enables even finer printing adjustments.
⊠ Default	Printing will differ depending on the printer. For details, see the printer's instruction manual.

NOTE: Any changes to the printing effects will be displayed on the LCD monitor, but the printed image may look different to the onscreen version.

Adjustable printing effects

Brightness	The image brightness can be adjusted.
Adjust levels	Select **Manual** to change the histogram's distribution, and adjust the brightness and contrast of the image. Press the **INFO** button to move the indicator. Press ◄► on the Multi-controller to freely adjust the shadow level (0–127) or highlight level (128–255).
Brightener	Effective in backlit conditions, which can make the subject's face look too dark. When set to **ON**, the face will be brightened for printing.
Red-eye corr.	Effective in flash images where the subject may suffer from red-eye. When set to **ON**, the red-eye will be corrected for printing.

› Date/Time/File Number

15) Rotate the ◌ Quick Control Dial to select 🕐. Press **SET**.

16) Rotate the ◌ Quick Control Dial to select the desired setting. Press **SET**.

› Number of copies

17) Rotate the ◌ Quick Control Dial to select 🗇. Press **SET**.

18) Rotate the ◌ Quick Control Dial to set the number of copies. Press **SET**.

› Trimming

Images can be cropped to remove extraneous detail, allowing you to print only the trimmed portion. Trimming should be carried out after the other print settings have been decided and selected.

19) Rotate the ◌ Quick Control Dial to select **Trimming**. Press **SET**.

20) Press the 🔍 Magnify button or ▦ Index button to enlarge or reduce the size of the trimming frame. The smaller the trimming frame, the larger the image magnification will be for printing.

21) Use the ✻ Multi-controller to move the trimming frame to the desired area.

22) Press the **INFO** button to rotate the trimming frame from a horizontal to a vertical orientation—this will allow you to create a vertically oriented print from a horizontal image.

23) If desired, rotate the ⚙ Main Dial to tilt the image up to +/- 10° in 0.5° increments.

24) Press **SET** to exit Trimming and return to the Print setting screen.

25) Rotate the ◌ Quick Control Dial to highlight **Print**. Press **SET** to print.

26) To stop printing, press **SET** while **Stop** is displayed and select **OK**.

Warning!

Depending on the printer, the trimmed image area may not print exactly as specified. The smaller the trimming area, the grainier the image will look once printed.

› Digital Print Order Format (DPOF)

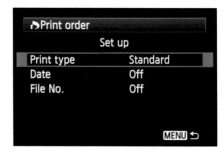

Digital Print Order Format (DPOF) records printing instructions to the memory card. You can set the print type, date, and file number imprinting to all print-ordered images, but not to individual images.

Setting the printing options:

1) Press **MENU**. Rotate the Main Dial or use ◄► on the Multi-controller to highlight Playback menu 1.

2) Rotate the Quick Control Dial or use ▲ ▼ on the Multi-controller to highlight **Print order**. Press **SET**.

3) Rotate the Quick Control Dial to highlight **Set up**. Press **SET**.

4) Rotate the Quick Control Dial to highlight the desired item. Press **SET**.

5) Rotate the Quick Control Dial to select the option for that item. Press **SET**.

6) Press **MENU** to display the **Print**

order screen. Rotate the Quick Control Dial to highlight **Sel.Image**, **By ■**, or **All image**. Press **SET** to select.

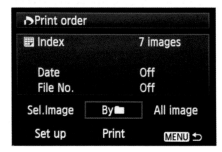

Print Ordering options:

Sel.Image allows you to select images one by one. Press the Index button and Magnify button to toggle between a single image and three images. When Standard or Both have been selected as the print type, use ▲ ▼ on the Multi-controller to set the number of copies (top left-hand corner). If you are printing an Index page, use ▲ ▼ on the Multi-controller to set a white check mark against the images to include.

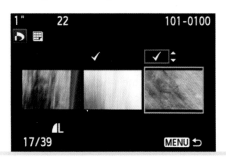

By ■ Select **Mark all in folder** to place a print order for one copy of every image in the selected folder. Select **Clear all in folder** to cancel a print order for the folder.

All image Select **Mark all on card** to place a print order for one copy of every image on the card. Select **Clear all on card** to cancel a print order.

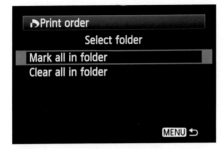

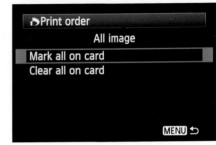

› Direct printing with DPOF

1) Connect the camera to a printer.

2) Press **MENU**. Rotate the ⌂ Main Dial or use ◄ ► on the Multi-controller to highlight ▶ Playback menu 1.

3) Rotate the ◎ Quick Control Dial or use ▲ ▼ on the Multi-controller to

highlight **Print**. (This option will only appear if the camera is connected to the printer and printing is possible.) Press **SET**.

4) Set the Paper settings *(see page 236)* and Printing effects *(see pages 236–7)*.

5) Highlight **OK**. Press **SET**. Select the desired setting. Press **SET**.

Printing options

	● Standard	Prints one image on one sheet.
Print type	⊞ Index	Multiple thumbnail images are printed on one sheet.
	● ⊞ Both	Prints both the standard and index prints.
Date	On	**On** imprints the recorded date on the print.
	Off	
File number	On	**On** imprints the file number on the print.
	Off	

» VIEWING IMAGES ON A TV

Displaying your images on a television is a great way of sharing them with an audience. The EOS 60D comes with all of the cords necessary for showing photographs and movies on a standard TV set. In addition, you can use HDMI cable HTC-100 (available separately) to play images on an HD (High Definition) TV.

Viewing images on a standard (non-HD) TV:
1) Make sure the camera's power switch is **OFF**.

2) Connect one end of the AV cable (provided) to the A/V OUT terminal on the camera.

3) Insert the other end of the AV cable into the VIDEO IN and AUDIO IN terminals on your TV.

4) Turn the TV on and switch its video input to select the connected port.

5) Turn the camera's power switch **ON**.

6) Press the ▶ Playback button on the camera. The images will be displayed on the TV; the LCD monitor will be blank.

7) To disconnect, turn the camera off, and then the TV, before disconnecting the AV cable.

Viewing images on an HD TV:
The HDMI cable (HTC-100) is sold separately.

1) Make sure the camera's power switch is **OFF**.

2) Connect one end of the HDMI cable to the HDMI OUT terminal on the camera.

3) Insert the other end of the HDMI cable to the HDMI IN port on the TV.

4) Turn the TV on and switch its video input to select the connected port.

5) Turn the camera's power switch **ON**.

6) Press the ▶ Playback button on the camera. The images will be displayed on the TV; the LCD monitor will be blank. Images will be displayed automatically at the optimum resolution of the TV.

7) Press INFO to change the display format.

8) To disconnect, turn the camera's power switch **OFF**, and then turn off the TV before disconnecting the HDMI cable.

Warning!

To display the images properly, ensure the correct video system format has been set in Ψ: Setup Menu 2.

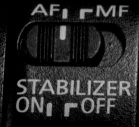

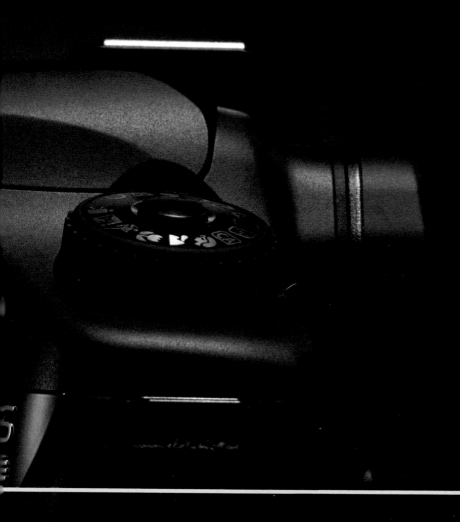

Chapter 10
CARE

10 CARE

Like any DSLR, the EOS 60D does not respond well to heat, humidity, dust, condensation, water, extreme cold, and human neglect. Thankfully, there are a few simple precautions you can take to protect your equipment from any serious harm.

» BASIC CAMERA AND LENS CARE

Hidden beneath the rugged exterior of your EOS 60D is some delicate engineering. As a result, it will not respond well to neglect. You can reduce the chances of dropping your DSLR by using a neck or wrist strap at all times. If your camera receives a knock or develops a fault, send it to your nearest authorized Canon dealer or service center—never try to repair it yourself.

If you don't plan to use your camera for a few months, remove the battery and replace its protective cover. If the battery is left in the camera for long periods, it will continue to release a small amount of current, which may affect its future performance. If you find that the battery drains quickly, even when it has been fully charged, check its recharge performance *(see page 123)* before buying a new unit. When not in use, store the EOS 60D in a cool, well-ventilated place, away from heat, corrosive chemicals, radio waves, and anything emitting a strong magnetic field.

BLACK LOOKS　　　　　　**«**
When the sensor is dusty, black splodges may be seen in light areas such as the sky.

Caring for your lenses

Protect your lenses with an ultraviolet (UV) or Skylight filter *(see page 223)*, and keep the lens cap on when not in use. Try to change lenses as quickly as possible, protecting both front and back elements during the swap. To clean the optics, first hold them upside down and use a blower to remove any loose dust, sand, or dirt. Next, roll a lens tissue into a loose ball and add a few drops of lens cleaning solution to it. (Never use solution designed specifically for eyeglasses.) Do not apply liquid directly to the lens, since it can seep along the edges and into the lens itself. Starting at the center of the lens, wipe the glass in circular sweeps, moving toward the outside edge.

Dusty conditions

Dust often appears as black marks or specks in pictures. Special devices are available to remove it, but try a puff with a blower before attempting any serious cleaning. Never use canned air inside the camera body, since the gas can freeze on the sensor. To prevent dust from entering the EOS 60D, switch it off and point it down when you are changing lenses, and never swap them in dusty, sandy, or windy environments. It can also help to use a vacuum cleaner to clear out your kit bag now and again. Remember that the sensor is extremely delicate; if it needs serious attention, it should be taken to a Canon service center.

» CLEANING THE SENSOR

When you clean the sensor of the EOS 60D, what you're actually doing is cleaning the low-pass filter in front of it. However, if you damage the low-pass filter, it can be just as costly as damaging the sensor itself.

› Using the Self Cleaning Sensor Unit

The low-pass filter of the EOS 60D is fitted with a Self Cleaning Sensor Unit. Every time you turn the power switch on or off, the unit automatically shakes to remove dust. This function can be disabled, or manually activated, at any time. In addition, the cleaning process can be interrupted by pressing the shutter button halfway.

1) Place the camera upright on a table or flat surface.

2) Press **MENU** and use the ⛭ Main Dial or ◄► on the Multi-controller to select ♥ᶤ Set-up 2.

3) Rotate the ◌ Quick Control Dial or use ▲ ▼ on the Multi-controller to highlight **Sensor cleaning**. Press **SET**.

4) Rotate the ◌ Quick Control Dial or use ▲ ▼ on the Multi-controller to highlight **Clean now**. Press **SET**. The message **Clean sensor** will appear on the LCD monitor.

5) Rotate the ⊙ Quick Control Dial or use ◀▶ on the Multi-controller to select **OK**. Press **SET**. The message **Sensor cleaning** will appear on the LCD monitor, and you will hear a shutter sound.

6) When the Self Cleaning Sensor Unit has finished, the LCD monitor will return to the **Sensor cleaning** menu. The **Clean now** option will be temporarily disabled.

7) To disable Automatic sensor cleaning, follow steps 1-3, then rotate the ⊙ Quick Control Dial or use ▲ ▼ on the Multi-controller to highlight **Auto cleaning**. Press **SET**. The message **Automatically clean sensor during power on/off** will appear on the LCD monitor. Rotate the ⊙ Quick Control Dial or use ◀▶ on the Multi-controller to select **Disable**. Press **SET**.

Using Dust Delete Data

If dust spots remain in your photographs after using the Self Cleaning Sensor Unit, fear not. The EOS 60D is capable of locating the position of blemishes and recording their whereabouts as Dust Delete Data. You can append this information to files, enabling you to automatically delete the marks later, using the Digital Photo Professional software provided.

To obtain the Dust Delete Data, you need to find a solid white object with no pattern or design—such as a piece of paper—to photograph. Next, set the focal length of the lens to 50mm or longer. Now switch the focus mode on the lens to MF (Manual Focus) and set the focus to ∞ infinity. (If your lens has no ∞ infinity symbol, hold the camera with the front facing away from you and turn the focusing ring on the lens counterclockwise as far as it will go.

1) Press **MENU** and use the 🖫 Main Dial or ◀▶ on the Multi-controller to select ◘ᴵ Shooting menu 3.

2) Rotate the ⊙ Quick Control Dial or use ▲ ▼ on the Multi-controller to highlight **Dust Delete Data**. Press **SET**. The message **Obtain data for removing dust using software. Refer to manual for details** will appear on the LCD monitor, along with the date when the information was last updated.

3) Rotate the ⊙ Quick Control Dial or use ◀▶ on the Multi-controller to highlight **OK**. Press **SET**. The camera will clean the sensor automatically before proceeding to the next stage. When the self-clean is finished, the message **Fully press the shutter button, when ready** will appear on the LCD monitor.

4) Place the white object 8-12in (20-30cm) away from the camera and, keeping the focal length of the lens at 50mm or longer, fill the viewfinder entirely with the object.

5) Press the shutter-release button down fully—the picture will automatically be taken in Av (Aperture priority AE) mode using an aperture of f/22.

6) When the shot has been taken, the EOS 60D will automatically obtain the Dust Delete Data. When this is done, the message **Data obtained** will appear on the LCD monitor, with the word **OK**. Press **SET**. The Dust Delete Data will be attached to every JPEG and RAW image taken thereafter.

7) If the exercise fails, the message **Could not obtain the data. Try again** will appear on the LCD monitor. Rotate the ⊙ Quick Control Dial or use ◀▶ on the Multi-controller to highlight either **Cancel** or **OK**. Press **SET**.

8) To use the Dust Delete Data to erase dust spots, load the Digital Photo Professional software CD into a computer *(see page 233)* and follow the instructions provided in the PDF manual.

› Manual sensor cleaning

While the Self Cleaning Sensor Unit on the EOS 60D will banish most dust spots from the sensor, any particles that remain may need to be removed manually. Before proceeding, make sure that the sensor is actually dirty: dust and debris can appear to be on the sensor when, in fact, they are on the lens, viewfinder, or computer screen. Next, consider using the Dust Delete Data function. If this fails to cure the problem, read on.

Cleaning accessories

The market is rife with gadgets designed to blow, vacuum, wipe, and brush the sensor back to health. Admittedly, some methods require more bravery than others, so be sure to always follow the instructions carefully.

Before performing any form of manual sensor cleaning, make sure that the battery is fully charged or, preferably, connect the EOS 60D to a household power supply using AC Adapter Kit ACK-E6 *(see page 228)*. If the camera loses power (or is switched off) while a blower or other cleaning device is inside the body, it can cause serious damage to the shutter curtains, sensor, or

DUST OFF　　　　　　　　　　　　**«**
Tools such as the Visible Dust Arctic Butterfly Pro kit offer an effective alternative to using liquid and swabs on the sensor.

10

mirror. In addition, you must not open the battery compartment cover or card slot cover while cleaning is in progress.

Cleaning the sensor

1) Remove the lens from the camera *(see page 27)* and turn the power switch **ON**.

2) Press **MENU** and use the ⚙ Main Dial or ◀▶ on the Multi-controller to select ♥² Set-up menu 2.

3) Rotate the ⊙ Quick Control Dial or use ▲ ▼ on the Multi-controller to highlight **Sensor cleaning.** Press **SET**.

4) Rotate the ⊙ Quick Control Dial or use ▲ ▼ on the Multi-controller to highlight **Clean manually.** Press **SET**. The message **Mirror will lockup. After manually cleaning sensor, turn power switch to OFF** will appear on the screen.

5) Rotate the ⊙ Quick Control Dial or use ◀▶ on the Multi-controller to select **OK**. Press **SET**. As a result, the reflex mirror will lockup, the shutter will open, and **CLn** will appear on the LCD panel.

6) When you have finished cleaning the sensor, turn the power switch on the camera to **OFF**.

> **Note:**
> If you are using a battery grip with AA/LR6 batteries, manual sensor cleaning will not be possible.

> **Note:**
> Before you attempt to clean the sensor manually, be aware that any damage caused as a result will not be covered by the warranty. If you are in any doubt, take the EOS 60D to a Canon service center to have the sensor professionally cleaned.
>
> On rare occasions, spots on the sensor may be caused by lubricant from the internal parts of the camera. In this instance, it is advisable to have the sensor professionally cleaned.

» ATMOSPHERIC DANGERS

› Heat and humidity

If the EOS 60D is exposed to extreme heat, it can cause parts to warp and lubricants to leak. To prevent this from happening, never leave the camera next to any heat source or in a car during hot weather.

Transporting your camera from a cool environment into humid conditions, or vice versa, can lead to condensation forming within the lens. To prevent this, place each piece of kit (camera, lens, etc) in a ziplock bag or airtight container and add sachets of silica gel before resealing. The gel will soak up any moisture, and condensation will form on the bag or tub, not on your equipment. Wait for the container to reach the ambient temperature, and then remove your equipment.

› Cold conditions

Camera batteries drain quickly when exposed to extremely cold temperatures, resulting in the mechanics of the camera becoming sluggish or ceasing to operate altogether. To avoid such situations, keep your camera close to your body until you are ready to take a picture, and store spare batteries in your pockets.

PERILS OF THE SEASIDE ⌄
Sand and saltwater can lead to serious problems for your camera. Always clean your equipment thoroughly after a day at the beach.

› Protection from water

Electronics and water simply do not mix. Unless you are using a special housing, your EOS 60D is not waterproof. If small amounts of rain, etc should splash onto your equipment, wipe it off with a clean, dry cloth. Exposing your camera to saltwater, on the other hand, is more serious, and can lead to corrosion and malfunction. A day at the beach should result in a thorough clean of your equipment on your return home. To prevent exposing your kit to water, invest in a rain cover.

› Caring for memory cards

Treat your memory cards with the same care and attention you give to your camera—if you drop them on a hard surface, or subject them to severe vibration, it may damage the data they contain. Similarly, do not expose cards to direct sunlight, dusty environments, or excessive heat; keep them away from liquids, and protect them with purpose-built plastic cases. Memory cards should not be stored on or near anything that produces a strong magnetic field—such as a TV set or stereo speakers—since doing so may result in loss of image data.

» GLOSSARY

Aberration An imperfection in the image, caused by the optics of a lens.

AE (autoexposure) lock A camera control that locks in the exposure value, allowing an image to be recomposed.

Angle of view The area of a scene that a lens takes in, measured in degrees.

Aperture The opening in a camera lens through which light passes to expose the CMOS sensor of the EOS 60D. The relative size of the aperture is denoted by f/stops.

Autofocus (AF) A reliable through-the-lens focusing system that provides accurate focus without the user manually turning the lens.

Bracketing Taking a series of identical pictures, changing only the exposure, usually in half or one f/stop (+/-) differences.

Buffer The in-camera memory of a digital camera that temporarily holds image data before writing to the memory card.

Burst size The maximum number of frames that a digital camera can shoot before its buffer becomes full.

Cable release A device used to trigger the shutter of a tripod-mounted camera to avoid camera shake.

Center-weighted metering A way of determining the exposure of a photograph, placing importance on the lightmeter reading at the center of the frame.

Chromatic aberration The inability of a lens to bring spectrum colors into focus at one point.

CMOS (complementary oxide semi-conductor) An image sensor consisting of millions of light-sensitive cells—the more cells, the greater the number of pixels and the higher the final image resolution.

Color temperature The color of a light source expressed in degrees Kelvin (K).

Compression The process by which digital files are reduced in size.

Depth of field (DOF) The amount of an image that appears acceptably sharp. This is controlled by the aperture: the smaller the aperture, the greater the depth of field.

dpi (dots per inch) Measure of the resolution of a printer or scanner. The more dots per inch, the higher the resolution.

Dynamic range The ability of the camera's sensor to capture a full range of shadows and highlights.

EF (extended focus) lenses Canon's range of fast, ultra-quiet autofocus lenses.

Evaluative metering A metering system whereby light reflected from several subject areas is calculated based on algorithms.

Exposure The amount of light allowed to hit the camera sensor, controlled by aperture, shutter speed, and ISO. Also the act of taking a photograph, as in making an exposure.

Exposure compensation A control that allows intentional overexposure or underexposure.

Extension tubes Hollow spacers that fit between the camera body and lens, typically used for close-up work. The tubes increase the focal length of the lens.

Fill-in flash Flash combined with daylight in an exposure. Used with naturally backlit, or harshly side-lit or top-lit subjects to prevent silhouettes from forming, or to add extra light to the shadow areas of a well-lit scene.

Filter A piece of colored, or coated, glass or plastic placed in front of the lens.

f-stop Number assigned to a particular lens aperture. Wide apertures are denoted by small numbers such as f/2, and small apertures by large numbers such as f/22.

Focal length The distance, usually in millimeters, from the optical center point of a lens element to its focal point.

Focal length and multiplication factor The CMOS sensor of the EOS 60D measures 22.3 x 14.9mm—smaller than 35mm film. The effective focal length of the lens appears to be multiplied by 1.6.

fps (frames per second) The ability of a digital camera to process one image and be ready to shoot the next.

HDMI (High-definition Multimedia Interface) Cable transmission of uncompressed digital data from one compatible device to another.

Histogram A graph used to represent the distribution of tones in an image.

Hotshoe An accessory shoe with electrical contacts that allows synchronization between the camera and a flashgun.

Hotspot A light area with a loss of detail in the highlights. This is a common problem in flash photography.

Incident-light reading Meter reading based on the light falling on the subject.

Interpolation A way of increasing the file size of a digital image by adding pixels, thereby increasing its resolution.

ISO The sensitivity of an image sensor to light, measured in terms equivalent to the ISO rating of film. The higher the ISO, the more sensitive the sensor is to light.

JPEG (Joint Photographic Experts Group) A universal image format supported by virtually all relevant software applications. JPEG compression can reduce file sizes to about 5% of their original size with little visible loss in image quality.

LCD (liquid crystal display) The large screen on a digital camera that allows the user to preview images.

Megapixel One million pixels are equal to one megapixel.

Memory card A removable storage device for cameras.

Mirror lockup A function that allows the reflex mirror of an SLR to be raised and held in the up position, before the exposure is made, to reduce vibration.

Pixel Short for "picture element"—these are the smallest bits of information in a digital image.

Predictive autofocus An autofocus system that can continually track a moving subject.

Noise Colored image interference caused by stray electrical signals.

Partial metering A metering system that places importance on a relatively small area at the center of the frame to calculate the exposure of the photograph.

PictBridge The industry standard for sending information directly from a camera to a printer, without having to connect to a computer.

Red-eye reduction A system that shines a light into the pupils of a subject, prior to taking a flash picture. The pupils shrink, reducing the chance of red-eye.

RAW The format in which the raw data from the sensor is stored without permanent alterations being made.

Resolution The number of pixels used to capture or display an image. The higher the resolution, the finer the detail.

RGB (red, green, blue) Computers and other digital devices understand color information as a combination of red, green, and blue.

Rule of thirds A rule of thumb that places the key elements of a picture at points along imagined lines that divide the frame into thirds.

SD (Secure Digital) card A small removable memory card that allows fast data transfer.

Shading The effect of light striking a photosensor at anything other than right angles, incurring a loss of resolution.

Shutter The mechanism that controls the amount of light reaching the sensor by opening and closing.

SLR (single lens reflex) A type of camera (such as the EOS 60D) that allows the user to view the scene through the lens, using a reflex mirror.

Spot metering A metering system that places importance on the intensity of light reflected by a very small portion of the scene.

Teleconverter A lens that is inserted between the camera body and main lens, increasing the effective focal length.

Telephoto lens A lens with a large focal length and a narrow angle of view.

TTL (through-the-lens) metering A metering system built into the camera that measures light passing through the lens at the time of shooting.

TIFF (Tagged-Image File Format) A universal image file format that can be compressed without loss of information.

USB (universal serial bus) A data transfer standard, used by the EOS 60D when connecting to a computer.

Viewfinder The camera's small window used to compose the picture, giving an approximate view of what will be captured.

White balance A function that allows the correct color balance to be recorded for any given lighting situation.

» USEFUL WEB SITES

CANON

Canon UK
www.canon.co.uk

Canon USA
www.usa.canon.com

Canon Camera Museum
Online history of Canon cameras and
their technology and design.
www.canon.com/camera-museum

Experience Seminars
Training courses for photographers using
Canon EOS digital cameras
www.experience-seminars.co.uk

GENERAL

Digital Photography Review
Independent digital camera reviews
and news
www.dpreview.com

ePHOTOzine
Online magazine with a photographic
forum, features, and monthly competitions
www.ephotozine.co.uk

EQUIPMENT

Adobe
Creator of photo-editing software, including
Photoshop and Lightroom
www.adobe.com

Apple
Creator of photo-editing software, including
Aperture, plus notebook and desktop
computers
www.apple.com

PHOTOGRAPHY PUBLICATIONS

**Photography books & Expanded
Camera Guides**
www.ammonitepress.com

Black & White Photography magazine
Inspiration and information for
monochrome enthusiasts

Outdoor Photography magazine
Features, tests, and techniques for lovers of
the great outdoors
www.thegmcgroup.com

EOS magazine
Print and digital magazine for Canon SLR
users
www.eos-magazine.com

» INDEX

CANON EOS 60D
THE EXPANDED GUIDE
SYMBOLS USED

- Main Dial
- Quick Control Dial
- Multi-controller
- Shooting menu 1
- Shooting menu 2
- Shooting menu 3
- Shooting menu 4
- Playback menu 1
- Playback menu 2
- Set-up menu 1
- Set-up menu 2
- Set-up menu 3
- Custom Functions menu
- My Menu
- Movie shooting menu 1
- Movie shooting menu 2

- Movie shooting menu 3
- Playback button
- Magnify button
- Reduce button
- Erase button
- Image protected
- Quick Control button
- Top LCD illumination button
- Single-frame advance
- High-speed continuous advance
- Low-speed continuous advance

- Self-timer 10-second delay
- Self-timer 2-second delay
- Focus confirmation light
- Flash off mode
- Flash exposure compensation
- Flash-ready indicator
- Built-in flash
- External flash
- Evaluative metering mode
- Center-weighted metering mode
- Partial metering mode

- Spot metering mode
- AF-point selection button
- FE lock/Index button
- AE lock button
- Auto rotate image (camera & PC)
- Auto rotate image (PC only)
- Image quality Fine JPEG
- Image quality Normal JPEG
- Custom white balance
- Auto white balance
- Daylight white balance
- Shade white balance

- Cloudy white balance
- Tungsten white balance
- Fluorescent white balance
- Flash on
- Flash high-speed sync
- Picture Style
- Sharpness parameter
- Contrast parameter
- Saturation parameter
- Color tone parameter
- High temperature warning
- Movie mode
- Live View/Movie shooting

- Live View Quick AF mode
- Face Detection Live mode
- Movie set
- Exit
- Play
- Slow motion
- First frame
- Previous frame
- Next frame
- Last frame
- Volume
- Edit movie

- Movie edit trim start
- Movie edit trim end
- Save edited movie
- USB connection
- PictBridge direct printing
- Printing effects
- Printing effects options
- Printing date/time settings
- Printing number of copies
- Print single image
- Print multiple thumbnails
- Select by folder